Clackamas Chinook Perfc

Studies in the Anthropology of
North American Indians Series

EDITORS
Raymond J. DeMallie
Douglas R. Parks

Clackamas Chinook Performance Art

Verse Form Interpretations

VICTORIA HOWARD

Transcription by Melville Jacobs
Edited by Catharine Mason

PUBLISHED BY THE UNIVERSITY OF NEBRASKA PRESS, LINCOLN

In cooperation with the American Indian Studies Research Institute, Indiana University, Bloomington

This book is published as part of the Recovering Languages and Literacies of the Americas initiative. Recovering Languages and Literacies is generously supported by the Andrew W. Mellon Foundation.

Library of Congress Cataloging-in-Publication Data
Names: Howard, Victoria, 1870–1930. | Mason, Catharine, editor. | Howard, Victoria, 1870–1930. Works. Selections. | Howard, Victoria, 1870–1930. Works. Selections. English.
Title: Clackamas Chinook performance art: verse form interpretations / edited by Catharine Mason.
Description: Lincoln: University of Nebraska Press; Bloomington: in cooperation with the American Indian Research Institute, Indiana University, [2021] | Series: Studies in the anthropology of North American Indians series | Includes bibliographical references and index.
Summary: "Carefully edited by Catharine Mason, Clackamas Chinook Performance Art by Victoria Howard pairs performances with biographical, family, and historical content that reflect Howard's ancestry, personal and social life, education, and worldview"—Provided by publisher.
Identifiers: LCCN 2020038267
ISBN 9781496224118 (hardback)
ISBN 9781496230416 (paperback)
ISBN 9781496225276 (epub)
ISBN 9781496225283 (mobi)
ISBN 9781496225290 (pdf)
Subjects: LCSH: Howard, Victoria, 1870–1930. | Howard, Victoria, 1870–1930—Family. | Clackamas Indians—Folklore. | Clackamas Indians—Oregon—Grand Ronde Indian Reservation | Indians of North America—Folklore. | Grand Ronde Indian Reservation (OR)
Classification: LCC E99.C818 H692 2021 | DDC 323.11970795—dc23
LC record available at https://lccn.loc.gov/2020038267
Set in Merope by M. Kolander and L. Buis.

For Trey, Arabella, and Zoey

CONTENTS

CULTURAL LANDSCAPES

TABLES

One thing leads to another. Scientists call this the causal chain of events. The circumstances that led to my discovery of Victoria Howard's Upper Chinookan poetry and ethnography are a somewhat haphazard combination of academic, geographical, and social events. However, what has persistently led me back to Howard's work over the years is not only scientific curiosity, heightened by the cultural material of the 1929–30 Victoria Howard-Melville Jacobs corpus, but also an ever-increasing sense of awe inspired by Howard's compelling stories, resonating from the singular voice of her tellings. Beyond the cultural and historical aspects of her work, the personal voice, vision, and narrative art of our Molalla-Clackamas poet and historian have challenged and enriched my understanding of culture, knowledge, and aesthetics and forever transformed my practice of theoretical science.

Studying a literary corpus that originated at a great distance from one's own cultural background brings forth particular challenges. Encountering a worldview so radically different from one's own—in this case, one entirely distinct from the mythological, linguistic, and theoretical references of conventional Western culture—ultimately demands a reevaluation of one's assumptions and criteria for truth and meaning. Such questioning and redefinition are, to be sure, imposed whenever one embarks upon a journey into the infinity of particularities that inevitably emerge from any given culture and that serve in a unique construction of selfhood and social life. The work of ethnolinguistics and ethnopoetics has clearly demonstrated that these processes of constructing personal and social reality are inseparable from the specific and ever-evolving symbolic representations of the world as they manifest in the art, language, and knowledge of that culture. Moreover, symbolic configuration of concrete reality provides the very basis of what makes communal exchange and growth possible. Symbolic meaning can, therefore, never be taken for granted.

Victoria Howard's corpus is not only a rich source for symbolic study— whether literary, cultural, historical, linguistic, naturalistic, or epistemological—of countless entities, dynamics, and formulations of Chinookan

civilization. Like all great works, it also provides a unique perspective on universal matters of human existence, social livelihood, and understanding of the concrete world. As a scholar I have sought to safeguard, for readers of this collection, the encompassing worldview of Chinookan civilization as manifested in the literary and ethnographical details of Howard's discourse. It has been especially important to identify the personal voice of her Molalla-Clackamas performances in their connections to both her inherited cultural worldview and the specific context from which she spoke. Throughout, I assume that an essential comprehensive unity grounds Howard's discourse as a particular manifestation in a much larger system of symbolic knowledge and creative potential in Northwest Coast Native American cultures. And since the whole is never a mere sum of its parts, it has been necessary to seek out not only the connection of each particular element with the "intelligible cosmos" of Chinookan thinking but also the formal properties—the "inner law of the expression itself," in the words of the German philosopher Ernst Cassirer—that operate in Howard's literary production (Cassirer 1996, 111).

My initial study of Howard's poetry and ethnography was largely an empirical investigation of the literary and linguistic elements, operations, and contours of her narratives and of other types of discourse that she produced. From her more stylized works, I chose examples of various discourse genres performed in her sessions for Melville Jacobs's attentive and probing ear, especially her myth-tellings, stories of transitional times, historical narratives, folktales, personal and family narratives, and ethnographical descriptions of objects, events, and purposes. My continued study focuses on the structural parallels and framing devices that provide shape and coherence to each discourse, focusing on formal patterns of temporal, spatial, symbolic, narrative, semantic, grammatical, rhetorical, metaphorical and metonymic, dialogical, phonological, musical, and visual elements in Howard's individual works.

As an academic pursuit, my journeys into the mythical, social, and historical landscapes of Howard's narrative art have sought to reveal the artist's creative impulse in her "symbolic grasp of pure relationships and orders of meaning" as opposed to "passive awareness" (Cassirer 1996, 111). It was not until 2009, when I first visited Howard's birth home in Grand Ronde, Oregon, that a more human and indigenous dimension of interpretive potential

opened up to me. Cultural and intellectual life at the Confederated Tribes of Grand Ronde further revealed a creative impulse and symbolic grasp similar to those of their ancestor. Enriching exchanges with descendants of Chinookan and other cultural traditions of the American Northwest Coast provided new analytical, mythical, and poetic insights that have given my work a more discursive approach, without which I may never have undertaken the present publication.

Much of my research into Victoria Howard's works has been guided by a wish to map out Chinookan worldviews. I have also sought to advance more general problematics in the editing of oral discourse, applying ethnopoetic and, later, ethnohistoric principles of philology as well as comparing Howard's works to other oral traditions and ethnographies. However, the present edition of selected texts resulted more from a focus on Howard's personal voice as an artist, historian, and member of the Grand Ronde community. Numerous visits to Grand Ronde and surrounding areas have allowed for archival studies, along with formal and informal meetings with tribal members, cultural specialists, and local scholars, which have broadened my understanding of Howard's multifold discourses. Extensive consultation with Howard's direct descendants and access to their private collections of photographs and letters have provided a basis for a more intimate understanding of the directions and complexities of Howard's cultural and historical testimonies.

I am greatly indebted to the late Dell Hymes for his assistance in my studies of the Clackamas language and for our many discussions about Victoria Howard's poetics during the preparation of my dissertation at the Université Bordeaux Montaigne. It has been one of my greatest fortunes as a scholar and as a humanist to have benefited from Hymes's critical feedback in my study of Chinookan literatures, as well as in my exploration of various critical approaches to oral literature, during the preparation of my doctoral dissertation in the 1990s.

I am also indebted to my dissertation supervisor, Bernadette Rigal-Cellard, for her faithful and sustained support as I grappled for a viable hermeneutics—an interpretive framework—within which some of the deeper and more wide-reaching meanings and references of Howard's works might be disclosed. Also, within the French context, my discussions with Emmanuel

Désveaux led me to a greater appreciation of the importance of the contri-
butions of structural anthropology to our understanding of indigenous
American literatures.

The continued interest of the late Virginia Hymes in my study of the
Victoria Howard corpus, along with her own work on Sahaptin narratives,
provided inspiration and critical input for the preparation of this edition.
I am also indebted to the late John Miles Foley for our discussions of com-
parative methodologies in the interpretation and editing of oral poetry and
his encouragement to experiment with new approaches.

Tony Johnson, certainly the most articulate individual scholar of Victoria
Howard's narratives today, with whom I have been able to share my work,
has provided critical insights and support through our discussions and in his
considerations of my analytical interpretations. The thoughtful assistance of
Gary Lundell and other staff members during my consultations on the Mel-
ville Jacobs Papers, at the University of Washington Special Collections, has
allowed for important understanding of the archiving and editorial processes
that enable the conservation and valorization of records of indigenous lan-
guages and traditions. I am also indebted to William R. Seaburg for sharing
documents and personal insights into the lives and works of Melville Jacobs
and his devoted associate and wife, Elizabeth D. Jacobs.

The coming together of this collection of Clackamas literature has greatly
benefited from an elaborate exchange with Native American historian Clara
Sue Kidwell, who has been generously forthcoming with her insights into
epistemological matters comparing indigenous American and European
worldviews. Likewise, the precious guidance of Raymond J. DeMallie Jr.
and Douglas Parks and expert editorial assistance of Paul Kroeber and Den-
nis Christafferson at the American Indian Studies Research Institute of
Indiana University have proven inestimable. Multiple visits to the institute
afforded me the opportunity to better anchor my work in the wider scope
of Native American studies in light of the leading advances in ethnohistoric
and anthropological linguistic scholarship achieved there.

Close consultation and collaboration with Grand Ronde historian June
Olson is richly reflected in the preparation of the present volume. My dis-
cussions with Chinuk Wawa specialist Henry Zenk and with Grand Ronde
tribal members Bobby Mercier, Eirik Thorsgard, David Lewis, and Kathy Cole,

along with my visits to the Elders' Center at Grand Ronde, have allowed me to gain valuable new insights into the history and culture of Grand Ronde.

It is with special thanks and affection that I acknowledge Victoria and Eustace Howard's great-granddaughter, Barbara McEachran Danforth; her husband, Allen Danforth; their late brother, George McEachran; and their daughters, Sara Rose Danforth Johnson and Amy Danforth, who have shared family history, memories, and heirlooms, and whose ongoing support has proven invaluable.

Interpreting, Editing, and Valorizing Traditional Works from Ethnographical Recordings

Victoria Howard was born Victoria Wishikin around 1865, a little more than ten years after the founding of the Confederated Tribes of Grand Ronde in western Oregon.[1] Her mother, Sarah Quiaquaty,[2] was of Clackamas-Molalla origin, and her father, William Wishikin, was a Tualatin Kalapuyan fisherman who traveled back and forth between his home on the Columbia River and his home at Grand Ronde. Wishikin died when Victoria was about ten years old, and she went with her mother to live with her maternal grandparents. Howard would no doubt have already been exposed to Clackamas and Tualatin literary traditions, but this significant change in social life was clearly an opportunity for her to gain more intimate access to the Clackamas tradition. Her Clackamas Chinook narratives are strong evidence that she contemplated and internalized the complex meanings and everyday lessons of the myths that her grandmother performed in the traditional context of winter recitals.

Howard's maternal grandmother, Wagayuhlen Quiaquaty, was a successful and valued medical shaman at Grand Ronde,[3] and her maternal grandfather, Quiaquaty, was an elite Molalla chief. In the texts selected for this book, we meet other powerful and respected members of both sides of her family. Ethnographical descriptions in her texts attest to the traditional lifestyle and environment in which Howard grew up, while fine details of cultural and historical events reveal the great consideration and devotion with which she recalled her past and that of her people.

Howard married Marc Daniel Wacheno, the son of a Clackamas chief, at about the age of fifteen, and she left her grandparents' home to begin a family of her own. She would have nine children with Wacheno during years of considerable poverty and mortal disease at Grand Ronde. During these years, Howard would also discover more about Clackamas history and culture through the myth-tellings and other narratives of her mother-in-law,

Charlotte Wacheno, referred to by Howard and the Grand Ronde community as Wásusgani. Following these years of childbearing and child rearing at Grand Ronde, Howard left Wacheno to marry Eustace Howard, a Santiam Kalapuyan, also from Grand Ronde. Victoria and Eustace left Grand Ronde around 1901; they found employment in the hop fields, and perhaps elsewhere, near their home in West Linn. They had one child, Agatha Howard Howe, who, along with her daughters, Bernice Howe (whose married name was McEachran) and Priscilla Howe, would survive the Grand Ronde couple.

In the summer of 1929, Melville Jacobs, an anthropologist at the University of Washington, asked Victoria Howard to record traditional Clackamas material for his study of oral literature in the Pacific Northwest. Howard and Jacobs worked together several days in July and again in August, and Howard dictated Clackamas vocabulary, Clackamas and Molalla songs, and several narratives of various genres for transcription in Jacobs's field notebooks (hereafter, JFN). Jacobs returned several times a week to the Howards' home for long recording sessions during the winter of 1930, transcribing an outstanding collection of Clackamas myths, folktales, and ethnographic descriptions performed by Victoria in the Clackamas language.[4] Jacobs also transcribed a substantial collection of traditional Kalapuyan narratives from Eustace. The couple received two dollars per day each for their work. Though Jacobs was not impressed with the works that Eustace performed, he was delighted with Mrs. Howard's talent and sharp wit. He writes of her in his field notes: "I might note, at this point, a conviction that has been growing upon me with increasing intensity, since I commenced working with Mrs. H.; it is that here is the unsurpassably intelligent and sublimely loquacious informant. Her dictation, too, is nicely distinct, perfectly timed for the most rapid dictation, and never a moment hesitant, even in more non-ik'áni narrative."[5]

We are further informed by Jacobs, in his introduction to volume one of *Clackamas Chinook Texts*, as to the orientation of his ethnographic inquiries, which would shape Howard's choices and developments in the rendering of her tradition: "I wanted to record in text and translation every myth and tale which she remembered. I sought as many songs and items of an ethnographic kind as I could record between the long periods of text dictation and translation." The professionalism, as well as the literary focus, of these

performance sessions is reflected in another of Jacobs's recollections of his work with his Clackamas poet:

I wrote down everything which she volunteered, but I stressed folklore and music. Few interruptions marred the hours spent in her home. Mr. Howard, the Howards' daughter, the latter's children, and occasional guests rarely intruded in the small quiet room where I sat writing comfortably on a Singer sewing machine, with Mrs. Howard in a rocking chair beside me. (Jacobs 1958, 2)

As a young doctoral graduate in linguistics from Indiana University, Dell Hymes anxiously awaited Jacobs's publication of Victoria Howard's Clackamas works. A great admirer of Jacobs's focus on literary aspects of Native oral tradition, Hymes would develop new approaches to the interpretation of oral narratives. One of his most productive methods of literary interpretation is known as "verse analysis" (see below), which would first be demonstrated on the basis of Howard's reconfiguration of a myth ("Seal and Her Younger Brother Lived There"). Other narratives from Howard's collection would be studied for their artistry and historical meanings in demonstrations of the principles of performance ethnography that Hymes advocated. Through careful analysis of the Clackamas corpus, Hymes has revealed contemporary innovations crafted by Howard's traditional and creative impulse as a female member of her society. My own study of her work attests to her achievement as a verbal artist—a true poet, highly attentive to her immediate surroundings and times.

Thanks to Hymes's intricate studies, Howard's "Seal and Her Younger Brother" has been published in anthologies, attracting the attention of scholars of Native American studies, literary critics, linguists, anthropologists, and folklorists around the world. I have often wondered how Victoria Howard would have responded to all the academic attention that her Clackamas Chinook verbal art has drawn. It brings to mind a scene in D. A. Pennebaker's documentary, *Don't Look Back*, in which the young Bob Dylan boasts of the gripping material that his song lyrics would provide for generations of scholars to come. Later, Dylan would deny all interest in literary interpretation of his works, insisting on his identity as a "song and dance man." Howard

could never have foreseen the abundant critical analyses and methodologies that have resulted from the extraordinary collection of artistic, historical, and ethnographical texts that she recorded with Melville Jacobs in 1929–30.

However, as for Dylan and all of the many poets whose critical comments and analyses accompany their literary legacies, I am convinced that Howard was conscious of a future reception of her performance texts by both local and academic audiences. There can be no doubt as to the high value she placed on the quality of her literary heritage and upon the importance of Grand Ronde history. Throughout her intense recording sessions with Jacobs—hours and days of tedious dictation, transcription, questioning, reviewing, discussing, defining, and translating—she would become familiar with the scholarly and technical processes of producing a written collection of complex and culturally defined material. In a letter to Jacobs, which she dictated to her daughter Agatha, Howard expresses interest in Jacobs's work on the Molalla language—"I wish I was there I would learn some of the hard words"—as well as her commitment to their continued work together (Howard 1929, personal correspondence).[6]

Likewise, as she followed the scratchings of Jacobs's pen, fixing onto paper the traces of her vast oral literary heritage that she selected to recite, she would have had many an opportunity to ponder the arid muteness of a field notebook as compared to an authentic, live performance of Clackamas oral tradition. Unfortunately, Howard would not live to see the publication of *Clackamas Chinook Texts* (hereafter, cct). We will never know if she would have rejoiced in the bare-bones survival of traditional performances, or if she would have been disappointed in the lack of sound and human context that inevitably characterizes transcription. I tend to believe that she would have felt the joyful rewards of her creative work as well as sadness over the loss of her language and the break in the cultural transmission of her literary heritage. She and all her people had lived in such distress, from disease and political treachery and internal tribal strife, for so long that it is impossible today to assess the hope she must have held out for her people, which gave rise to the breadth of her artistic expression as recorded by Jacobs.

Victoria Howard died on September 26, 1930, just a few months after her last recording sessions with Jacobs. She had been admitted to the Oregon City hospital for heart trouble and died the same day. An obituary in the *Twice-*

a-Week Banner-Courier of Oregon City (September 29, 1930) states that she had "met with an automobile accident when struck down to the pavement at West Linn." Investigation has not revealed the details of this accident, although Howard's great-grandchildren, Barbara McEachran Danforth and George McEachran, recall from oral family history that it occurred while Mrs. Howard was walking her granddaughters to church and that it was a hit-and-run incident. Although the journalist had no apparent knowledge of Howard's work with Jacobs, we do read that "her ancestors came her[e] years before the whites settled in this country, and she remembered hearing them tell of the early life of the Indians in Clackamas County." It would be another twenty-eight years before printed copies of her works appeared.

THE PRESENT TEXT COLLECTION

This republication of selected texts from Howard's Clackamas corpus, more than half a century after Jacobs's original publication, is motivated by the wish to make a variety of her more well-crafted pieces accessible to Chinookan descendants and to members of the Confederated Tribes of Grand Ronde and for the benefit of further scholarly work on American Northwest Coast literatures. More generally, it is my hope to make Howard's works available for greater understanding and celebration of the rich cultural heritage that lies therein.[7]

In selecting works for the present collection, I have given preference to performances with biographical, family, and historical content that reflect Howard's ancestry, personal and social life, education, and worldview. At the request of some Grand Ronde tribal members and other Chinookan descendants, I have excluded myth narratives from this edition. This is largely out of respect for inheritors' rights to appropriate and define the values and purpose of cultural heritage. It is also because one must acknowledge the remoteness of the contextual meanings and, especially, the ancestral meanings of Howard's repertoire. These issues, in combination with the complex nature of myth itself, inevitably leave gaps in expressive meaning that cannot be recuperated without painstaking interpretation and analysis. As one of the deepest layers of human consciousness accessible to objective study, myth is entangled with configurations and codes of historical and symbolic real-

ities that require constant adjusting of conceptual frameworks and methodological approaches. Academic interpretation of this complex symbolic form should be most carefully carried out in cooperation with its cultural inheritors, an ongoing endeavor that I hope to continue with my associates and friends of Native American descent in the Pacific Northwest.

I have made an exception to this rule, however, for two short myth excerpts that are not really performed as myths: "Seal and Her Younger Brother Lived There" and "Two Maidens: Two Stars Came to Them." In both of these narratives, Howard interprets brief mythic episodes as contemporary historical events, pointing to the cultural context of contact with Euro-Americans. Given the modern implications of Howard's interpretations of these myth excerpts, her performances of them emerge as entirely distinct from the sacred myth-tellings of Chinookan tradition. They also reflect the daily discursive use of myth excerpts and references in the indigenous life of Howard's ancestors and contemporaries. (See my discussion of *Mythe et quotidien* [Mason 1999, 213–36].) This kind of secular use of mythical insights, images, and views of social life, expressing renewed interpretations in light of changing political circumstances, is still practiced among American Northwest Coast Natives today.

It is well known that myth performances in American Northwest Coast civilizations were complex, culturally encoded, formal events at which participating children and adults honored the authority of the tellers and the lessons, both sacred and profane, that were to be learned from them. Community rules, beliefs, and principles guiding their performance had been handed down and respected from generation to generation. These practices were disrupted by the removal of Natives of western Oregon from their homeland, the imposition of Euro-American cultural beliefs, the criminalization of Native practices and, finally, the dispersion of individual Natives, separating communities and families, as a consequence of economic pressures and the eventual termination of the Confederated Tribes of Grand Ronde. The material base of indigenous cultural practice was all but eradicated, and the collective lifestyle that provided the spiritual and pedagogical foundation of traditional practice has been destabilized by the necessity of conforming to Euro-American governance and life demands. In short, the fragmentation and wearing down of cultural practice and social exchange

has destroyed the languages in which the highest forms of expression of Native customs, beliefs, and worldviews were transmitted.

The existence of written and audio recordings of Clackamas and Molalla myths thus poses a dilemma for all interpreters and editors of Howard's work. It also establishes a responsibility, for tribal members and scholars alike, to determine the guidelines and principles for handling sacred materials: for identifying the parameters of their sacredness and seeking a means of making that sacredness, as well as the many other elements that serve the narrative's meaning and artistry, accessible to Northwest Coast descendants. This cannot be a matter of simply applying traditional rules to the contemporary setting, since Native traditions have been altered — suppressed in some cases, revitalized in others — and where oral traditions have not been broken, cultural traditions have naturally evolved, since the number of forms of media and the material challenges of preserving, interpreting, and protecting cultures and languages have increased tremendously. All of these matters must be worked out as part of an ongoing dialogical interpretive process to which I remain fully committed.

Selection of pieces edited for this volume has been based on three broad themes: personal, historical, and cultural landscapes of the artist and her people. These groupings derive from the specific biographical line of inquiry that has guided my study of Howard's works over the past twenty years and are not intended to exclude other themes that may be seen as dominating Howard's corpus. First, many of Howard's exceptional pieces involve, for example, shamanistic practices and healing ceremonies, which could be placed under the category of "spiritual landscapes." However, shamanism is interpreted by Howard primarily in relation to its function as a medical practice, grounded in biological, natural, and historical circumstances. Moreover, the significant number of medical shamans in Howard's personal narratives is, no doubt, a reflection of the large number of practitioners in Victoria Howard's family as well as the poor health conditions at Grand Ronde during her early adulthood.

Another running theme in Howard's recordings is the degrading impact of white culture on Native life, especially at Grand Ronde. Despite the stark episodes and cutting irony of Howard's depictions, this historical tragedy is often presented in a comical light. "Laughing at Missionaries," "Wásus-gani and Wačínu," and "The Honorable Milt" all portray residents of Grand

Ronde mocking Euro-American culture and Native attempts to embrace it. We discover in these texts a curious merging of derision of others and derision of self, seen in a particularly comical light in "Fun-Dances Performed by Visitors," a narrative of an attempt by Clackamas traders to imitate a traditional dance performed by Kalapuyan traders.

A final theme that integrates her works, bringing light to their highly charged and esoteric content, is found in the lively descriptions of the people that populated Howard's environment and imagination. Some of these people were integral parts of the artist's family and social world, while others rapidly moved in and out of her circle with singular purposes. Still others were people she had only heard about. Nonetheless, they all make up a sociocultural group whose history and social activity connect through shared cultural orientation and purpose in Howard's narrative collection.

If one distinction between Grand Ronde culture and Euro-American culture at the time of Howard's life should be pointed out, it is the difference between a collectivist and an individualist frame of reference. In many ways, Howard's works are the result of a collision of these two worldviews. She grew up in a collectivist world, where strict rules and beliefs regarding the cohesion of natural and social environments, interdependent with supernatural forces, are founded upon a worldview in which every individual is to be held accountable for the wider social well-being. But she would venture out and survive in an individualist society of wage-earners, foreseeing the future of her children and grandchildren, dominated by European values and skills mastered by a quickly evolving American society. Her keen sensitivity to both worlds made it possible for her to cross over from oral tradition into the world of written text, pursuing innovative narrative configurations and adapting traditional materials to a contemporary context. Victoria Howard's greatest success as a published verbal artist may be found in the considerable number of personalities, families, and social circles portrayed in her narratives, which she both individuates and places in their social context. This is true of her myths, as Jacobs points out (see below), but is equally true of her histories, her elaborate descriptions of cultural life, and her contemporary narratives. She provides an extraordinary elaboration of each portrayal with human qualities and traits, perceived and

articulated from keen observation and through having lived a life that had survived these collisions of worlds.

TRANSLATION

In revising Jacobs's work for the current edition, four aspects of his translations of Howard's texts are placed in focus. First, I have given priority to conveying stylistic and rhetorical features of Howard's Clackamas recitations in linguistic choices of translation, taking as a guiding principle the goal of capturing the uniqueness of Clackamas poetics and of Howard's style, without seeking to embellish the English versions of the originals. In some cases, this has meant eliminating some of the awkwardness of Jacobs's original translations as seen in the published *Clackamas Chinook Texts*—translations that originated in his work with Howard and were subsequently reworked by him. In other cases, however, I have willingly, though not intentionally, added some awkwardness. In these cases, what may be an unusual form in English is, in fact, a calque or a literal rendering of the original Clackamas form.

A second category of translation choices that modify Jacobs's versions is, in fact, an instance of this latter policy, in the domain of syntax and the ordering of grammatical units—more specifically, in the placement of grammatical objects.[8] In Chinookan languages, it is not uncommon to place a grammatical object in front of a verbal phrase—to say, for example, "Her car, she drove it."[9] It is rather common for the object to precede the verb in Howard's Clackamas, though it is not a fixed rule; a grammatical object may also fall after the verb. In revising Jacobs's edited translations of the texts selected for this edition, I have sought to identify and duplicate in translation occurrences of this structure in which the object is given special weight or in which it is placed early in the clause on account of its meaning; in such cases, I have placed the object before the verb in the English as well. In some cases, the Clackamas form is duplicated literally due to a rhetorical function, such as, once again, placing the grammatical object in the forefront.

A different rhetorical use of object-verb phrase ordering may be observed in consecutive uses of the form. Such formal repetitions serve to create syntactic parallels that come through effectively in translation. In some such

occurrences of object-verb phrase order, I have replaced this order with the standard English subject-verb-object sentence form, since reproducing the Clackamas order in English would lead to excessive awkwardness.

The third general type of revisions to Jacobs's translations is modifications of grammatical tense. One modification of this sort is that, where Jacobs uses the past tense (preterit) to translate the Clackamas iterative verb form (an aspectual form that indicates repeated action, marked with the prefix *a-* and suffix *-a*), I often use the hypothetical past modal *would*, except where English rules of tense usage do not allow for it. I have also modified, somewhat systematically, certain narrative verbal forms that do not seem to reflect the temporal logic of the original narrative in the Jacobs translations. In other words, I have paid careful attention to English narrative norms as regards the use of verb inflections as a means of maintaining an even flow of narrated events.

A fourth and final way in which I have revised the original translations is to attempt to replicate onomatopoeia—the use of a term that sounds like the phenomenon that it represents—by means of English onomatopoeic terms where Jacobs used action verbs. Use of onomatopoeia in the English translation is another way in which I have given priority to stylistic characteristics of the original version, even though they may sound awkward or naive in English literary material. Onomatopoeia also provides sound qualities that carry significant value in oral discourse. The production of sound to describe an action creates a more realistic effect, which establishes a sense of immediacy for the events of the story. This stylistic device is a salient characteristic of Chinookan languages (see Boas 1911, 655–56), and the choice to translate it literally in the English versions presented here is intended to allow audiences to adapt to its effects and to better appreciate the oral contours of Clackamas literary tradition.

PHONEMIC TRANSCRIPTION

In the present re-entextualization of Howard's performances, the Clackamas version is presented in essentially the Americanist phonetic orthography used by Melville Jacobs in *Clackamas Chinook Texts*.[10] This makes it easy to compare entextualizations as they appear here with their form in

Jacobs's publications and field notebooks, although the orthography used in the latter differs somewhat from that in the published texts. The spelling of Native proper names conforms, however, to a certain extent, to the Anglicized forms proposed by Grand Ronde historian June Olson in consultation with Dr. Henry Zenk, a linguist working on Chinuk Wawa revitalization at Grand Ronde. The initiative to standardize the spellings of names of Grand Ronde members is, in part, an effort to familiarize today's English-speaking members with the names of important figures in the history of Grand Ronde, for greater ease in classrooms and university discussions. These standardized spellings are based on an English pronunciation that comes as close as possible to the original Chinookan pronunciation, based on transcriptions by Jacobs, when available, and from other field sources. The present work employs a combination of Jacobs's phonetic spellings and the standardized spellings of June Olson in her outstanding collection of biographies of Grand Ronde members.

BUILDING ON PREVIOUS LITERARY ADVANCES

In some very important ways, the work provided in this collection of Victoria Howard's verbal art performances has been made possible by the ethnolinguistic and ethnopoetic advances of Melville Jacobs and Dell Hymes. In turn, Jacobs and Hymes revealed various features of individual performance texts and of Howard's body of work, bringing to light a rich and coherent body of literature. These features include a number of distinct forms that result from a personal style of linguistic, metaphoric and metonymic, narrative, dialogical, and thematic strategies.

Jacobs provides significant insights into the structural and cultural matrices of the corpus in *The Content and Style of an Oral Literature* and *The People Are Coming Soon*, pointing to both literary traits in Howard's verbal art as well as in her literary tradition. Much of Jacobs's deeper literary analysis of Howard's work makes use of psychological categories, including those used in psychoanalysis, though he never wavers from connecting his findings to questions of worldview and social context. Jacobs informs us that "Clackamas literature stressed social relationships," illustrated in his table, "Leading Kinds of Content" (Jacobs 1959b, 128), reproduced here.

Table 1. Leading kinds of content

Content items	Approximate number of stories
Relationships (apart from sex)	62
References to traits of personality	30
Explanatory and origin items	30
Humor-generating items	25
Ethical implications	25
Spirit-power references	20
Stimuli to a response of horror or terror	10
Stimuli to a response of tragic feeling	45
References to foods (in most instances only incidental)	45
Overt references to sex	25

Note: This count excludes the epilogue, which was a required feature of style in each of the forty-nine myths.

Perhaps of greatest importance, Jacobs's two-volume publication of Howard's performances sorts his collection of 148 texts into literary genre categories. The Howard-Jacobs genre system includes myths (Clackamas and Molalla), stories of transitional times (Clackamas and Molalla), Clackamas stories of pre-white times, and ethnographic texts. Performances included in the genre of "ethnographic texts" contain descriptions of cultural phenomena including social, political, historical, naturalistic, and technical themes. The three narrative genres of myths and "stories" reflect a chronological sequence of narrative origin dating from the most ancient form (myth) to a time just before the arrival of the Europeans. They range from mythical times to the recording session and gather, in some instances, very elaborate narratives of literary interest. Jacobs elaborates on this grouping:

> Mrs. Howard was definite about three stages of evolution: a long precultural era, the Myth Age, in which often extraordinary events succeeded one another; a later and probably much shorter transitional era; and a brief modern period whose actors and events were significant features of the modern world structure or the physical aspects of pre-cultural times. (Jacobs 1959a, 195)

Jacobs's generic descriptions, along with his attentiveness to patterns of content, remain closely linked to his analysis of form and style throughout his work, innovating new approaches and objectives for understanding oral literatures in the 1960s and inspiring Dell Hymes's fruitful demonstrations of "covariation of form and content."

Hymes's study of the works of Victoria Howard and of numerous other Pacific Northwest Coast verbal artists (including Charles Cultee, Louis Simpson, Hiram Smith, and Philip Kahclamet) would come to focus more on personal voice, contextual meaning in performance, and formal organization of units of discourse. His engagement with performance-centered dynamics would ultimately lead to his demonstrations of verse structure as an essential device in the creation of deep-set meaning (Hymes 1981, 1983, 2003). For Hymes, a performance embodies both traditional and innovative formal qualities that are versical in nature and that are disclosed through close attention to linguistic and stylistic detail (Hymes 1981, 1985, 2003). Dell and Virginia Hymes inspired a wide and diverse group of scholars in linguistic ethnography and folklore to take up a method that became known in the United States as "verse analysis" (V. Hymes 1987) and that reflects long-standing principles of philology and literary criticism.

ORAL TRADITION AND LITERATURE

Semantic confusion naturally arises when critics discuss "oral texts" or "oral literature," two terms that have become unavoidable in the study of vocal and verbal arts. These terms seemingly ignore the obvious fact that the act of speaking and the act of transcribing are separate steps toward producing a written document whose purpose is to represent a speech event. Raymond DeMallie's discussion in *The Sixth Grandfather*, as he unravels the interpretive processes of transcription and translation that went into John Neihardt's *Black Elk Speaks*, has brought to light the responsibility of editors and historians to reveal metatextual and contextual dynamics as well as historical details of textual configuration in the valorization of an oral literary production (DeMallie 1984).

Ethnographic interviews such as those of Jacobs and Neihardt (see DeMallie's elaborate annotations in the reedition of Black Elk's testimonies in Nei-

hardt 2008) produce elaborated narratives employing traditional artistic verbal materials. While it is possible to distinguish these from information-seeking interviews, the distinction is difficult to make, since all interviews of the latter kind can potentially produce literary works and all literary works naturally provide information. Jacobs was a pioneer in focusing on literary tradition and in the time and attention he accorded to collecting and interpreting material that stands apart from the ordinary discourse of everyday life. His keen understanding of the cultural and linguistic value of such materials led him to devote much of his work with Victoria Howard to matters of community transmission and interpretation of traditional narratives—indeed, after publishing Howard's texts, Jacobs went on to publish two volumes of his own interpretive analysis of individual stories (Jacobs 1959b and 1960).

Focus on literary culture is not possible, however, unless the speaker who produced the discourse was competent in literary performance of traditional narratives, as were Black Elk and Victoria Howard. Several such Native associates worked with ethnolinguists on the American Northwest Coast in the late nineteenth and early twentieth centuries and left a rich collection of valuable literary art—among them Charles Cultee, Hiram Smith, Joe Hudson, and other traditional verbal artists interviewed by Franz Boas and other ethnolinguists trained by Boas. Victoria Howard stands out among these important figures for the exceptional number of works she produced with Jacobs, as well as for the variety of genres, hybrid genres, and styles that she performed. Both qualitatively and quantitatively, Mrs. Howard produced a rich and vast corpus of traditional narrative, ethnographical narrative and description, and historical and biographical narrative. Her innovation in narrative and genre strategies is likewise exceptional and worthy of advanced literary analysis.

Interpretation of oral literature begins with the moment of utterance—indeed, the moment at which the artist speaks, making choices about what events will be described, what characters will be developed, and which audience expectations will be targeted. The artist also determines to which literary genre (such as folktale, personal anecdote, historical narrative, myth, or joke) or genre hybrid the uttered text should be assigned, and to what extent the conventions of that genre will be respected.

In recording oral literary materials, the speaker strikes a balance between cultural tradition, personal voice, and cross-cultural accessibility, more

or less conscious of the fact that the scientific inquiry of an ethnographer will help to shape the transcription and translation of a complex work. In traditional settings, works are transmitted by community performers and their audiences, all of whom bring with them past experiences of performances and interpretations, which include everyday verbal exchanges in which they contemplate meanings and implications of community verbal art. A great deal of community interpretation is carried out in the form of analogies between events in the story and real-life events. In what ways are the characters a reflection of community members? In what ways do they reflect archetypes and ideals? In what ways do traditional narratives and the historical events they recount reflect upon contemporary life and struggles? What moral lessons, values, and information in the narrative are pertinent to present-day relationships and activities in the community? As our understanding of performance poetics advances, these are the types of questions that ethnographers have started to include in their exchange with community members.[11]

Academic interpretation thus begins with community interpretation; the scholar must seek to identify the function or functions of a literary performance in a community and the traditional contexts that help shape the performance event and its arena. Scholars also have effects on the performance event and the narrative itself by their very presence as well as through the insights and questions that they bring to the discourse. In the case of ethnographical interviews in which few or no community members are present and traditional context is all but absent, the event unfolds much like a closed-door studio rendition of a performance piece. Such a rendition could be called a "recording performance," to emphasize the technological and academic processes involved in interpreting and producing the edited text. In the rest of this introduction, I attempt to outline such processes, as they have affected my editorial choices in the present volume of Victoria Howard's Clackamas recordings.

NARRATOLOGICAL INTERPRETATION AND EDITING

Narrative configuration involves the ordering of events into a coherent and expressive plot. The narrative artist, or storyteller, develops a focus for the

audience through elaboration of details, arousal of expectations, stimulus of sensation or emotion, or any sort of stylistic maneuver that incites literary interpretation. The artist may employ any number of tools to coherently sequence the events, dialogues, and descriptions in the narrative in a way that will foreground those that reveal the story's meaning. Background events and descriptions, on the other hand, figure as ways of enhancing the overall quality and sensibility of the narrative.

Many of the elements and devices used to build plot and create literary effect are specific to the culture from which the artistic work comes. Likewise, the material basis of the language in which the work is produced implies unique vantage points, references, and sound patterns; the meaning and effect that these create are not always translatable without annotation and, often, elaborate analysis. Victoria Howard's narrative techniques include careful construction of event sequences and descriptions, the development of suspense, character profiles, social values, and the unfolding of cultural problematics. These skills are by no means unique to her; many of the narrative structures she uses may be found in the performance texts of other Chinookan and Northwest Coast verbal artists. Mrs. Howard's unique voice is heard, however, in an elaborated focus on female issues and on concerns of her own generation.[12]

Two significant aspects of Jacobs's editing may be identified through comparison of the versions of Howard's performance texts that appear in Jacobs's notebooks with those in the published texts. Both involve insertions, but of different degrees of significance. In Jacobs's published versions, the numerous parenthetical notes or wordings inserted in the translations are intended to clarify meaning and/or guide the reader's comprehension of the narrative logic of events. Many such parenthetical insertions appear as part of the English translation in Jacobs's field notebooks.

Jacobs's inserted remarks are quite helpful, at times necessary, for bringing to light cultural assumptions and presuppositions that would be unavailable to readers not familiar with complex or subtle Chinookan narrative patterns and cultural references. Such annotations also clarify elements of the narrative that may be understood from the oral qualities of the spoken discourse but are not obvious in a written text. For instance, Jacobs specifies

who is speaking in dialogue, while Howard often omits the names of speakers — or any discourse markers — to create a more lively sense of the verbal exchange between characters. Erasing the voice of the narrator in this way foregrounds characters and makes the dialogue more animated; however, the omission of such markers can cause readers to have difficulty following the story, losing track of who is saying what.

In my entextualizations of Howard's recordings, Jacobs's inserted remarks and endnotes are included as endnotes on each piece. The removal of this material from within the text itself is intended to help readers discover the stylistic qualities of sparseness, in some cases, and of orality, in others. Hopefully, relegating some of Jacobs's parenthetical insertions to endnotes, rather than including them in the text of the translations, will foreground elliptical qualities of the original narratives, which I hope will stimulate readers to investigate further the narratological use of devices such as ambiguity, arousal of expectations, and codes of the unspoken.

Jacobs has also inserted narrative episodes from discussions with Howard, following performances, into their published versions. In his notebooks, such additions are transcribed in Clackamas along with their translations, usually on left-hand pages, with indications of where they are to be inserted in the flow of the performed text. Jacobs does not indicate at what point in the recording process Howard dictated these episodes. He incorporates them into the published version without specifying that they were added or why.

Clearly these added episodes were introduced by Howard, whether during the original dictation, during later revision, or during the translation process. Whenever these episodes were introduced, Jacobs included all of them in the published versions of Howard's work. Most of them appear in myth narratives and serve as expansions of the performances. The most elaborate use of such additions in the present volume is found in "Wásusgani and Wačínu," one of Howard's most accomplished works and one of the last narratives to be recorded.[13] All in all, it would seem that the technology of writing and translation influenced Howard's artistic strategy; she adapted to both the hindrances and the potentials of the editorial process that transforms spoken word into written literature.

VERSE FORM EDITING

The present edition of selected Clackamas performances is based on an analysis of how verbal segments combine in an individual discourse, creating literary design and meaning. Such an analysis focuses on the formal properties of language. These reflect choices made by speakers to shape their messages in particular ways for particular effects. In presenting the basic content that makes up such discourses, speakers configure the flow of information to enhance their personal views of events or topics.

Carefully configured speech makes use of culturally recognized literary devices that align listeners and readers with the speaker's point of view. Devices commonly found in both oral and written literature include the following:

- sound patterns, both phonological and musical, that foreground attitudes or moods;
- dialogue patterns that serve to develop characters and their relations as well as viewpoints and event structures;
- stylistic features such as metaphor and imagery;
- narrative sequencing of temporal and spatial relations;
- cultural paradigms, such as formulaic expressions and characteristic patterns of human behavior;
- historical references, such as the names of heroes or significant events;
- grammatical patterns that code factors such as time, mood, and aspectual viewpoints;
- rhetorical devices that motivate ideological views or arouse cultural values;
- role playing that gives audience members a sense of purpose or belonging.

All of these features are observable in Victoria Howard's performance texts and allow us to identify contours and building blocks whereby both personal and cultural meaning are enhanced.[14]

Both Melville Jacobs and Dell Hymes identified literary patterning in Howard's Clackamas narratives, although their interpretations differ con-

siderably. While Jacobs divides Howard's works into paragraphs marked by indentations and further divided into numbered subparagraphs, Hymes has edited a selection of her works into segments he refers to as lines, verses, stanzas, scenes, acts, and parts, calling his method "verse analysis."[15] While Jacobs identifies the organization of Howard's works as reflecting staged plots and dramatic landscapes, Hymes searches for poetic and rhetorical features, anchored in the logic of the Clackamas language and in Howard's particular use of the language.

Many of the narrative segments identified by Hymes correspond with the paragraph units in Jacobs's interpretation of Howard's recordings—that is, the overall structural interpretations of the two linguists show significant consistency. But this is not always the case. While Hymes's significant findings on Howard's work tend to focus on smaller-scale patterns of lines and verses, the textual details and variations that he identifies through comparative analysis often lead to interpretations of overall narrative meaning that differ considerably from those of Jacobs. One of Hymes's most intriguing findings is the extraordinary frequency of grouping of text units in threes and fives—five being a structurally and semantically significant number in Chinookan culture. The best-known example of Hymes's verse analysis is his discussion of Howard's "Seal and Her Younger Brother" (Hymes 1984).

Despite their differences, the work of Jacobs and Hymes, taken together, has established high standards for the literary analysis of oral discourse in general, and of Victoria Howard's place in American literature more specifically. It has, indeed, been an honor, a pleasure, and a non-negligible challenge to follow in the footsteps of these two great scholars. The editions that I provide here in many ways result from a close study of the clarifications of method that result from the rigorous processes of transcribing, editing, interpreting, and translating that Jacobs and Hymes developed, explicated, and revised.

The edited versions of Howard's texts presented here are the result of figuring and refiguring narrative logic, rhetorical development, cultural form, and contextual meaning at linguistic, literary, and historical levels that merge in a comprehensive whole. If even a single element stands out as incoherent or inconsistent, a complete verse analysis is not possible. In some cases, I have deferred the final analysis of a text for as long as several years because

I was unable to grasp the implications of a short episode. But once I have worked through the temporal units of narrative events, the grammatical form, the interchange of voices, the sequencing of events, the contrast and concurrence of viewpoints, and the rhetorical features of the unique style of all the segments of a text, I bring my editing process to a close. At such a point I am satisfied that the edited form provides a valid representation of the poet's meaning and unique purpose, and of a firm connection of the performance to its cultural heritage and context.

Although the marking of the segmentation of texts has been kept to a minimum, the verse scheme followed in this volume employs these editorial terms and conventions:

> A *line* is a rhythmic utterance that provides an integer of meaning (semantic, syntactic, narrative, functional, and so forth), and is also referred to as a *breath group*, in that it is often framed by the speaker's intake and release of breath within a discursive flow; typographically, a line is indicated by being placed within a single horizontal line of print.
>
> A *verse* is a group of one or more lines; typographically, verses are indicated by placing the first line of the verse at the left-most margin, while subsequent lines are given increasing indentations.
>
> A *stanza* is a group of one or more verse(s); typographically, stanzas are demarcated by spacing above and below them.
>
> An *act* is a group of one or more stanza(s); these are marked by capital letters (A, B, C, and so forth).
>
> A *part* is a group of one or more acts, marked by a Roman numeral (I, II, III, and so forth).
>
> A *text* is a complete discourse, marked as such in JFN or in CCT. A text may also be referred to as a *narrative*, to underline its event-based structure, or as a *piece*, to emphasize its performance characteristics.

The verse presentations of Howard's texts in this volume are not intended to suggest a definitive representation of her performance poetics, nor of the specific texts; rather, they constitute a literary representation that reflects

both my own personal sensitivities and more objective methodologies. While narrative form and style have been the primary foci of my research, one must not suppose that cultural form and poetic meaning are ever cleanly separable. In fact, narrative logic overlaps imagery, which overlaps sound patterning which, in turn, is intricately linked to grammatical operations, historical processes, and cultural dynamics that emerge in a performance situated in time and space. No single translation can capture all the semiotic values of a performance of verbal art. An unlimited number of performance elements and processes will remain hidden or obscure in any textual representation of a live performance, not only those that cannot be represented with ink or font, or those that are simply not translatable, but also those that are embedded in historical and cultural activity and references to which we have no access whatsoever.

While I am committed to scholarly standards and principles, I am also convinced that such approaches assume a particular view of language and cultural production that should never be perceived as a final statement of the meaning of such a production, nor of its holistic worth. It is my hope that members of Grand Ronde and other Native communities of the American Northwest will come to appreciate the value of a scholarly approach without being put off by its technical abstractions. It is far from my purpose to allow scientific theory to dominate the way we think about Howard's works. I seek, rather, to provide interpretive insights into the artistic and human values of Howard's dense and complex body of literature in hopes of stimulating further interpretation and discussion. One of the greatest challenges of this academic process has been to reach back to the moment of narration of Howard's performed works, and to the historical context of her people, for inspiration and guidance as I seek to bring her voice into the present for her descendants, for scholars of languages and literatures, and for the growing number of people who are attentive to indigenous worldviews.

Clackamas Chinook Performance Art

Personal Landscapes

The Wagʷə́t

This short narrative poem depicts the symbolic role of the *wagʷə́t* bird, whose song may be heard in early dawn.[1] The wagʷə́t sings as the more industrious Clackamas go about their early-morning activities. It is said that those who rise early have the spirit-power of the wagʷə́t. Victoria Howard's grandmother's voice takes over the narration, describing her daily routine as inspired by the wagʷə́t.

A Łixtmaẋ iłáẋalalčk káwux,
 kʷalá yučúkdidix:
 aġa íwa łkdála.
 Aġa aqłulxáma,
 "Łúxʷan agʷə́t amíyułmaẋ." 5
 Áyma wagʷə́t,
 kʷala·' [2] yučúkdidix:
 aġa íwa aqalčə́mlitma.
 Aġa alugʷagíma,
 "Aġa yučúkdidix: 10
 "aẋəlčə́mlit wagʷə́t."

B Agə́škix nagímẋ,
 "Ánġa qáẋba ančúya—,
 "ančẋlúkšama awači dán—
 "qáẋba ančúya, 15
 "áġa áẋka anšẋagəlmílagʷa.
 "Sámniẋ gʷə́tgʷə́t,
 "a·'ġa ančẋláyučgʷa,
 "anšẋəltwíčgʷa,
 "aġa nčuya.[3] 20
 "Aġa qa·'··ẋba nišúwit,
 "kʷalíwi ayučúkdiyaẋdixa."[4]

A Someone rises early in the morning,
 just as dawn breaks:
 now they are already off and about.
 Now they would say to them,
 "Perhaps the wagʷə́t is your spirit-power." 5
 Only the wagʷə́t,
 ju·ˊ·st as dawn breaks:
 now already they will be hearing her.
 Now they would say,
 "Now dawn is breaking: 10
 "the wagʷə́t will be heard."

B My mother's mother said,[5]
 "Long ago, wherever we would go—
 "we would go berry picking or such—
 "wherever we would go, 15
 "now we would be listening out for her.
 "Hearing[6] 'gʷə́tgʷə́t,'
 "no·ˊw we would rise,
 "we would get ready,
 "now off we go. 20
 "Now fa·ˊ··r away we arrived there,
 "before it would become full dawn."

Náyma ganúłayt wagəškix
(I Lived with My Mother's Mother)

Victoria Howard performed this piece as a response to her interviewer's request to tell about her own life.[1] Her maternal grandmother becomes the prominent figure in this autobiographical poem. Rather than a deviation from her "personal life," as suggested by Jacobs, this text may be interpreted as bearing witness to the importance of relationships and of collective life in the traditional Clackamas perception of "self."

A Ənk'áškaš níšqi mánk dnx̣ə́lutkt.
 Wi·'čm gayúmaqt.
 Ganə́duya wagə́qu wišgə́škixba:
 kʷábá gandúłayt.
 Ákʷa gnúk'ʷayc. 5

 Łúxʷan qánčíx̣,
 íyaλqdix aġa wagə́qu wálimx̣ náx̣ux̣.
 Aġa náyma ganúłayt wagəškix.

B Aqugálmama qáx̣ba λ'áλ'a akłúx̣ama.
 Káywax alax̣láčgʷa, 10
 alúya qáx̣ba díx̣t itgʷə́łiba;
 łúxʷan mákʷšt łún itqʷłímax̣ alawíya.

 Dán iwá díx̣t itgʷə́łí alúya,
 λ'áλ'a akłúx̣a.
 Akłgúλġa, 15
 alax̣łámida itgúnax̣ba itġʷə́łi:
 kʷábá wít'ax̣ λ'áλ'a akłúx̣a.
 P'ála akłúx̣a
 alax̣aykłámidayax̣dixa díx̣tba wit'ax̣ itġʷə́łi:
 λ'áλ'a akłúx̣a. 20
 Alúyama.

C Aġa lawíska,
 agnulxáma,
 "Amxə́lkiłẋ aġa!
 "Iłčə́qʷa amúya!" 25
 K'ʷaλqí anẋúẋa.

 Aġa dánmaẋ akdúkʷsdamida,
 aġa nčẋłẋə́lma.
 Ančẋk'íλxuma,
 sáq'ʷ. 30
 P'ála ančẋúẋa.

 Aġa dán agilkʷłíčgwa.
 Ičə́k'ak'u ačuġúmčẋuga,
 "Qá aġa gʷiłáčgmam?"

 Agyulxáma, 35
 "Áġa mánk p'ála ikíẋaẋ.
 "Łúxʷan ławá t'áya aliẋátẋ."

D Néšqi dán náykẋiču.
 Íxtmaẋix dán qánaġa núλ' qá alagíma.

 Néšqi dán galanẋə́lutk łán gakłgə́mixtk awači kłúmila. 40

 Qánaġa alagíma,
 "Kánawi łán iłəlẋášux,
 "Kínwa łẋlúwida iłgʷə́łilx."
 K'ʷáλqí alagíma.

A Of myself as a child, I do not remember much.
 My fa·'·ther died.
 there we lived.[2]
 I was still small. 5

I do not know how long after,
> but after quite a while now my mother married.[3]
Now I alone lived with my mother's mother.

B They would come to take her to where she would warm them.[4]
Early in the morning she would get up, 10
> she would go there, to some house;
>> perhaps she would go through two or three houses.

She would go to the first of the houses,
> she would warm the person.
When she got done, 15
> she would move along to another house:
>> there too she would warm a sick person.
When she finished,
> she would go on to still another house:
>> she would warm the person. 20
She would come back.

C Now in the evening,
> she would tell me,
>> "Make a fire now!
>> "Go fetch water!"[5] 25
That is what I would do.

Now she would cook various things,
> now we would eat.
We would finish eating,
> all done. 30
We were finished.

Then she would recount something.
My mother's father would ask her,
> "How is the sick person now?"

She would reply to him, 35
 "He is getting better and finished with it.
 "Maybe he will slowly get well."

D She never spoke ill about anything or anybody.
 Once in a while she would just speak a little critically of something or
 other.
 I do not recollect anything about some person whom she slandered or
 criticized. 40

She would merely say,
 "All of them, our kindred,
 "Even strangers: our people."[6]
That is the way she would speak.[7]

Summer in the Mountains

This family narrative illustrates a traditional summer camping trip in the mountains during which different foods are gathered and prepared for winter.[1] Howard identifies members of her family that participated in these lengthy trips, along with various activities the adults carried out in preparation for the winter season.

Gančúyx̣ itbuǧuxmáx̣ba:
 íčłm,
 agə́qu,
 agə́škix,
 agə́tum, 5
 štmákʷšt išgútxix išdákʾayčax̣.

Íčłm níx̣qʾʷax̣.
Káwux ákʷa nšǧéwitam alidímama.
Ačíλama ilálax:
 aǧa ayágikal agyúx̣ša; 10
 ałgux̣ašámida iłgʷə́l;
 aǧa wayágikal náwi agiyałə́lx̣aymama ipʾáskʷl iłčə́qʷaba.

Aǧa ančúya,
 kʾʷə́tkʾʷt ančkłúx̣ama iłə́kaməkš.
 ančdímama. 15

Aǧa x̣ábixix aǧa wagə́škix akłučmáya.
Ałúksda,
 aǧa λáqʷ akłúx̣a;
 aǧa lúlumax̣ akłúx̣a;
 aǧa ičáǧayλ waǧələmq máła, 20
 aǧa kʷabá akłíx̣utgayax̣dixa.
Ayučúkdiya aǧa kánawi łx̣íšəqʷt;

aġa wáx̣wax̣ aqlúx̣a waġaɫáx̣ba.
A·ʹ·y ganškx̣x̣ašámit.

Aġa šdáx̣ ix̣gʷə́l gašgux̣ašámit; 25
 wít'ax̣ idsə́qsəquks ɫábla.

Íyax̣qdix ganšx̣ídlayt kʷába kʷalíwi ganšx̣átk'ʷay.
Aġa dáx̣ka daxiya ičax̣élqɫm gadánšx̣idəmx̣.

We used to go to the mountains:
 my mother's brother,
 my mother,
 my mother's mother,
 my uncle's wife, 5
 two cousins who were small.

My mother's brother hunted.
The following morning we were still sleeping as he was returning.
He had brought a deer:
 now his wife would butcher it; 10
 they smoke-dried the meat;
 now his wife at once placed the hide in water.

Now we went,
 we picked blackberries.
 we got back. 15

Now in the evening now my mother's mother boiled them.
When they were done,
 now she took them out;
 now she made round, flat berry-dough cakes;
 now on a large clean bark, 20
 now there she placed it beside the fire.

When the sun rose now they were completely dry;
 now she scattered them about in the sunlight.
We dried lots of things.

Now they smoke-dried the meat; 25
 also a lot of buckskins.

A long time we stayed there before we came back home.
Now those were the things that we ate during the wintertime.[2]

My Grandmother Never Explained Childbirth to Me

Victoria Howard recalls that when her uncle's wife goes into labor, Howard's maternal grandmother, Grand Ronde medical shaman Wagayuhlen Quiaquaty, attends to her.[1] As the delivery approaches, the young Victoria is covered with a blanket and told that it is for her protection. She wonders exactly how they get the baby out of the mother's abdomen. She is not told and she does not ask.

Íčłm ayágikal ałagəmłə́lgʷačgʷa.
Agə́škix akšalglágʷačgʷa.

Q'ʷábix ƛáqʷ akłúx̣a iłk'áškaš,
 aġa ałgənkgílaġʷa.
Ałgnulxáma, 5
 "Iłk'áškaš iƛáq'amšukš ałkdməłx̣ʷáya."

Ganx̣łúxʷayt,
 "Łúxʷan[2] qáx̣ba iłk'áškaš ałkłglgáya?
 "Łúxʷan ƛ'ə́x̣ alix̣úx̣a iłáwan?
 "Kʷábá iłk'áškáš ałkłglgáya?" 10
K'úya:
 nέšqi qánčix̣ gagnulxámx̣ qáx̣ba gaqłgə́lgax̣ iłk'áškaš;
 nέšqi qánčix̣ ganuġúmčx̣uga agə́škix.

My mother's brother's wife would become ill.[3]
My mother's mother would take care of her.

When she was close to giving birth to the child,
 now they would cover me over.
They would say to me. 5
 "The child's intestines might wrap around you."

I thought,
> "I wonder, where will they get the child?
> "I wonder, will they cut open her abdomen?
> > "From there, the child, will they take it?" 10

No:
> never did she tell me where they got the child;
> never did I ask my mother's mother.[4]

Weeping about a Dead Child

During a gooseberry-picking trip, the young Victoria Howard hears her grandmother Wagayuhlen's weeping and wonders what is wrong.[1] Upon returning home, the grandmother washes her face and explains to her husband that she discovered the stick toys of her deceased granddaughter, hence her weeping. She cries out for her granddaughter, and the young Victoria is perplexed. The next day the grandmother weeps again, but as in olden days, she does not wash her face before eating but waits for the sun to be on the other side of the sky.

Gandúyx̣,
 gantgyup'yáłxamx̣ iq'ámašəqšq.
Kʷálá aǧa ganalčmáqʷax̣ nakčáx̣mx̣.
Gan̓x̣łuxʷáytx̣,
 "Qá akíx̣ax̣ agə́škix?" 5
Íyaƛqdix aǧa gagnulxámx̣,
 "Aǧa atxk'ʷáya."

Gandúyx̣,
 gandúyamx̣.
Lawi·'·ska gagnulxámx̣, 10
 "Iłčə́qʷa łə́nit."
Gan̓ƛalútx̣.
 gałax̣k'ʷíčux̣,
 gałax̣úƛkax̣.

Aǧa nax̣aylkʷłíčkʷax̣ ičə́k'ak'u. 15
Gagyulxámx̣,
 "Náx̣atx̣ k'úyabt,
 "nə́šqi qánčíx̣ kʷábá ganúyx̣ qáx̣ba gałax̣admútx̣mx̣.
 "Kʷaƛqi·'· ux̣inx̣átx̣ idə́mqu gagúx̣idnx̣a,
 "dáx̣ka inúǧikl. 20

"Aġa dáyax k'ʷaλqí imšǵənx̣čəmaq."
Aġa ganx̣łuxʷáytx,
 "Áw qúšdyaxa dáx̣kaba gatqlqt aǵə́škix."

Nax̣tgímniɫ,
 "Dágu! 25
 "Wáktkn!"
Inx̣łúxʷayt,
 "Dánba k'ʷáλqí agímniɫ?"
Káwux nax̣láčkʷax̣,
 núyx̣ λáx̣nix, 30
 aġa wít'ax̣ nakčáx̣mx̣.
Íyaλqdix nišgúpqax̣,
 néšqi gałax̣k'ʷíčux̣,
 néšqi nax̣lx̣ǝ́lǝmx̣ áłqi láx̣ʷ waġáłax̣,
 kʷalíwi nax̣łx̣ǝlǝ́mx̣. 35
K'ʷaλqí nux̣áx̣ax̣ ánġa idǝ́lxam.

We went off,
 we went to pick gooseberries.
Soon now I heard her weeping.
I thought,
 "What is going on with my mother's mother?" 5
After quite some time now she said to me,
 "Now let us go back home."

We went,
 we got back.
During the evening she said to me, 10
 "Get water for me."
I gave it to her:
 she washed her face,
 she finished.

Now she explained to my mother's father. 15
She told him,
 "Not since that time,
 "never had I been back to that place where she used to play.
 "The sticks are still standing there like that,
 "I saw them. 20
 "Now that was why you heard me weep like that."
Now I thought,
 "That was indeed why my mother's mother was weeping."

She said,
 "Daughter's daughter! 25
 "My daughter's daughter!"
I thought,
 "Why does she say that?"[2]
The following day, she got up,
 she went outside, 30
 now again she wept.
After some time she went inside,
 she did not wash her face,
 she did not eat until the sun was far to one side,[3]
 then she ate. 35
That is the way it was done long ago by people.

A Molale Hunter Who Was Never Frightened

Victoria Howard's maternal Molalla uncle, Moses Allen, was a brave and skilled hunter.[1] He would nonetheless tell this story of how he was once frightened by a strange creature during a hunting trip. After setting up camp, he goes off to hunt. When he hears a fawn crying, he proceeds with caution and discovers an animal that is part snake and part deer.

Íčłm gačinčlx̣íkʼałx̣ax̣ ánġa,
 łġá nix̣qʼʷálalmx̣,
 gʷánisim néšqi dán gačiġə́lglx̣,
 áwači dán ačilčmágʷa.

Nigímx̣, 5
 "Anúyama qánčix̣bt itbuġúxmax̣.
 "X̣ábixix waġə́lmq anaglgáya:
 "itġʷə́łi andúx̣a,
 "kʷábá anx̣úkšit.
 "Néšqi kʼʷáš anx̣úx̣a:" 10
 "néšqi dán anilčmágʷa,
 "áwači alingátġʷama."

"Káwux anúya,
 "anx̣qʼʷáya.
"Yáymayx íxdix núyt, 15
 "kʷálá aġa ganx̣ə́lčə́maq aqʼíx̣šap úqlqt.
"Ganx̣łúxʷayt,
 "ʼkʷálá wákaq aladíya.'
"Łáwa·' ganx̣áqʼqʼʷλwa;
 "ganagútxʷit wámqu ax̣ímat. 20
"Íwi gasinx̣ə́lutk:
 "dángi ix̣ímat cʼə́mmmm[2] λʼa-qʼíx̣šap-díwi.
"Ičíyaw kánawi,

"yáyma iyáqʼakstaq:
 "aqʼíx̣šap. 25
"Idíyax̣u ičʼíyaw."

Kʼʷáƛqi ačinčulx̣áma:
 alix̣ənčilkʷɬíčgʷa.

My mother's brother told us a story long ago:
 when he had to be out hunting,
 at no time did he ever see anything,
 nor did he hear anything.[3]

He said, 5
 "I would arrive after so many mountains.
 "In the evening, I would gather bark:
 "I would make a house,[4]
 "there I would lie down.
 "Never was I afraid:[5] 10
 "nothing would I hear,
 "nor would anything come upon me."

"The following day I would go off,
 "I would hunt.
"Only once, while I was going along, 15
 "soon now I heard a fawn crying.
"I thought,
 "'Soon her mother will be coming along.'
"Slowly I moved along with caution;
 "I stood on a log that lay there. 20
"I turned and looked:
 "something spotted all over lay there just like a fawn.[6]

"All of it was snake,
 "except for its head:
 "a fawn. 25
"Paws on the snake."

That is the way he would tell us about it:
 he would inform us of it.

A Shaman Doctored Me for My Eyes

Victoria Howard experiences severely troubled eyesight, and her condition becomes worse after following the advice of her mother-in-law, Wásusani Wacheno, to rinse with cold water.[1] She leaves her marital home to seek help at her maternal home. Her father's aunt (Howard's great-aunt), Grand Ronde medical shaman Šə́mxn, is called in.[2] Šə́mxn diagnoses an evil disease power and begins treating her niece. The shaman discovers that her patient's head is cold and reports that the mother-in-law may have wanted to cause the young woman to go blind.[3]

> Agə́p'nənkaw q'ʷáp gə́nx̣atx̣.
> Wákšdi gagnulxámx̣,
>> "Níšqi kɬúšk'ʷayt iɬčə́qʷa aɬəmxk'ʷíčwa.
>> "Cə́s iɬčə́qʷa wáx̣wax̣[4] ɬə́mxux̣."
> Wáʔáw wígʷa: 5
>> nə́šqi asənxəmk'nágʷačgʷa.
> Xábixix kʷalíwi angíkšda.
> Aġa ganx̣luxʷáytx̣,
>> "Anúya agə́quba ganúwix̣."
>
> Ganúyamx̣ idə́kaqʷɬba. 10
> Káwux gagnulxámx̣,
>> "Anúya,
>>> "anugálmama amík'iš.
>>>> "akmə́tkšdama."
> Núyx̣. 15
> Kʷálá galúyamx̣,
>> gagnulxámx̣,
>>> "Aladíya."
> Gančagəmláytx̣.

Kʷálá aġa núyamẋ. 20
Agə́qu gaginglúẋaẋix,
 kʷábá ganẋ·áymaẋ.
Nangiláytẋ.
Gagnulxámẋ,
 "Łúxʷan dán gamxatgíġʷaġʷa yámlayx, 25
 "Káwux néšqi gamẋgʷátẋ.
 "Aġa gamẋłẋə́ləmẋ,
 "iłčə́qʷa gamłuġúmštẋ.
 "Dáẋka dádáx díluẋt imíġʷamnił.
 "Tgmulxmát iłmíqʼakštaq, 30
 "mẋłúxʷan ismíxus imíčġmam."

Aġa wítʼaẋ nangiláytẋ,
 gagəngəlgníłẋ iłgə́qʼakštaq.
Gagnulxámẋ,
 "Ka·ʼ·nawi cə́s amkíẋaẋ." 35
"ə̂··."

"Dán imẋəlẋúla ipłə́ẋ?"
Ganulxámẋ,
 "Kʼu·ʼya.
 "Kʼu·ʼya dán." 40
"ə̂·!"
 gagnulxámẋ.
 "Íyaƛqdix mánk,
 "aġa pú amípʼnənkaw aluẋamlúẋa.
 "Néšqi wítʼaẋ cə́s iłčə́qʷa aləmxkʼʷíčʷa. 45
 "Kłúškʼʷayt iłčə́qʷa łáẋka aləmxkʼʷíčwa.
 /"Łúxwan qánaġa wámišdi aẋłúxwan pú amípʼnənkaw
 alaẋamlúẋa!"

I became nearly blind.
My mother-in-law told me,
 "Do not wash your face with warm water.
 "Pour cold water on yourself."[5]
It became worse during the day: 5
 I could not see around me.
It was nighttime before I could see.
Now I thought,
 "I shall go to my mother."

I got to her house. 10
On the following day she said to me,
 "I shall go,
 "I shall go fetch your father's aunt,[6]
 "she will come to see you."
She went off. 15
Soon she returned,
 she said to me,
 "She will come."
We waited for her.

Soon now she arrived. 20
My mother fixed a bed for me there,
 I lay down at that place.
She doctored me.
She said to me,
 "Possibly you dreamed of some bad thing,[7] 25
 "And the following day you did not swim.
 "Now you ate,
 "you drank water.[8]
 "It is this thing right here that is staying in your heart.
 "It is swinging your head, 30
 "you may be thinking that your eyes are sick."

Now she doctored me again,
 she felt all over my head.
She said to me,
 "You are completely cold." 35
"Yes."

"What medicine have you used?"
I replied to her,
 "No.
 "Nothing at all." 40
"Well well!"
 she replied to me.
 "After a while longer,
 "you might now have become blind.
 "Do not wash your face again with cold water. 45
 "Warm water is what is to be used to wash your face.
 "Perhaps your mother-in-law just thought that she would
 make you blind!"[9]

Ičə́čg̓mam ganx̱átx̱ aġa Dúšdaq ningidə́layt
(I Was Ill, Dúšdaq Doctored Me)

Victoria Howard's mother solicits the expertise of the powerful Tualatin-Kalapuya medical shaman Dúšdaq following ineffective consultations with a number of other shamans.[1] This autobiographical narrative attests to the complex social processes of personal health and medicinal practice in West Oregon indigenous tradition. Among the decisions Dúšdaq asks the patient's family to make about treatment is his recommendation of community participation through ritual dancing. The family announces the dance the following day, and it is held that evening. Opening the doors to the family home in this way brings in the malicious Umpqua shaman Úbidi. Dúšdaq has learned of Úbidi's imminent menacing intervention from a dream and has used his spirit-power to take necessary precautions against the intruder's interference. The family never loses confidence in the authority of the shaman, who guides Howard to full recovery.

Ičə́čg̓mam gánx̱ux̱.	*Preamble*
Ganx̱ímax̱it íyaλqdix.	

1A Agə́qu aqłglgáya idłáġiwam ałəngiłáyda.
 Néšqi t'áya gałgnúx̱ux̱.

Wít'ax̱ łgúnax̱ aqłglgáya. 5
Wít'ax̱ k'ʷaλqí.

Łúx̱ʷan qánčix̱bt gagúgitga.
Aġa yáx̱t'ax̱ Dúšdaq[2] gagiglgáx̱.

1B Ningiláytx̱;
 λáqʷ gačinx̱úx̱ax̱ wímqt. 10

Gačulxámẋ aǵə́qu,
 "Qá anyúẋa dáyax wímqt?
 "Aniwáǵʷa?
 "áwači aníwčkča anyalẋʷqčgʷáya?"
Aǵə́qu gagyulxámẋ, 15
 "Íwaq!"

Aǵa gačiwáqʷaẋ.
Sáqʷ,
 wátułba gačławiłátaẋ iłíyamuxti,
 ƛú galẋúẋaẋ. 20

1C Gačulxámẋ,
 "Sámniẋ néšqi amšguwimidə́čgʷa,
 "néšqi łuxʷan t'áya aláẋuẋ."
 Néšqi qa gałgyulxámẋ.

 Káwuxčwa aǵə́qu nákimẋ, 25
 "Ačlẋulxáma t'áya ačúẋa,
 "k'ʷaƛqí algúẋa."
 Gałigmláytẋ.

 Wít'aẋ gayúyamẋ.
 Aǵa aǵə́qu gagyulxámẋ, 30
 "Amnčulxáma t'áya alaẋúẋa,
 "ančgʷímitčgʷa."

 Gačulxámẋ,
 "ə́ⁿ.
 "Nẋłúxʷan k'ʷaƛqi." 35
 Aǵa áǵanwi kánawi gałẋlp'aláwəlalamẋ.

1D Aǵa káwux aǵa gałgdulxámamniłẋ;
 ẋábixix aǵa gatgíyamẋ,
 Yúxt kʷaba Dúšdaq.

Núλ'ix aġa gałglalámẋ. 40
Yáẋt'aẋ niglalámẋ.

Sáq'ʷ,
 aġa ningiláytẋ.
P'ála gačnúẋaẋ.

Aġa nuxʷak'ʷáyuniłẋ. 45
Kawéx xábixix wít'aẋ gatgíyumniłẋ,
 mánk łábla idǝ́lxam.
Aġa k'ʷaλqí wít'aẋ nugʷalalámẋ.

Sáq'ʷ,
 aġa ningiláytẋ. 50
Wít'aẋ p'ála gačnúẋaẋ,

Aġa nuxʷak'ʷáyuniłẋ.

2A Kawéx xábixix aġa yániwa niglalámẋ.
Nigímẋ,
 "Iłgʷłílx iłẋadúgʷl, 55
 "łẋdgíkšdámt."

Niẋk'ayawǝlalǝmẋ.
Káwux xábixix wít'aẋ niglalámẋ yániwa.
Aġa gačłulxámẋ,
 "Ik'útk'ut idít, 60
 "dángi číyuqšt."³

Sáq'ʷ,
 p'ála niẋúẋaẋ,
Aġa dáyt'ikš alugalaláma.

Sáq'ʷ, 65
 aġa aluxwak'ʷáyuniła.

2B Wít'aẋ káwux xábixix gayúyamẋ.
 Nigímẋ,
 "Iɫgʷə́ɫilx ɫdít.
 "Aɫdímama dáwax wápul. 70
 "Iɫíč aɫλíλama."

 Kʷalá aġa gaɫgímẋ itgáġiwam adít.
 Núyamẋ,
 lxéliw núyẋ,
 nuɫáytẋ. 75

 Kʷalá gatgíyamniɫẋ idə́lxam,
 aġa ɫábla dapáλpaλ itġʷə́ɫi.

2C Aġa yániwa wít'aẋ niglalámẋ,
 gaɫiẋúλqaẋ.
 Aġa áẋt'aẋ ayágikal, 80
 gaɫaẋúλqaẋ.
 Áẋt'aẋ agə́qu.
 aġa kánawi ɫán sáq'ʷ.

 Aġa áẋt'ax gitgáġiwam náglalamẋ,
 sáq'ʷbt kálamt akíẋaẋ. 85
 λáqʷ gakɫúẋaẋ ič'ínu iɫyáyč;
 aġa ɫáẋka gakɫwímidačqʷaẋ.

 P'ála naẋúẋaẋ.
 Yáxa yáẋ Dúšdaq,
 yu·ʹ···ẋt yaẋigát iyákʷšẋat cəmumu·ʹ·. 90
 Sáqʷ,
 aġa nuxʷak'ʷáyuniɫẋ.

3A Káwux yaxa náyax aġa p'ála ganẋúẋaẋ.
 Néšqi wít'aẋ ičəčġmam:
 anẋláčgʷa, 95

anúya λáx̣nix,
 anúya anx̣łx̣ə́lmama.

Aġa xábixix,
 aġa wít'ax̣ yániwa gayúyamx̣.

Nigímx̣, 100
 "Itgáyułmax̣ dániwádikš itgadímamnił.
 "Ux̣iłúxʷan dán atgiġlgláya."
Yaxíba λáx̣nix išə́qiba yúx̣t,
 cúk'itkt.

Nix̣k'ayáwəlaləmx̣. 105
 "Nanúyama xábixix nanx̣úkšida,
 "nanx̣gíġʷaġʷa iłgʷə́łilx it'úkdix ałdímama.
 "Nałgíλama ikdílwayt;
 "anyúxtga,
 "aniłxúxtga." 110

K'ʷáλqi nix̣łúxʷan.
Nix̣k'ayáwəlaləmx̣.

Xábix̣ix atgíyamniła.
Kʷalá aġa nɛšgúpqax̣ áyxt itgáġiwam.

Na·'·wi gasaxəmk'nágacgʷax̣. 115
Yaxa yáx gayułáydamx̣ iłə́pulba.

Kánawi gagíyamx̣,
 gatgíyamniłx̣.

3B Aġa niglalámx̣ yániwa.
 Aġa gačdulxámx̣, 120
 "Ayamšulxáma:
 "Qánaġa alx̣mútx̣əmx̣;

"néšqi áǧanwi iwi·ʼ·ladáyax̣.
　"qánaǧa agə́mqlqt wagáxan dáwax waǧagílak.
"Mšx̣łúxʷan dánmax̣ amškdə́λa dába dán amšǧiǧlgláya:　　125
"K'úya!
"Néšqi dan amšǧiǧlgláya."
Aǧa wápul gatgʷíyučqʷax̣.

Gačugáqʷdix.　　　　　　　　　　　　　　　*Ending*
Aǧa lúlu gakdúx̣ax̣,　　　　　　　　　　　　130
　gaqdugʷigʷíčux̣ dánmax̣ kánawi.
Aǧa ičə́bučxan gayútxʷitx̣,
　búškš[4] nix̣úx̣ax̣.
Yáxa ičə́mut yáx̣ iglálam.
Sáq'ʷ,　　　　　　　　　　　　　　　　　135
　p'ála nux̣áx̣ax̣,
Aǧa nuxʷak'ʷáyniłx̣.

I became ill.[5]　　　　　　　　　　　　　*Preamble*
I lay there for a long time.

1A　My mother got a shaman to doctor me.
　　He did not make me well.

　　Again, she got another one.　　　　　　　5
　　Again, the same thing.

　　I do not know how many others she got.
　　Now she got Dúšdaq himself.

1B　He doctored me;
　　　he took the disease-power out of me.　　10

　　He asked my mother,
　　　"What shall I do with this disease-power?

"Shall I kill it?
　　"Or shall I wash it and give it back to her?"
My mother told him, 15
　"Kill it!"

Now he killed it.
All done,
　he spit into the fire,
　　it flared up.[6] 20

1C He told her,
　　"If you do not dance for her,
　　　"she may not become well."
　They said nothing whatsoever to him.

　It was the following day before my mother said, 25
　　"If he tells us that he will make her well,
　　　"that is what we will do."
　They waited for him.

Again he came.
Now my mother told him, 30
　　"If you tell us that she will get well,
　　　"we will dance for her."[7]

He replied to her,
　"Yes.
　"I do think that."[8] 35
Now indeed they all discussed it.

1D Now the following day now they went to announce it;[9]
　　in the evening now they got there,
Sitting right there was Dúšdaq.[10]

Soon now they started to sing. 40
He himself sang.

When they were done,
 now he doctored on me.
He finished with me.

Now they went back home. 45
On the following evening again they came,
 even more people.
Now the same way again they sang.[11]

When they were done,
 now he doctored me. 50
Again he finished with me.
Now they went back home.[12]

2A The following evening now he was first to sing.
 He said,
 "Some people are thinking of coming here, 55
 "wanting to look on."
 He laughed about it.

The following evening he again was the first to sing.
Now he told them,
 "A dog is coming here, 60
 "biting into something."[13]

All done,
 he finished.
Now the others sang.

All done, 65
 now they went back home.

2B Again the following evening they returned.
 He said,
 "Some person is coming here.
 "That one will arrive tonight. 70
 "That person will carry a bird's tail."[14]

 Shortly now they said that their shaman was coming.
 She arrived there,
 she went to the rear,
 she sat down. 75

 Pretty soon people were coming there,
 now lots of people packing in the house.

2C Now again he was the first to sing,
 he came to the end.
 Now her, his wife, 80
 she came to the end.[15]
 Her, my mother.
 now they were all done.[16]

 Now her, the shaman sang,
 completely full of her spirit-power was she.[17] 85
 She pulled out the eagle's tail;
 now she held it.[18]

 She finished.
 As for Dúšdaq,
 he just kept seated holding his mouth and grinning. 90
 All done,
 now they went back home.

3A The following day, as for me, now I was pulling through.
 I was no longer ill:
 I would get up, 95

I would go outside,
 I would go and eat.

Now in the evening,
 now again he was the first to arrive.

He said, 100
 "The spirit-powers of such persons have been coming here.
 "They thought that they might see something."
Outside yonder by the door it sat,
 he was watching them.[19]

He was a-laughing, 105
 "When I got back home last night I lay down,
 "I dreamed of a person with a good one coming here.
 "She brought a large pearl-like shell;
 "I stole it,
 "I stole it from her." 110

That is what he was pondering.
He was a-laughing.[20]

In the evening, they came.
Soon now entered one woman shaman.

Right away she looked about. 115
As for him, he was sitting in the shadows.

Everybody came,
 they kept coming.

3B Now he sang first.
 Now he told them, 120
 "I shall tell you:
 "We are merely enjoying ourselves;

 "this is not really a spirit-power dance.
 "this woman is merely crying over her daughter.
 "You think of bringing such things so as to see
 something:[21] 125
 "No!
 "Nothing will you see."

Now into the night they danced.

It dawned. *Ending*
Now they gathered up the things, 130
 they took everything down.
Now my husband's brother stood,
 he potlatched things away.
As for my stepfather, he sang.[22]
All done, 135
 they finished,
Now they went back home.

Náyka kʷalíwi wágəlxt (I and My Sister-Cousin)

This narrative is an example of how, among the indigenous people of the American Northwest Coast, spiritual beliefs and acts manifest as an integral part of social life and personality.[1] Victoria Howard's cousin, X̣ax̣šni (anglicized as Khakhshni to facilitate pronunciation),[2] is vested with the spirit-power of the myth character Kitsimani (Grizzly Woman) following the death of her horse during an overnight berry-picking trip in the mountains.

A Gandúyx̣ wágəlxt itbuǵúxmax̣ba;
 gandúyamx̣ kʷábá lawíska.
 Nantx̣lgílx̣ax̣.
 Gagnulxámx̣,
 "Áłqi káwuxčwa atx̣lúkšama." 5
 "Âw," ganulxámx̣.
 Yaxát mank tqáwadikš uxʷítgiłxl.

 Káwux aǵa gandúyx̣,
 K'áwk'áw gantkšigúx̣ax̣ix išəndáxyutan.[3]
 Gagnulxámx̣, 10
 "Náyax̣ néšqi antłáluda iłčə́qʷa,
 "áłqi áx̣ka aqłúǵúmšda."
 Gandu·'yx̣.

 Lawíska aǵa ganix̣čə́mlidəmx̣ ičə́xyutan šix̣itǵílxl.
 Ganx̣łuxʷáyt, 15
 "Lúxʷan sdúx igax̣áykux̣ix agáxyutan."
 Kínwa ganagilúmnił,
 néšqi gaganx̣čə́maqʷax̣.
 Ganúyx̣,
 ganx̣dáqʷax̣, 20
 gančgúǵamx̣ iškíwtan:[4]
 ax̣adéymat,

úmqt agáxyutan wágəlxt.
Kínwa ganunáx̣ƛamx̣,
 ganugilúmnił. 25
Áyxtyámt aǵagílak gaknulxámx̣,
 yaxí gígʷlix akíx̣ax̣.

Ganúyx̣,
 ganagúǵamx̣.
Ganulxámx̣, 30
 "amíxyutan úmqt."
"Û.....!" gagnulxámx̣.
 "Qá igáx̣ux̣?"

Ganulxámx̣,
 "Ax̣ímat." 35
"Âw," gagnulxámx̣.

B Gandúyx̣,
 gandúyamx̣ kʷábá iškíwtanba:
 ax̣adémat akíwtan.
Gagnulxámx̣, 40
 "Qá atx̣úx̣a?"
Ganulxámx̣,
 "Íxtka itx̣áxyutan.
 "Təl amx̣úx̣a,
 "aǵa máyt'ax̣ amikłáyda; 45
 "náyax̣ ankdáya."
 "Təl anx̣úx̣a,
 "náyt'ax̣ anikłáyda;
 "aǵa máyt'ax̣ amkdáya."
"K'úya," gagnulxámx̣. 50
 "Amúya,
 "amdúkʷła dánmax̣ itgákdi.
 "Yaxa náyax̣ ankdáya.

"Anúyama dáwax wápul.
 "K'ʷáλqi amulxáma." 55
Ganúyẋ.

Aġa wít'aẋ anaġəmłáyda.
Wímqu gagíglgaẋ;
 ičáẋiqdima gagyúẋaẋ.
Qíġəmtġix gagnwáẋ. 60

Íłaqawadix ganaġmłáyda,
 nangúġamẋ.
Ganuġlgə́lx,
 mánkčxa iẋlúydix ičáġigliw,
 čáłbálumit wákax. 65
Gagnulxámẋ—⁵
 ičtẋʷə́la dagéymakʷt,
 kdúq'ayc ičáġikawba—

Gagnulxámẋ,
 "Néšqi amənġəmłáyda. 70
 "Míya!
 "Aġa lálayx!
 "Lawíska-aq!"
Ganu·'·yẋ.

Aġa wít'aẋ ganaġəmłáytẋ. 75
Kʷalá adít,
 qánčiẋbt agə́łutkt.
Ganẋluxʷáytẋ,
 "Lúxʷan tə́l akíẋaẋ."

Ganulxámẋ, 80
 "Máyt'aẋ igáλayt ikíwtan."
Gagnulxámẋ,

"Kúya.
"Yamuxúla míya-aq!
"Kʷálá xábixix alixúxayaxdixa." 85

C Aǧa ganaglúqłqax̣,
 ganu·'·yx̣ náwi idə́kaqʷłba.
 Ganulxámx̣ wagáxan,
 "Dádax dánmax̣ itgákdi."
 Gagnulxámx̣, 90
 "Qáx̣wax áx̣?"
 Ganulxámx̣,
 "Adít.
 "Kʷálá aladímama."
 "Âw," gagnulxámx̣. 95

 Aǧa ganaglúqłqax̣, *Closing*
 ganuxk'ʷáx̣.⁶

A My older sister-cousin and I went to the mountains;⁷
 we arrived there in the evening.⁸
 We built a fire.
 She told me,
 "Tomorrow, we will go berry picking then." 5
 "Alright," I told her.
 A little ways on, some others are making fires.⁹

 The next day now we went,
 we tied up our horses.
 She told me, 10
 "We will not give her water,
 "later on, she will drink by herself."¹⁰
 We went on and on.

 In the evening now I heard my horse neighing.
 I thought, 15

"Maybe her horse got untied there."
In vain I called and called to her,
 she did not hear me.
I went,
 I went back, 20
 I got to the two horses:
 she is lying there,
 she is dead, the horse of my older sister-cousin.[11]
In vain I looked for her,
 I called and called to her. 25
Another woman told me,
 she was down below yonder.

I set out,
 I got to her.
I told her, 30
 "Your horse is dead."
"Oh·····!" she told me.
 "What happened to her?"
I told her,
 "She is lying down." 35
"Indeed," she replied to me.

B We set out,
 we got to where the two horses were:
 lying there, the horse.[12]
She asked me, 40
 "What shall we do?"
I told her,
 "Only one single horse do we have.
 "When you tire,
 "now you yourself will ride; 45
 "I shall walk.
 "When I tire,
 "I myself shall ride;
 "now you shall walk."

"No," she replied to me. 50
 "You go along,
 "you take all my things.
 "I myself will walk.
 "I shall be there tonight.
 "That is what you will tell her."[13] 55
I set out.

Now again I would wait for her.
A stick, she grabbed hold of one;
 a cane, she made from it.
From behind she followed me. 60

Several times, I waited there for her,
 she reached me.
I looked at her:
 she seemed different looking,
 her face had become reddish. 65
She told me —
 a little pack: she had it on her,
 a small one on her back —

She told me,
 "Do not wait for me. 70
 "Go along!
 "Now hurry!
 "It is evening already!"
I went on and on.

Now again I waited for her. 75
Soon she comes along,
 all the while, she is panting.[14]
I got to thinking,
 "Maybe she is getting exhausted."

I told her, 80
 "You yourself shall ride the horse."[15]
She told me,
 "No.
 "I told you to go along now!
 "Soon night will be coming on." 85

C Now I left her,
 I went on and on, straight to her house.
I told her daughter,
 "Here are all of her things."
She told me, 90
 "Where is she?"
I told her,
 "She is coming.
 "Soon, she will be here."
"Very well," she replied to me.[16] 95

Now I left her, *Closing*
 I went home.[17]

A Tualatin Woman Shaman and Transvestite

This narrative portrayal of Šə́mxn, a reputable medical doctor at Grand Ronde, lends insight into Victoria Howard's family history as well as shedding light on her paternal great-aunt's community reputation and the success of her practice.[1] Emphasis is placed on the peculiarities of the Tualatin shaman's habits and on the full cooperation of her patients' families.[2] Other details relating to diagnosis, treatment, and follow-up give this text a visual quality and a strong focus on the social processes of healing.

A Wíčm ayáɫak itgágiwam.
 Ičáx̣liw Qánat'amax̣ wít'ax̣ Šə́mxn.[3]
 Ičáyuɫmax̣ It'álap'as.

 Qáx̣ba aqugálmama itkilálitbamat,
 aġa alugʷagíma, 5
 "Ɫábla dánmax̣ əmšgə́tx̣.
 "Amskdúksdamida."
 Aġa k'ʷáƛqí aluxáx̣a.

 Alúyama,
 aqalġʷíma, 10
 alax̣ɫx̣ə́lma.
 Qáwat mákʷšt áwači ɫún itgák'utk'utkš,
 adagəmláyda.
 Alax̣ɫx̣ə́lma,
 dáx̣ka šít'ix akdawidíma itgák'utk'utkš. 15

 Sa·'·qʷ dán aqyalúda akduƛx̣úma.
 Dán núƛ' agik'áydix̣ida,
 kánawi akdawída itgák'utk'utkš,
 kʷáłiwi alugiláyda.

P'ála akłúx̣a, 20
 aǵa wít'ax̣ aqalǵʷíma,
 kʷáliwi alaxk'ʷáya.

Aǵa akdulxáma,
 "Qáx̣ wígʷa áwači xábixix andíya.
 "Iłlásxʷa amšxtk'ínax̣λa, 25
 "k'áwk'aw amškłə́tx̣a."

"Âw," aqulxáma.
Aǵa k'ʷáλqí nux̣áx̣ax̣.
Ałk'ínax̣λa iłlásxʷa,
 č'ə́x̣č'x̣ aqłúx̣a, 30
 k'áwk'aw aqłúx̣a,
 łúxʷan qáwatbə́t.

Łáx̣ka akłkq'mágʷačǵʷa;
 k'ʷáλqí nugiláytx̣.
Nugʷagímx̣ It'álap'as ičáyułmax̣; 35
 qánaǵači k'ʷáλqí nugiláytx̣.[4]

B Alałgiláyda iłgʷə́łilx,
 akłǵəlgláya qá łkíx̣ax̣,
 aláx̣łuxʷáyda,
 "Łúxʷan iłlásxʷa anλgatq'mágačǵʷa." 40
 Kłúqmit łúxʷan qáx̣ba łgúšgiwal xábixix yámlayxba,
 łúxʷan qáx̣ba itk'imx̣átǵmax̣ba:
 išə́qała qʷə́λ tx̣ałə́lux̣t.[5]

Aǵa aláx̣łúxʷáyda,
 "K'ʷáλqí antłúx̣a." 45

Aqłalúxa iłlásxʷa,
 íxtmax̣ix ǵʷə́nma k'áw aqłúx̣a.
Aǵa alúyama.

Yániwadix alałgiláyda.
Aġa akdulxáma, 50
 "Aġa t'áya əmškłẍíma."

Aġa kʼʷáƛqí aqłúẍa:
 aqłkgílagʷa dán iyámla.

Aġa alaglaláma.
Wáx aqłúẍa, 55
 aġa alałẍƛánkʷła.
Aláglalama ġʷénmix alałẍƛágʷa.
Aġa agúlayda,
 "hî· hî· hî· hî· hî·," ġʷə́nmix.
Aġa wít'aẍ alałẍƛánkʷła. 60

Qáẍba alútxʷida,
 aġa alágłalama aksupnáwənxma qánčiẍbt.

Íwi akłúẍa;
 alagíma,
 "K'úya. 65
 "Néšqi yúčġayt.
 "Kánawi íyałq iẍk'ínyakʷt."

Aġa wít'aẍ aláglalama,
 akłkqʼmágʷačgʷa,
 alwíčgʷa. 70

Šámniẍ čxə́p ałẍúẍa iłgálasxʷa alagíma,
 "Qánaġa kʼʷáƛqí ənkíẍaẍ."
Akłẍimáya.
 łgúnaẍ wáx akłúẍa.
Aġa wít'aẍ alwíčgʷa. 75

Yáxa néšqi čxə́p ałx̣úx̣a,
 íwi akłúx̣a iłgʷə́łilx:
 łúčg̣ayt.
Aġa alagíma,
 "Âw. 80
 "Łúxʷan ławá t'áya alix̣átx̣a.
 "Néšqi iłčə́qʷa amškłídima."

Aġa wít'ax̣ alwíčgʷa,
 ġʷénmix.
Aġa akłġəlgílaġʷa, 85
 aġa alałgiláyda,
 λáqʷλaqʷ agyúx̣a wímqt.
Kánawi akdulxáma,
 "Łúxʷan qáx̣ wígʷa wít'ax̣ anítkšdama."

A My father's father's sister was a shaman.
 Her name was Qánat'amax̣ and also Šə́mxn.[6]
 Her spirit-power was Coyote.[7]

 At whatever place they came from to fetch her for doctoring,
 now they said,[8] 5
 "Make various things ready for her.
 "Cook for her."
 Now that is what they did.[9]

 She would come,
 they would give her food, 10
 she would eat.
 As many as two or three of her dogs,
 they would sit beside her.
 She would eat,
 half of it she would share with her dogs. 15

E·'·verything they gave her, she would eat it.[10]
Any little bit that was left over,
 all of it, she would give to her dogs,
 before doctoring.

She finished,[11] 20
 now again they would give her food,
 before she would go back home.

Now she said to them,
 "Some day or evening, I shall come back.
 "Go look for pitch, 25
 "tie it up."[12]

"Alright," they said to her.
Now that is what they did.
They sought wood with resin,
 they split it,[13] 30
 they tied them up,
 I do not know how many of them.

She would use them for waving;[14]
 that is the way she used to doctor.
They said that Coyote was her spirit-power; 35
 that is the reason she doctored that way.

B When she doctored a person,
 when she saw what was the matter,
 she would think to herself,
 "Perhaps I shall wave pitch over that person."[15] 40
She saw that perhaps the person had been going to a bad place at
 night,
 perhaps somewhere by a cemetery:
 a dark shadow hovering over him.

Now she thought,
 "That is what I shall do to this person." 45

They made pitch brands,
 sometimes they tied together five of them.
Now she would arrive.
First, she would diagnose him.[16]
Now she would say to them, 50
 "Now lay him out well."

Now they would do that:
 they would cover him with some old thing.[17]

Now she would sing.[18]
She would light it, 55
 now she would circle around.
She would sing and go around him five times.
Now she would halt,
 "hî· hî· hî· hî· hî·," five times.
Then she would go around again. 60

There where she stood,
 now she would sing and jump as much.[19]

She would look at him;
 she would say,
 "No. 65
 "He is not perspiring.
 "His body is entirely wrapped and covered."[20]

Now again she would sing,
 she would wave it over him,
 and she would dance. 70

If the pitch went out she would say,
 "To no avail, I am doing this."
She would lay it aside.
 She would light another.
Now again she would dance. 75

If on the other hand it did not go out,
 she would examine that person:
 he is perspiring.
Now she would say,
 "Yes. 80
 "Maybe he will slowly get well.
 "Do not give water to him."

Now again she would dance,
 five times.[21]
Now she would uncover him, 85
 now she would doctor upon him,
 she would take out the disease-power from him.
All things, she would tell them,
 "Maybe I shall come to see him again someday."[22]

A Shaman at My Mother's Last Illness

This narrative recounts the tragic death of Howard's mother and the elaborate attempts of the medical shaman to save her.[1] The patient's imminent death is implied early on in the description of events and made more or less explicit when the shaman, an older Molalla-Kalapuya relative, informs the patient's brother and daughter that he was called in too late. He nonetheless makes a final attempt to cure his niece with his strongest spirit-power.

A Agə́qu ičáčg̓mam náx̣ux̣.
 I·'·yaλqdix nax̣ímaxit:
 itgáqʷit idə́dapš gatkdáwəlx;
 néšqi nútxʷitx̣ awači nagúšgiwaləmčk.
 Qánag̓a nax̣ímaxit. 5

 I·'·yaλqdix íčłm ayúyama;
 ačúkʷšdama.
 Íxtmax̣ix lawíska ayúyama.
 Íxtmax̣ix káwux wígʷa ayułáyda.

 Íxdix gayúyamx̣, 10
 ag̓a gačulxámx̣,
 "Qá mx̣łúxʷan?
 "Wítx̣ałm idyáx̣ilalit ačmə́tkšdama pu?"
 Gágyulxámx̣,
 "Lúxʷan níšqi itgə́łx̣iwəlx. 15
 "Lúxʷan ačndlálalma,
 "wáʔaw níšqi itgə́łx̣iwəlx anx̣átx̣."
 Gáčulxámx̣,
 "Qánag̓a q'áx̣š tgə́nux̣t alix̣anitkʷłíčgʷa."[2]
 "Áw," 20
 gágyulxámx̣.

Gačulxámx̣,
 "Káwúx anúya.
 "Anyúkšdama qá ačnulxáma."
"Áw," 25
 gagyulxámx̣.
 "Qá ačmulxáma,
 "amdíya amənč̓ʌxámama."
"ə̂..,"
 gačulxámx̣. 30

B Káwux šít'ix waǧałáx̣ ganiǧəlgə́lx̣ idít.
 Ganulxámx̣ aǵə́qu,
 "Aǧa íč̓m idít."

 Gayúyamx̣,
 gayašgúpqax̣. 35
 Gayagəmłáytx̣,
 gačulxámx̣,
 "Inígəlga.
 "Ičnúlxam alidíya kʷála.
 "Díka anx̣úx̣a, 40
 "anigəmłáyda."

 Kʷálá aǧa gančgiǧəlgə́lx̣ idít.
 Gayúyamx̣,
 gayašgúpqax̣.
 Náwi gayagəmłáytx̣. 45
 Gačənčulxámx̣,
 "Néšqi íyaʌqdix anułáyda.
 "Áyaq anaǧəlgláya."

 Gayagəmłáytx̣ q'ʷáp:
 aǧa niglalámx̣.[3] 50
 Lúxʷan qáwadix gačuláytx̣.
 Gačyulxámx̣ íč̓m,

"K̓úya.
"K̓ʷatx̣ála íyaƛqdix galx̣ímat."

Íčɬm gačyulxámx̣, 55
 "Itʼúkdix:
 "dáx̣kaba íyamugálmam,
 "amx̣anəlkʷɬíčgʷa."

Aġa wítʼax̣ niglalámx̣,
 íyaƛqdix, 60
 gačuláytx̣.

Nigímx̣,
 "Lúxʷan iɬgʷə́ɬilx k̓ʷáƛqí galə́katx̣.
 "Dáyax wímqt yúx̣t yuxtkʼíla ƛʼá-wákʼadaqi-díwi.
 "*Úguk sík míɬayt gágʷa dúnus·ámn.*"⁴ 65
 "Kínwa anigəlgáya:
 "Iwád ayux̣uġíx̣aba idə́kkši.
 "Iwád šáx̣lix ayúya.
 "Ayuxtkʼílalma;
 "néšqi anigəlgáya." 70
ƛáqʷƛaqw gačúx̣ax̣ ɬúxʷan mákʷšt awači ɬún wímqt:
 gačiwáqʷax̣.

Ganƛilútx̣ iɬčə́qʷa iqʼə́miba,
 púpu gačyúx̣ax̣,
 kʷábá láplap gačyúx̣ax̣ wímqt, 75
 kʷalíwi íyakʷšxatba gačiwáqʷax̣.
Sáqʼʷ.
Aġa pʼála gačúx̣ax̣.

Gačyulxámx̣ wíčɬm,
 "Néšqi dán aminlúda. 80
 "Níšqi amtx̣lúwida:
 "yamdášux.

"Łúxʷan káwux wígʷa kʷalíwi andíya wít'aẋ.
"Sámniẋ k'ʷáλqí,
 "aġa p'ála anátẋa. 85
"Aġa qánaġa alẋakmadláyda."
"Áw,"
 gačiwlxámẋ.
Nixk'ʷáẋ.

C Káwux wi·ʹ·gʷa, 90
 xábixix gayúyamẋ.
Nigímẋ,
 "Aga sáq'ʷbt anagiláyda dáwax wápul."
Dángi ílt̓ẋʷat,
 gayagiláytẋ, 95
 niglalámẋ.

Łúxʷan qíq'ayaq wápul gačənčulxámẋ,
 "Áġa p'ála anúẋa.
 "K'úya:
 "néšqi q'ʷáp núẋt; 100
 "íyaλqdix.
 "Aġa galẋímat."
Gačyulxámẋ wíčłm,
 "It'úkdix:
 "néšqi iyámlayx amẋúla. 105
 "Dáẋkaba níyamugalmam."

A My mother was ill.
 A lo·ʹ·ng time she lay there:
 her legs and her feet were swollen;
 she did not stand nor did she walk about.
 Simply she lay there. 5

 A lo·ʹ·ng time before my mother's older brother would come;
 he would come to see her.

Sometimes in the evening he would come.
Sometimes all the next day he would stay.

Once when he came, 10
 now he asked her,
 "What do you think?
 "Our mother's brother, the shaman, could come to see you?"[5]
She told him,
 "Perhaps I am not strong enough. 15
 "Perhaps if he moves me,
 "I will lose my strength."
He told her,
 "All I want is for him to inform me."
"Alright," 20
 she told him.

He told her,
 "Tomorrow I will go.
 "I will go see what he will tell me."
"Alright," 25
 she told him.
 "Whatever he tells you,
 "come back and tell me."
"Alright,"
 he told her. 30

B The following day at half sun I saw him coming.[6]
 I told my mother,
 "Now my uncle is coming."

He arrived,
 he came inside. 35
He sat down beside her,
 he told her,
 "I found him.
 "He told me he would come soon.

"Here, I shall stay, 40
 "I will wait for him."

Soon now we saw him coming.
 He arrived,
 he came inside.
Straightaway he sat down beside her. 45
He told us,
 "Not for long shall I stay.
 "Quickly I will look at her."

He sat down close beside her:
 now he sang. 50
I do not know how many times, and he rested.
He told my uncle,
 "No.
 "She has been leaving us too long a time."

My uncle told him, 55
 "That is good:
 "that is why I have come to get you,
 "so that you will inform me."

Now again he sang,
 a long time, 60
 and he rested.

He said,
 "Maybe some person did like that to her.
 "The disease-power is right in there wriggling just like a trout.
 "This sickness is here just like a little fish." 65
 "In vain I will try to catch it:
 "This way, it will go through my fingers.
 "This way, it will go up and over.
 "It will swim all around;

"I cannot catch it." 70
He snatched maybe two or three disease-powers:
 he killed them.

I gave him water in a pan,
 he blew on it,
 there he drowned the disease power,[7] 75
 before killing it in his mouth.
All done.
Now he halted.

He told my uncle,
 "Nothing shall you give me. 80
 "You are not strangers:
 "you are my relatives.
 "It may be all day tomorrow before I shall come again.
 "If it is like this,
 "now I will stop. 85
 "All we shall do is wait with her."
"Alright,"
 he told him.
He went back home.

C The next day a·ʼ·ll day long, 90
 in the evening he arrived.
He said,
 "Now with everything[8] I will doctor her tonight."
With something around his neck,[9]
 he doctored her, 95
 he sang.

Perhaps in the middle of the night he said to us,
 "I will stop now.
 "No:
 "I have not come close; 100

"too long a time.
"Now she is leaving us."
My uncle told him,
 "That is good:
 "nothing wrong have you done.
 "That is why I came to get you."[10]

105

Historical Landscapes

Spearfishing at Grand Ronde

Victoria Howard speaks of her maternal grandmother, Wagayuhlen, commenting on the geography of a myth she has told about Grizzly Women.[1] She identifies a water hole at Grand Ronde as possibly being the reservoir built by the two Grizzly Women to hoard fish for themselves. Wagayuhlen describes the water hole and tells of how her son, along with others, would spearfish there.

> Ik'áni gyaẋúla agə́škix,
>> aġa agyulxáma ičə́k'ak'u.
>>> "Łúxʷan kʷábá gašgə́tutk dánmaẋ iškítsimani[2] itbuġúxmaẋba.
>>> "Nugʷagímẋ gúk'ayc wáqał λxʷábix,
>>>> "núλ' itqə́nakš ugakíẋaẋ.
>>> "Kʷábá aqdułúmniła.
>>> "Kʷábá gayúyẋ itẋáxan.
>>> "Dánmaẋ ačdə́λama."

My mother's mother would be telling a myth,[3]
> now she would tell my mother's father.[4]
>> "Perhaps that is where the two Grizzly Women kept all of them
>> in the mountains.[5]
>> "They used to say that at a hole there at a small creek,
>>> "there were a few rocks.
>> "That was the place where they went to spearfish.
>> "Our son used to go to that place there.[6]
>> "All sorts of things he would bring back."[7]

Slaughtering of Chinook Women

Upper Chinook women are camping out near Hood River during a camas-digging excursion when a young woman sees a strange movement in the distance.[1] She warns her mother of danger, but her mother pays no heed. Upon returning to the camp, the young woman warns the other women, but only her two sisters-in-law consider the danger. The three women go off to fetch water and see a reflection of Snake Indians (Northern Paiutes) in the water. They return to camp and warn the others, but no one believes them. The young woman runs away from the camp with one of her sisters-in-law. They are hiding in a fir tree when they hear the screams of the other women being slaughtered. They run back to the riverbank across from their village, where they are rescued by other villagers. They tell their story of warning the others and being ignored, completing their account with the tragedy of the massacre and their own escape.

A Gatgíyaẋ,
 nugaq'ílabamẋ itmúyqʷit.
 Áyxt aġagílak kʷalíwi agáxan,
 áliq,
 ak'íwala wákaq. 5

 Aġa dángi gagíġlkl.
 Gagúlxam wákaq,
 "Dángi yaxiya ikdát it'álap'as-díwi."
 Aġa úẋt saẋélutqt iwátka,
 aġa wít'aẋ dángi gagíġlkl: 10
 wít'aẋ iškʷalíxʷa šẋlímačł.

 Aġa gagúlxam wít'aẋ wákaq.
 Gagúlxam,
 "Iškʷalíxʷa išẋlímaču,
 "k'uma néšqi iškʷalíxʷa-díwi." 15

Gagúlxam,

"Qánaġa qʼə́mqʼm amkíx̣ax̣!"

Gagúlxam,

"Kʼúya.

"Dángi idə́lxam-díwi. 20

"Čʼánix!

"Mə́kikšt!

"Yax̣íyax ikdát itʼálapʼas,

"kʼuma łgʷałéx̣-diwi!"

Aġa gátqi kʼʷáš náx̣ux̣. 25

Aġa lawíska gašdə́xkʼʷa itġúymx̣aba,[2]

aġa naxawigʷə́łičk.

Aġa gatgúlxam,

"Qánaġa qáwayčgi ux̣awáywal."

Néšqi gatġax̣gíšga. 30

Aġa mákʷšt išgátum gakšyúlxam,

"Aqəlx̣udínay."

Aġa šdáx̣tʼax̣ kʼʷáš gašdə́x̣ux̣.

B Aġa x̣ábixix níx̣ux̣ix,

iłčə́qʷa gałúya. 35

Iłkʼíwax gałgə́łukł.

Gałúyam waqbúqba:

aġa qúšdyaxa aġa dałx̣láytix.

Aġa áyxtga gagáłġlkl iłčə́qʷaba.

Nákim, 40

"Aná!

"Dángi iníġlkl."

Aġa áyxt gagúsmit.

Gagúlxam,

"Ákʼʷaška! 45

"Níšqi qá łx̣atx̣úla!"

Aġa gałúya,
 aġa gałgłút'iba iłčə́qʷa,
 aġa gałúyam.
Aġa gałx̣gʷə́łičk. 50
Aġa gaqłúġánimčk.

Gaqłúlxam,
 "K'uma qánaġa itx̣láywimax̣ ugášgiwa."
Aġa nugagíwitx̣it.

C Aġa dáwax wáliq gúkʷłt agátum, 55
 gašx̣aġmúkšitx wámqu ax̣ímat.
 Mánk iyáλqdix aġa wátuł λ'ə́ł nax̣úx̣ax̣.
 Aġa mánk yaxát gašə́duyx̣:
 "Aġa díka atx̣úx̣a."
 Aġa gašdagúwəlx̣t aqíx̣alq, 60
 aġa kʷabá gašdúłayt,
 šáx̣lix gašdagə́łayt waqíx̣alq.

 Aġa łúxʷan qánčix̣ wápul,
 aġa sáq'ʷ gaqə́tux̣,
 aġa gaqdúdina. 65

 Itqígyułmax̣ gašgawičə́maq,
 aġa gə́štkim,
 "aġa qdudínax̣."

 Aġa gašdáglču aqíx̣alq,
 aġa gašdə́kta. 70
 Gašdilgałx̣ámx̣,
 aġa gaqšugálmam.

D Aġa gáštkim,
 "Aġa iqdúdina kánawi."

Nákim wáliq, 75
 "Nanugigláya idə́lxam.
 "It'álap'as nigíkta,
 "nɛšqi it'álap'as-díwi.
 "Nináƛxam agə́qal,³
 "'Íkšda! 80
 "'It'álap'as ikdát,
 "'aġa wít'aẋ iškʷalíxʷa!'
 "Néšqi nigə́nẋatgíšgayt."

"Aġa lawíska nində́xk'ʷa,
 "aġa wít'aẋ kínwa ninẋawitgʷə́ł ičk: 85
 "iwa nitgntgánimčk."

"Xábixix nigíẋatẋiẋ,
 "aġa iłčə́qʷa ninšúya.
"Aġa kʷábá wít'aẋ ničgúġitka iłčə́qʷaba.
"Ninčúyam, 90
 "aġa wít'aẋ ninčktƛə́xam idə́lxam wuẋiláytiẋ iłčə́qʷaba.
 "aġa wít'aẋ nitgnčtgánimčk.
"Nitgnčƛə́xam,
 "'Qánaġa uẋawáywala itẋláywimaẋ.'"

"Aġa nə́ta nintdwáẋit, 95
 "nintẋaqmátkʷšit wámqu.

"Yáƛqdix mank aġa yáxat nindúya,
 "nindagúwəlxt waqíẋalq,
 "aġa nintgúẋatmilakʷt:
 "aġa áġanwi aġa itqígyułmaẋ nintgawičə́maq. 100
"Aġa nində́xtkim,
 "'Aġa qdudínaẋ.'
"Aġa yáẋka dáyaxa ntxdát."

A They went,
 they went to dig camas.
 There was one woman and her daughter,
 a maiden,[4]
 she was digging with her mother. 5

 Now she saw something.
 She said to her mother,
 "Something coyote-like is running out there."
 Now she is sitting there, looking over in that direction,
 now again, she saw something: 10
 again two ravens diving down.[5]

 Now she again told her mother.[6]
 She told her,
 "Two ravens, each one dives down,
 "but not quite like ravens." 15
 She told her,
 "You are just lazy!"[7]
 She replied to her,
 "No.
 "It is like people. 20
 "Take heed!
 "Look!
 "A coyote is running out there,
 "but it is like a person!"
 Now she was kind of frightened. 25

 Now in the evening, the two of them went back to their campsite,
 now she informed them about it.
 Now they said to her,
 "Somebody was merely running about."
 They did not believe her. 30
 Now she told her two sisters-in-law,
 "They might kill us."

Now the two of them did become frightened.

B Now when the evening fell,
 they went for water.[8] 35
 A torch, they took along with them.
 They got to the spring,
 now truly, now they were there.[9]

 Now one of them saw them in the water.[10]
 She said, 40
 "Oh dear!
 "I see something."
 Now the other one nudged her.
 She said to her,
 "Shush! 45
 "Do not say anything!"

 Now they went,
 now they dipped out some water,
 now they got back.
 Now they informed them. 50
 Now they laughed at them.

 They told them,
 "It's only kids roaming around."
 Now they went to bed.[11]

C Now this girl took her sister-in-law, 55
 the two of them lay beside a log lying there.
 A little later now the fire went out.
 Now the two of them went farther away:[12]
 "Now let us stay here."
 Now the two of them went up into a fir, 60
 now they stayed there,
 high above, they stayed in the fir.

Now I do not know when during the night,
> now they were all done with them,
>> now they slaughtered them.[13] 65

The two of them heard their screams,
> now they said,
>> "Now they are slaughtered."

Now the two of them came down from the fir,
> now they ran away. 70
They got to the river,
> now they went to get them.[14]

D Now the two of them said,
> "Now they have slaughtered all of them."[15]
The maiden said, 75
> "I saw some people.
> "A coyote ran along,
>> "but unlike a coyote.
> "I told my mother,
>> "'Look! 80
>> "'A coyote is running by,
>>> "'and also two ravens!'
> "She did not believe me."

"Now in the evening we went back,
> "now again in vain I told them about it: 85
>> "they just laughed at me."

"In the evening it became dark,
> "now we went for water.
"Now we saw them again at the water.
"We returned, 90
> "now again we told them that people were sitting there at the
> /water.

"now again they laughed at us.
"They said to us,
 "'It's merely kids roaming around.'"

"Now we went and hid, 95
 "we lay beside a log.

"A while later now we went farther from there,
 "we climbed a fir,
 "now we listened:
 "now to be sure now we heard their screams.[16] 100
"Now we said to each other,
 "'Now they are slaughtered.'
"Now we ran away from there."[17]

Captives Escape Snake Indians

Chinook women are massacred during a camas-digging trip. A woman and her son are shot trying to escape, and they are taken captive.[1] Another woman, trying to defend herself, is killed and her friend is also taken captive. While the mother treats her son's wound, she informs him that they will try to escape. One night, the son unties himself and his mother; they run away and hide under a fallen cedar tree near the river. Soon they hear the war cries of their captors, who are out looking for them. They wait for the captors to leave, and the following day they head to the river. They call out to their people, who come to get them. They tell the story of their capture, the girl who was killed, and the other one who was taken captive.[2]

Tgít,
 gatgíx̣,
 nugʷak'ílabamx̣ itmúykʷit.

Aǵa tgít,
 tgíyamt kʷaba, 5
 aǵa ugak'íwi.
Aǵa x̣ábixix níx̣ux̣ix,
 nugaǵíwitx̣it.
Q'ʷáp yučúkdidix,
 aǵa sáq'ʷ gaqə́tux̣; 10
 aǵa gaqdúdina.

Aǵa ax̣káwaxiya áyxt waǵagílak ičámaq gaqyálux̣,
 aǵa gaqáglga.
Aǵa wít'ax̣ ičáxan iyámaq gaqílux̣,
 ik'áškaš. 15
Aǵa gašax̣ə́lqiłx̣.
Gaqúlxam,
 "Máykači imíxan?"

"ʔÂⁿⁿ,"
 gakdúlxam. 20
Aġa gaqíglga,
 gatgyálut wáyaq.

Aġa kʷalíwi štmákʷšt išə́liq gašgugígayu.
Kínwa áyxt gagúlxam,
 "p'ála mə́x̣ux̣!" 25

Wáʔaw gagugígayu.
Ayš ákʷa gatgúwaq,
 aġa áyxtka gaqúkʷła.
Łúxʷan qánčix̣ wíkayt,
 aġa íyaƛqdix tgít. 30
Aġa ičáłačk ičáčǧmam nax̣úx̣ax̣,
 aġa łúq'ʷłuq'ʷ gałax̣úx̣ax̣ iłġáwəlkt.
Kʷalíwi yáx̣ka wít'ax̣ ičáxan,
 łúqʷ'łuq'ʷ gakłix̣úx̣ax̣ iłġáwəlkt.

Aġa gačúlxam, 35
 "Qáx̣ba wíska qə́tx̣ukʷłt?"
Aġa gagyúlxam,
 "Néšqi qá łxtgímnił."
Gagúlxam,
 "Áłqi atx̣ux̣atp'íłaya." 40
Aġa nix̣łáwxayda.

Gatgġúyx̣,
 k'áwk'aw gaqúx̣ax̣,
 aġa yáx̣t'ax̣ ik'áškaš k'áwk'aw gaqyúx̣ax̣ idíyax̣u idyáqʷit.
Aġa tgít. 45

Aġa tgə́ġʷit wít'ax̣,
 aġa kláyx qyúqtgamitt.
Aġa ix̣ə́ġʷitqt łúxʷan qánčix̣ wápul,

aġa sdúxʷsduxʷ ikíx̣ax̣ iłyáqačmani,
 aġa kánawi sdúxʷsduxʷ níx̣ux̣. 50
Aġa ława·'·· gayuq'ʷíłx̣iba idə́lxam:[3]
 ugaġíwitim łúx̣iqʷálal.
Aġa gayúya,
 gačunáx̣łam wáyaq qáx̣ba úktk,
 gačáglq áw iq'áyakʷtt idə́lxam. 55
Aġa ława·'·· gayúya,
 gayagə́młayt iłgáq'akštaqba,
 aġa gačúlxam,
 "Nimantx̣úla yáx̣a atx̣ux̣ap'íłay idə́lxam."
Nax̣łúxayt, 60
 "qánaġa anx̣gíġwálkʷ!."
Íwi náx̣ux̣,
 gagíġlkl ičáxan.

Aġa sdúxʷsduxʷ gačúx̣a itgáqʷit dányu,
 sáq'ʷ. 65
Aġa núłayt.
Aġa dáx̣t'ax̣ itgáx̣u sdúxʷsduxʷ gačúx̣a,
 sáq'ʷ.

Aġa nuq'íłx̣iba idə́lxam ugaġíwitim.

Aġa gašwáxida, 70
 gašdúya iyáƛqdix.
Aġa gagyúlxam,
 "Aġa qtx̣únaxƛ-aq.
 "Łġa q'ʷáp wímał qámatgi kʷaba."
Aġa iwádka gašdúya, 75
 aġa gašgíglga wíškan ix̣ímat,
 na·'··mni iłyáłpukš na·'··wi iłə́lx̣áymat iłčə́qʷaba.
Aġa kʷabá gašdíłłx̣ipq'ix̣,
 aġa kʷába gasgísinq'ʷiyayx̣.

Aġa íwa⁴ idə́lxam gašgawičə́maq: 80
 winx̣yámxʷltgiwx̣;⁵
 q'ʷáp gaqšúx̣amx̣.
Aġa kʷába gaqšúnax̣ƛ̓čk.
Łuxʷan aġa wíkayt kʷaba gašdíłaydix.
Iłámakʷšt wíkayt aġa nə́šqi gašgawičə́maq, 85
 aġa gašdiq'áłx̣ibayx.

Aġa šxk'ʷát.
Aġa šdúyt,
 aġa tə́l nix̣úx̣ax̣ ik'áškaš,
 aġa ayax̣lúštx̣mida. 90
Aġa wítax̣ álikday.
A···ġa gašdilúƛx̣amix,
 aġa naglúmiłčk,
 "Íntgiƛa!"

Gaqalčə́maq. 95
Nugákim,
 "Łángi łdlúmnił."

Aġa gaqíšgla.
Aġa gašxk'ʷáyaytam-aq.
Adi·'··· widə́lxam nugáčax̣. 100
Gašx̣awigʷə́łičk yax̣ká yaxi gaqíškʷł,
 šdáx̣a šáxíya mákʷšt išə́liq,
 áyxt gaqúwaq yaxa áyxt gaqúkʷła.

Łġa gʷa·'·nisim k'ʷáƛqi gaqdúx̣ax̣ ġánġatbamat.

They go off,
 they went off,
 they went to dig camas.

Now they go off,
> they arrive there at this place, 5
>> now they dig.
Now evening was falling,
> they went to sleep.
As dawn was coming on,
> now they were all done with them; 10
>> now they slaughtered them.[6]

Now they shot one of the women,[7]
> now they caught her.
Now they also shot her son,
> a child. 15
Now she screamed.
They said to her,
> "Is he your son?"
"Yes,"
> she said to them. 20
Now they seized him,
> they gave him to his mother.

Now two girls fought them.
In vain one of them said to her,
> "Stop it!"[8] 25

Still harder, she fought them.
Now they just killed her,
> now they took the other one along with them.
I do not know how many days,
> now they had gone quite a distance. 30
Now she became sick from her shot,
> now she sucked blood from it.[9]
And from her son as well,
> she sucked blood.[10]

Now he said to her, 35
 "Where indeed are they taking us?"
Now she said to him,
 "Do not say anything."
She said to him,
 "After a while we might run away from them." 40
Now he thought about that.

They camped overnight,
 they tied her up,
 now they tied up the child himself also by his arms and legs.[11]
Now they went on.[12] 45

Now they halted again,
 now they put him in a different place.[13]
Now he woke up, I do not know when, during the night,
 now he unties himself with his teeth,
 now he got completely untied. 50
Now slo·′··wly he crawled away from the people:
 as they are sleeping and snoring.
Now he went,
 he looked for the place where his mother lay,
 he found her amidst the people. 55
Now slo··wly, he went along,[14]
 he sat by her head,
 now he said to her,
 "You told me we were to flee the people."[15]
She thought, 60
 "I am merely dreaming."
She turned and looked,
 she saw her son.

Now he first untied her feet,
 all done. 65

Now she sat up.
Now he untied her arms too,
 all done.
Now she crawled out and away from the people sleeping.

Now the two of them fled, 70
 they went a long ways.[16]
Now she said to him,
 "Now they are looking for us already.
 "There must be a river close by, somewhere over there."
Now they went off in that direction, 75
 now they found a cedar lying down,[17]
 all its limbs were lying right down in the water.
Now they got under it,
 now they lay there curled up.[18]

Now straightaway they heard the people: 80
 they were giving the war cry;
 close by, they came to the two of them.
Now they looked around there for them.
Maybe all day long now the two of them remained there.
On the second day now they did not hear them, 85
 now they crawled out from there.

Now the two of them went back home.
Now as they went,
 now the child became tired,
 now she packed him along. 90
Now she set him down again.
Now at length they got there to the riverside,[19]
 and she hallooed,
 "Come get us!"

They heard her. 95
They said,
 "Someone is hallooing."

Now they went to get them.
Now they got back.
Dear oh dear the people wept. 100
They told them of where they had taken them;
 those two, the two maidens,[20]
 they had killed one and the other one they had taken
 with them.

They must have been doing like that all the time in olden days.[21]

Wálxayu ičámxix gałx̌ílayt
(Seal and Her Younger Brother Lived There)

Seal's brother brings his new wife to live with Seal and her daughter.[1] Seal's daughter observes that the new wife makes the sound of a man when "she" goes outside to urinate. When she tells her mother, Seal tells her that she must not speak like that about her uncle's wife. After some time, the daughter again informs her mother of her suspicions, but as before, the mother tells her to keep quiet. One night, the girl feels something dripping on her face and alerts her mother. Seal tells her that her uncle is having sex with his wife. The girl rises and discovers that her uncle has been decapitated. She screams, and her mother cries at the loss of the head of the wealthy household. The daughter recalls her attempts to get her mother to react: "In vain I tried to tell you."

A Gałx̌ílayt:
> Wálxayu,
>> wagáxan,
>> ičámxix.[2]
> Lúx^wan qánčíx̌bə́t, 5
>> aġa iłġagílak gałigúqam Wálxayu ičámxix.

> Gałx̌ílayt.
>> Ałúya ƛáx̌nix x̌ábixix.
> Wak'áškaš alagíma,
>> agulxáma wákaq: 10
>>> "Áqu!
>>> "Dángi ix̌lúwidix wíčłm ayágikal:
>>>> "ƛ'á wiłə́kala-díwi alubáya."
> "Ák'^wáška!
> "Iwímiłm ayágikal!" 15

Í··yaλqdix k'ʷáλqí gałx̣ílayt.
 Xábixix ałubáywa.
Aġa agulx̣áma,
 "Áqu!
 "Dángi x̣lúwida wíčłm ayágikal: 20
 "alubáya λ'á wiłə́kala-díwi."
"Ák'ʷáška!"

B Wíčałm ayágikal ašx̣ugákʷšida wilx̣ə́mitba.
 Kʷálá šdáx̣ ašx̣úkšida q'ʷáp wátuł,
 ašx̣ašgmúkšida. 25

 Łúx̣ʷan qánčíx wápul, dangi yáguwit wákxba.
 Gagulálaləmčk wákaq.
 Gagúlxam,
 "Áqu!
 "Dángi ínguwit wákxba." 30
"M̂mmmm.
"Ák'ʷáška.
"Wímiłm šx̣lúyəm."

 Kʷálá aġa wít'ax̣ dángi gagilčə́maq síq'nukʷλpxix.
 Gagúlxam, 35
 "Áqu!
 "Dángi t'úq·t'úq·.
 "Dángi nilčə́mlit."
"Ák'ʷáška.
"Wímiłm šx̣lúyəm." 40

C Nax̣ə́lačk wak'áškaš,
 t'áya gagúx̣a wátuł,
 wáx gagə́łux̣ iłlásxʷa,
 gagíyukšdix qáx̣ba šdúktkba:
 Á·dí··! Iłġáwəlkt! 45

Íwi gagə́łuq'ʷma:
 íyalxmitba wíčałm,
 łq'úp íyatuk:
 yúmqt.
Gašax̌ə́lqiłx̌. 50

Gagúlxam wákaq,
 "Íyamúlxam.
 "'Dángi t'úqt'úq.'
 "Imnúlxam,
 "'Ák'ʷáška, šx̌lúyəm.' 55
 "Niyamƛə́xam,
 "'Dángi x̌lúwida wíčłm ayágikal.
 "'Álubáya.
 "ƛ'á iłə́kala-díwi alax̌unúda.'
 "Amnulxáma, 60
 "'Ák'ʷáška!'"
Nagə́čax̌.

Wálxayu nákim,
 "Áwi!
 "Wičúxix! 65
 "Iłk'áłəmgʷadi łíyaxinxat.
 "Wičúxix!"

Nagímniłčk.
Yáxa áx̌ wak'áškaš nagə́čax̌.

Nagímx̌, 70
 "Kínwa iyamúlxam,
 "'Néšqi iłgagílak-díwi,
 "ƛ'á wiłə́kala-díwi alax̌unúda wíčłm ayágikal.'
 "Imnúlxam,
 "'Ák'ʷáška!' 75

"Áná wíčɫm!
"Aná wíčɫm!"
Nagə́čax̣ wak'áškaš.

Aǵa kʷábt yáymayx inx̣ə́lutkt.

A They lived there:
 Seal,
 her daughter,
 her younger brother.
 I do not know how long it was, 5
 now a woman got to Seal's younger brother.

 They lived there.
 They would go out outside in the evening.
 The girl would say,
 she would tell her mother: 10
 "Mother!
 "Something is different about my uncle's wife:
 "it sounds just like a man when she goes out."[3]
 "Shush!
 "Your uncle's wife!" 15

 A lo··ng time like that, they lived there.
 In the evening, they would each go out.
 Now she would tell her,
 "Mother!
 "Something is different about my uncle's wife: 20
 "when she goes out, it sounds just like a man."
 "Shush!"[4]

B Her uncle and his wife would lie down on the bed up above.
 Pretty soon the other two would lie down close to the fire,

they would lie down beside each other. 25

Sometime during the night, something falls onto her face.
She shook her mother,
 she told her,
 "Mother!
 "Something is going drip drip." 30
"Mmmmm.
"Shush.
"Your uncle, they are going."[5]

Soon now again she heard something dripping.
She said to her, 35
 "Mother!
 "Something is going drip drip.
 "I hear something."
"Shush.
"Your uncle, they are going." 40

C The girl got up,
 she fixed the fire,
 she lit pitch,
 she looked where the two were:
 Ah! Ah! Blood! 45

She raised her light to it, thus:
 her uncle is on the bed,
 his neck cut:
 he is dead.
She screamed.[6] 50

She told her mother,
 "I told you.
 "'Something is dripping.'
 "You told me,

"'Shush, they are going.' 55
"I had told you,
 "'Something is different about my uncle's wife.
 "'She would go out.
 "'with a sound just like a man she would urinate.'
"You would tell me, 60
 "'Shush!'"
She wept.

Seal said,
 "Younger brother!
 "My younger brother! 65
 "They are valuable standing there.⁷
 "My younger brother!"

She kept saying that.
As for the girl, she wept.

She said, 70
 "In vain I tried to tell you,
 "'Not like a woman,
 "'With a sound just like a man she would urinate, my uncle's
 wife.'
 "You told me,
 "'Shush!' 75
 "Oh oh my uncle!
 "Oh my uncle!"
The girl wept.

Now I remember only that far.

Wišə́liq išqʼíxanapx gašdašgúqam
(Two Maidens, Two Stars Came to Them)

This narrative is an excerpt from a larger myth narrative in which two young unmarried and unaccompanied women wish for stars to become their husbands.[1] As opposed to the classic myth episode in which the two maidens find themselves in Sky Land, the home of their new husbands, the two maidens in Howard's narrative wake up and find that their star husbands have come to them. The younger woman, who had wished for a more distant star, finds herself with an older man. In both the traditional myth episode and in Howard's contemporary version, young women are warned not to wander too far from home.

A Nugagímx̣,
 išə́liq ƛáx̣nix gašx̣úkšitx̣.

 Šgiwxánawənx̣t łábla itqʼixánapx.
 Šx̣kʼayáwəla.

 Áyxt ax̣kʼə́sqax̣ nagímx̣, 5
 "Ánixčwa yaxíyax iqʼixánapx gyu·ʼkʼayc ingátg̣ʷamx̣!"
 Gašk'ayáwəlalx̣.

 Ax̣g̣ə́qʷənq nagímx̣,
 "Náyax̣ yaxíyax gyúqbayƛ ingátg̣ʷamx̣!"
 Šx̣kʼayáwəla. 10

 Gašdug̣úpdit.

B Gašx̣gúytg̣mx̣:
 adəlxámax̣ šgəmuktk.

Gašx̣łúxʷayt,

"Qáx̣ba łúxʷan adəlxámax̣ igantgátqʷam?" 15

I·ʼ·yaλqdix gašgšulxámx̣,

"Dán lax číwx̣t imdáǵʷamnił.

"Mə́dayka yaxa nəmtx̣łuxʷáyta,

"nə́mtgíma,

"ʼÁnixčwa šəntgátǵʷamx̣!' 20

"Aǵa dáyax̣ inə́tti."

Gašx̣łúxʷayt,

"Ú…!"

Káwux íwi

nax̣úx̣ax̣ ax̣kʼə́sqax̣, 25

íqʼiwqt!

Yaxa áx̣,

wágalxt,

iłx̣íyal gašdašgúǵamx̣.

Aǵa łúxʷan kʷabt aǵa qá galəx̣ux̣. 30

A They used to say,

two unmarried girls used to sleep outside.

They are looking up at lots of stars.

They laugh.

The younger one would say, 5

"Wish that distant small star would come to me!"

They would laugh and laugh.

The older would say,

"Let that distant big star come to me!"

They laugh. 10

They went to sleep.

B They woke up:
 two people are beside them.

They thought,
 "Wonder where these people got to us from?" 15

A lo··ng time they told them,
 "It is what your own heart wants.
 "You yourselves thought that,
 "you said,
 "'Wish they would come to us!' 20
 "Now we have come here."

They thought,
 "U...!"
With morning
 the younger looked closely: 25
 an old man!
As for the other one,
 her older sister,
 a young man had come to her.[2]

Now I do not know now what they did. 30

Wásusgani and Wačínu

This lengthy historical narrative covers a span of 110 years of Native West Oregon history.[1] It recounts a number of major events in Clackamas and Grand Ronde history, including contact with Euro-Americans, the arrival of European diseases, and the founding of Grand Ronde. Details relating the disruption of lives and struggles to overcome the decimation of their populations by infectious disease and impoverished conditions never before experienced by Victoria Howard's people combine into a stylistically coherent and informed depiction of nineteenth-century American history. Howard's account of the subordination of a once wealthy and prosperous civilization by a foreign power offers insights into the perceptions and reactions of the first peoples of the American Northwest Coast. Howard's keen understanding of political forces is matched by her remarkable sense of humor as she recounts, with historical consciousness and cultural integrity, the undoing of an indigenous Oregon civilization.

Alax̣əgálx̣a wákšdi,
 aǧa alaxəlp'aláwəlalma.
Íxtmax̣ix kaywáx[2] alax̣láčgʷa,
 axəlgílx̣al,
 aǧa alaxəp'aláwəlalma. 5

Nagímx̣ wíčam iyámla idyáǧiwam.[3] Insert 1
Qáx̣ba tǧíwam ačlúx̣a ilgʷə́lilx,
 aǧa qáx̣ba ayúya,
 alix̣qʷáydama.
Łúxʷan qánčíx̣ ayúyama; (5)
 dánmax̣ ačdawída idə́lxam:
 t'áya ačdúx̣a.

Aǧa ayułáyda.
Kínwa ʔə̣gúp[4] aqšigúx̣a;
 ayúyama x̣ábixix, (10)
 aliglaláma kalámt alix̣úx̣a.

Ačagəlgáya,
 alayx̂·aymáya iyág̣ikaw.
Kʷálá ag̣a ilg̣áwəlkt ačlumg̣úg̣ma,
 kʷákʷa ačúx̂a⁵ wag̣ámačx̂, (15)
 t'áya alix̂úx̂a.

Awači qáx̂ba aqigəlgáya ʾλq'úp aqyúx̂a,
 awači aqaylgámida waq'íwiqi,
 kʷáλqí wít'ax̂ alix̂úx̂a:
 ačləmg̣úg̣ma ilg̣áwəlkt. (20)

Sa·'·qʷ,
 t'áya alix̂úx̂a.
Kʷáλqí nagímx̂.

1A Alagíma,
 "A·'··ng̣a akʷa nəliqbt,
 "dáyax gačdúmla idánəmškš.
 "Łúxʷan qánčíx̂bt,
 "ag̣a aλig̣əldáqłg̣a." 10

 "Ag̣a łgúnax̂ ačlumlálma,
 "tqáwadikš idyánəmškš."

 "Náyax̂ akʷa nəliq,
 "ag̣a gačnúmla.
 "Ganúłayt; 15
 "níšqi áyaq ganəlgíłayt.
 "Idyánəmškš idłúnikš,
 "náyt'ax̂ kʷábá ganúłayt."

 "Nugʷagímx̂ tqáwadikš íg̣ipx ayux̂áx̂a;
 "aluxʷigáyu. 20
 "Níša k'úya:

"níšqi íǧipx nínčxux̣.
"Aⁱiǧəldáqⁱga ⁱíxt,
 "néšqi ačⁱugálmam."

Áyma Wamuláliš gandúⁱayt. 25
"Aǧa áx̣t'ax̣ náxkʼʷa,
 "galəntǧə́luqⁱq.
"Aǧa náyma gandúⁱayt."

2A "Aǧa qʼʷábix qúšdyaxa itkʼaníyukš tgadímamt.
 "Ya·ʼ·niwadix gatgíyamx̣ kdúⁱqdax̣ itkʼaníyukš. 30
 "Gaqdulxámx̣ idáx̣liw it*kinčúč*.[6]
 "Gatgíyam idác'*ikc'ikmax̣*,[7]
 "*imusmusgímax̣*[8] tgix̣gát.
 "Nux̣ʷílayt."

 "Tʼánwa gatgə́nčux̣ 35
 "iqʼə́mi,
 "watʼíwat,
 "dánmax̣ wackʼʷə́n gatgənlútimčk.
 "Anyawída dán gix̣ə́šaqʷt."

 "Łúxʷan qánčíx̣bt, 40
 "aǧa ⁱábla gatgadímamniⁱčk."

 "Aǧa ⁱúxʷan qáx̣ba gatkⁱuxúlaləmčk wiⁱ*lám*[9],
 "aǧa gaqⁱáwit itkáⁱukš.
 "Kʷálá aǧa kʼʷalalák aⁱx̣úx̣a."

 "Dánmax̣ witkdímax̣: 45
 "iⁱqábnx,
 "iⁱčáx̣iw,
 "wilkʼʷádi gatkdútimčk.
 "Gatkⁱux̣ámla iⁱg*álam*."

"Yaxa náyax̣ dánmax̣ gatkdənlútx̣. 50
"Dán atginlúda ikmałmádi dán—
 "ačágt,
 "íwiʔiwi—
 "ančkdúx̣a,
 "ančkduġʷánimčgʷa." 55

"Ikʷílt[10] gatginlútx̣.
 "kʷábá ganíġitkl,
 "kʷábá súk'ins gánx̣atx̣.
"Qá ganiġlgə́lx̣ ƛq'úpƛq'up ugʷakíx̣ax̣ idsil,
 "k'ʷaƛqí ƛq'úpƛq'up andúx̣a. 60
"Aġa ndúpčx̣a ikʷílt ganíwx̣.
"Dáyax wíkayt k'ʷáƛqí ənkíx̣ax̣,
 "wíkayt anx̣əlk'ípčx̣a."

"Aġa kʷábt gatkłə́tqəmšt itkáflukš,
 "k'ʷalalák ałx̣úx̣a. 65
"X̣ábixix aġa ałglaláma,
 "aqłgnx̣údinma.
"Aługúpdida,
 "aqłkgílagʷa.
"Aługúpdida, 70
 "ałx̣uġúwitġma;
 "aġa p'ála."
"Kʷáƛqí núx̣ax̣,"
 alagíma.

"K'úya dán idáġiƛbamax̣, 75
 "néšqi dán yawítit,
 "ƛ'á dáyax̣ a·'ġa.
"Qánaġa wíškan iłə́lux̣t k'áw iłə́łapš,
 "yáx̣ka łigútxʷlit."

"Wiq'ə́mi aqinšlúda išúmax̣, 80
 "aġa yáx̣ka ančx̣ilúkšdima.
"Ančk'ayáwəlalma íwiʔiwi ančgyúx̣a."

"Íxt iq'íwqt iyáx̣liw K'amíšdiqʷnq, *Insert 2*
 "gačíyutk íxt išúmax̣ iq'ə́mi.
"Wígʷa alix̣ilúkšdima,
 "ix̣i·'·mat čigəlgát íyaq'mi,
 "nêšqi gačix̣íma. (5)
"Ayułáyda čigəlgát íyaq'mi.
"Qáx̣ba ačix̣imáya ačikgílagʷa
 "nêšqi łán ałgigəlgáya."

"Wít'ax̣ wayáxan gagilg̣ʷímam isídlu.
"Gašix̣ilálagʷa, (10)
 "aq'íwiqi gačágəlga,
 "λ̣q'úpλ̣q'up pú gačíwx̣:
"K'u·'·ya.
 "níšqi λ̣q'úλ̣q'up gačíwx̣.
"Gačígəlga. (15)
 "gačiyawíłada.
"Níkim,
 "'Dángi tq'íx̣ gítx̣t,
 "'igitg̣ʷímam!
 "'Nx̣łúxʷan gʷiłíyašq.'"

"Yániwadix gančgíġitkl dángi k'ə́šmax̣,
 "idyágʷnináwyukš.
"Aġa k'ʷáλ̣qí gangyúpġnax̣." 85

"Qúšdyáxa dáyax aġa dánmax̣ aqyúgʷanx̣aya,
 "aqyúpġnaya idácəl·cl,
 "dánmax̣ itkáłukš itgák'iti.
"Kʷalíwi kʷábdix dánmax̣ gančgúġitkl."

Itmałmádi gatgiyálut. *Insert 3*
 gayaẋə́luẋ.
Galuẋuẋánima,
 gatgáǵəlkl,
 *gatguǵ*ʷ*ánimčk.* (5)

Gatgúlxam,
 "*Níx*ʷ*a əmgúšgiwaləmčk aqəmǵəlgláya.*"
Nagúšgiwaləmčk,
 *gatguǵ*ʷ*ánimčk wičáxmałmadi.*

Wít'aẋ aqyupǵnáya wiq'ísu. (10)
*Alagíma k*ʷ*aλqí wít'aẋ yuxúčk'it,*
 λ'á-wikmałmádi.

"*Idə́qat ančkdušíya,* 90
 "*aǧa λk'úpλk'up aluẋáẋa.*
"*Ančgíma,*
 "'*Ána·' dángi ẋlúwida dádax idə́qat.'*
"*Ančkduǵ*ʷ*ánimčg*ʷ*a,*
 "*k'*ʷ*áλqí núẋaẋ.* 95
"*Tqáwadikš nešqí nuẋímuẋ dawax wáqat,*
 "*yáxa tqáwadikš náwi nux*ʷ*idə́muẋ.*"

"*Dawáx wasábll*[11] *níšqi ənčə́gukl qá gaqúẋaẋ;*
 "*náyaẋ áyxt wabášdn*[12]
"*Gagnəngígiq'nanəmẋ qá gaqúẋaẋ wasábll.* 100
 "*ya·'·niwadix ganúẋaẋ ganuẋánimaẋ.*
"*Gančgug*ʷ*ánimčk*ʷ*aẋ wagə́sabll.*"

"*Kánawi dán k*ʷ*ábá:*
 "*gandáẋatẋaẋitk wabášdn.*
Ičáẋliw Bákli:[13] 105
 "*at'úkdi abášdn.*"

"Kánawi dán laẋáykabamat dán anyalúkʷła.
"Gixə́šaqʷt ayáẋəlmuẋma."

"Iłə́kamukš ałúkʷsda,
 "aǧa agənčulxáma, 110
 "'amškłnitp'yáłẋa.'
"Łábla iłə́kamukš ančkłup'yáłẋa,
 "anλalúkʷła."

"Dánmaẋ akdənlúda.
"Kʷábá dánmaẋ ičə́łẋlm ganə́ẋatẋ, 115
 "dán yuẋiláẋ itk'ániyukš."

2B "Łúxʷan qánčíẋbt,
 "aǧa łíxt k'ʷalalák łkíẋaẋ.
 "gałúyamẋ,
"Xábixix kʷálá aǧa gałglalámẋ. 120
 "gaqłgənẋúdinəmẋ łglálam.
 "kʷábá gałuǧúpditẋ."

"Káwux gaqłulxámẋ,
 "'Nə́šqi wít'aẋ p'ála amẋúẋa namglaláma,'
"Aǧa aqdulxámniła idə́lxam dáwax wápul, 125
 "nə́šqi qá gałkdulxámẋ."

"Áyxtba wápul aǧa gaqłgəlxákʷaẋ.
"Aǧa gałglalámẋ,
 "gatgʷíyučkwaẋ wápul."

"Káwux aǧa nugʷagímẋ, 130
 "aqdulxámniła qaẋbámaẋix idə́lxam.
"Łíxt aqłgəlgáya iłə́kala,
 "łáẋka ałúya,
 "ałkdulxámniła idə́lxam:
 "xábixix atgadímamniła." 135

"Aġa ałglaláma.
 "dánnmaẋ aqiyawídima.
"Aġa alugʷalaláma,
 "atgʷíyučgʷa.
"Qánčíẋbt wápul." 140

"Aġa p'ála aluẋáẋa,
 "aluxʷak'ʷáyuniła.
"Ġʷénmix wápul k'ʷáƛqí aluẋáẋa."[14]

"Qáẋbt,
 "aġa łgúnaẋ ałwíčgʷa. 145
Nagímẋ,
 "Łúxʷan pú k'úya wiłlám,
 "łúxʷan néšqi k'ʷáƛqi núẋaẋ.
 "K'ʷalalák ałẋúẋa,
 "aġa łglaláma. 150
 "Łúxʷan qánčíẋbt k'ʷáƛqí núẋaẋ."
Alaẋk'ayáwəlalma,
 "k'ʷáƛqí alagíma."

Alagíma, *Insert 4*
 "Níšqi čáxəlqłix ałglaláma.
 "Áyš aqłgəmxagába,
 "p'ála aqłúẋa.
 "Alugʷagíma, *(5)*
 "'Kʷálá čáxəlqłix,
 "'aġa aliwíčgʷa.'

 "K'ʷáƛqí nuẋáẋaẋ:
 "lábladikš k'ʷáƛqí núẋaẋ;
 "čáxəlqłix ałwíčgʷa łíxt: *(10)*
 "ałẋláyda,
 "qánčíẋ wápul aduxĩƛ'áymačgʷa,
 "kʷalíwi aġa wít'aẋ atgʷíyučgʷa qáẋba."

Kʷáƛqí nagímx̣.[15]

Alagíma, (15)
 "Qánaǧači kʷáš núx̣ax̣ idə́lxam;
 "ałglaláma náwi.
 "Aqłwímidačgʷa,
 "aǧa p'ála ałx̣úx̣a."
Alagíma, (20)
 "Łáx̣ka gałkłx̣ə́lwaq,
 "aǧa łglaláma.
 "Łáx̣ka aqługálmama;
 "ałałgəmłáyda,
 "ałglaláma; (25)
 "łáx̣ka ałgiłx̣ʷálčgmayax̣dixa."
Kʷáƛqí alagíma.

3A Wít'ax̣ alax̣anəlkʷłíčgʷa dán ayalgáłx̣a:
 "Qáx̣ba iłáčǧmam. 155
 "Ałgíma,
 "'Łúxʷan wat'lát'la gúx̣t,
 "'ičáčǧmam.'
 "Awači ałgíma,
 "'gʷə́tǧʷt akíx̣ax̣, 160
 "'awači iǧiláyupx.'"

Alagíma ánǧa idə́lxam néšqi tgíyukʷl dáyax wičǧə́mam;
 Kʷálá itk'aníyukšbt tgadímamt dáyax wílxba,
 kánawi dán dáyax ičǧə́mam tgíƛamt.

"Ya·'·niwadix ux̣áx̣ikʷłila ugʷakíx̣ax̣: 165
 "ux̣ax̣úla wímqt idít.
"T'lát'la ałx̣úx̣a,
 "náwi ałáłutk alax̣əngágʷa:
 "aǧa łúmqt."

"Łíxt iłə́kala łúx̣t ux̣áx̣ikʷłila ugʷakíx̣ax̣. 170
"Gałútxʷit,
 "galə́kim,
 "'A·'·ġa t'lát'la ənkíx̣ax̣!
 "'ʔHúʔhúʔhúʔhúʔ,'
 "gałə́x̣ux̣." 175
"Gałə́kim,
 "'A·'ġa gəngəlgát wat'lát'lá!'"

"Gaqyúlxam,
 "'Níšqi kʷáλqí łxtgímnił!
 "'Iyámla ičġə́mam idít.' 180
"'ə̂·,'
 "gačdúlxam."

"Łúxʷan qánčíx̣bt,
 "aġa gagúgiga wat'lát'la.
"Ya·'·niwa yáx̣ka yaxiyax čuġʷánimx̣, 185
 "wat'lát'la gatígəlga:
 "náwi gayúmqt."

"Itqádutinkš łkdála,
 "t'lát'la ałx̣úx̣a.
"Ałkdáya, 190
 "kʷálá łkdát kʷábá ałx̣ímaxit,
 "ałúmqda."
Nagímx̣,
 "Łábla nux̣ʷáłayt;
 "wat'lát'la gakdúdina." 195

3B "Łúxʷan qánčíx̣bt,
 "aġa wít'ax̣ ux̣áx̣ikʷłila núx̣ax̣:
 "nugákim,
 "'Iġʷə́tġʷt idít.'"
 "'A·'nâ·'··! 200
 "'Aġa dángi igúnax̣!'"

"Kʷálá łúxʷan qánčíx̣bt,
 "aġa łíxt g̣ʷə́tg̣ʷt galəx̣ux̣.
"Ałx̣ix̣łx̣ə́mkʷ'ayax̣dixa,
 "wa·'·ʔaw cə́s ałx̣úx̣a. 205
"Aqłkgíxatgʷaya,
 "wáʔaw ġʷə́ġʷt ałx̣úx̣a.
"Ka·'·nawi wíłałq ałinx̣áya."

"Qánčíx̣bt p'ála ałx̣úx̣a.
"Aġa ałučġáyda, 210
 "aliłəlx̣ašáya iłčə́qʷa.
"Áqłlúda,
 "ałkłuġúmšda.
"Qánčíx̣ wíkayt,
 "aġa gałúmaqt." 215

"Aġa wít'ax̣ łgúnax̣:
 "wít'ax̣ łúxwan tqáwadikš núx̣ax̣ ġʷə́tg̣ʷt.
"Kʷálá aġa łábladikš,
 "łúʷwan qánčíx̣.
"Yáġayx̣ idálxam, 220
 "sáq'ʷ gačúgiga iġʷə́tg̣ʷt.
"Díxt itg̣ʷə́łi qánčíx̣bt idəlxam idáčgmam·ax̣ núx̣ax̣."

"Nugʷagímx̣ ałučġáydabt,
 "ałúya wímałyámt,
 "ałkłuġúmšdama iłčə́qʷa; 225
 "ałxk'ʷáya,
 "kʷálá łúit,
 "kʷábá ałx̣ímaxida,
 "ałúmqda."

"Tqáwadikš ałučġáyda, 230
 "ałkdáya wímałba,
 "ałx̣ġʷádama;
 "ałalúpčga,

"kʷábá ałx̣ímaxida,
 "ałúmqda."[16] 235

Áyxt łǧá waǧagílak,[17] *Insert 5*
 núłx̣ax̣ gakłuǧúmšdamx̣ iłčə́qʷa.
Núpčkax̣,
 kʷábá nax̣ímaxit,
 galúmqtx̣. (5)
Gyúk'ayc ičáxan íyak'ałx̣ila.
Idə́lxam tgít qáx̣ba gatgə́łǧəlkl iłgʷə́łilx łx̣lála.

Gałə́kim,
 "Mánkčxa dángi ix̣lála iłgʷə́łilx-diwi,
 "níx̣ʷa algíkšdama." (10)
Gatgíya,
 qʷáp gatgə́łǧəlkl iłk'áškaš łk'łx̣íla:
 gałálk'ałx̣i,
 gałgútukš.

Gatx̣ígilayx, (15)
 gaqə́łǧəlga iłk'áškaš,
 aǧa gałgə́łukʷł.
Łúxwan qáx̣babamat idə́lxam gatgíwkʷł.

Kʷábá íyaǧayλ níx̣ux̣.
Gyúk'aycbt níšqi níwkʷl íyax̣liw. (20)
Iq'íwqtbt íyax̣liw K'amáłamayx,
 Íyaq'imaš.

Iyáǧayλ níx̣ux̣,
Aǧa wíyalxt gačix̣adámidagʷa gigát niq'ímašixba.

Díka gayúłayt. (25)

"Nux̣ʷáłayt idə́lxam,
 "łúxʷan qánčíx̣bt:

"tqáwatkadikš níšqi nux̌ʷáɫayt.
"P'a·ʹ·la núx̌ax̌ kʷalíwi gaqə́dilx̌akʷčg̓ix̌."

"Gaqə́tutk: 240
 "ka·ʹ·nawi p'ála núx̌ax̌.
"Ag̓a nux̌ʷílayt."

3C "Łúxʷan qánčíx̌bt,[18]
 "ag̓a wít'ax̌ wig̓iláyupx gačúgiga.
 "Ag̓a wít'ax̌ k'ʷáʎqí núx̌ax̌: 245
 "nuxʷáɫayt."

"Kʷáʎqí wít'ax̌ łáx̌ka łábla iɫčə́qʷa aɫkɫug̓úmšda,
 "lálayx aɫúmqda:
"Íyaʎqdix k'ʷáʎqí núx̌ax̌."

"Iɫk'áškaš aliɫgiláyuba, 250
 "cə́s·cs aɫx̌úx̌a:
 "aliɫɫúpg̓a,
"Kʷálá ag̓a ɫúmqda."

"Tqáwadikš gatx̌aludə́lkəmčk.
"Ka·ʹ··nawi alíɫgiláyuba, 255
 "iɫsdáxusba aliɫənxáx̌ida ig̓ílayupx."

"Tqáwadikš aɫag̓itbáya,
 "cə́s iɫčə́qʷa wáx̌wax̌ aɫx̌úx̌a.
"Kʷalá aɫúmqda."

"Łíxtmax̌ aɫag̓itbáya, 260
 "aɫx̌·aymáya,
 "aqɫkgíxatg̓ʷaya,
"T'áya aɫx̌úx̌a."

"Íyaʎqdix mánk ag̓a néšqi wáʔaw nug̓ʷáɫayt.
"I·ʹ·yaʎqdix kʷalíwi gačux̌áyma ičg̓ə́mam." 265

3D "Łúxʷan qánčíx̣bt,
 "aġa wít'ax̣ wík'iqʷšt gačúgiga."

 "Łíxt idłáġiwam lálayx gałgígǝlga,
 "ałúqšixida,
 "ʔa·′ ʔa·′ ʔa·′ ałx̣ux̣a. 270
 "Ałúmqda."

 "Gaqǝ́łgǝlga łíxt idłáġiwam,
 "gaługílayt.
 "Gałǝ́kim,
 "ʌ́áqʷ anyúx̣a; 275
 "'ik'útk'ut anilx̣aymáya ičġǝ́mam.'"

 "ʌ́áqʷ gałgíwx̣ ičx̣ǝ́mam,
 "gałgilx̣áyma ik'útk'ut.
 "Kʷálá aġa itk'útk'utkš ičġǝ́mam gačúgiga:
 "ayúqcixida: 280
 "ga·′ ga·′ ga·′ ga·′, ayúya.
 "Alix̣ímaxida,
 "kʷábá ayúmqda."

 "Kʷálá qánčíx̣ aġa t'áya nux̣ax̣ idǝ́lxam,
 "néšqi mánk łábla nux̣ʷáłayt; 285
 "dáyma itgák'utk'utkš kánawi nux̣ʷáłayt.
 "K'ʷáʌqí nagímx̣."

3E "Dábá dáyax wílx wít'ax̣ gačúgiga wičgálit.
 "Łíxt iłk'áni idłáġiwam gałúłayt.
 "Iłáčǧmam ałx̣úx̣a, 290
 "aqługálmama,
 "aqłúkʷła qáx̣ba gʷidáčǧmamax̣ idǝ́kaqʷł."

 "Aqłúkʷłama gʷiłáčǧmam,
 "čáwčaw aqłúx̣a.

"Ačiłlúda ipłə́x̣, 295
 "iłčə́qʷa ačłlúda.
"Kʷálá aġa ałúmqda."

"K'ʷáʌqí gačə́tux̣ wik'áni idyáġiwam.
"Łábladikš nux̣ʷáłayt."

3F "Aġa íxt íyačg̣mam níx̣ux̣. 300
 "Gaqyugálmam,
 "gaqíwkʷł,
 "gaqyúkʷłam.
"ʌq'úp gaqłíx̣ux̣ iłíyaqšu.
 "čáwčaw gaqíwx̣." 305

"Łíxt—
 "łúx̣ʷan qáx̣babamat,
 "iłgʷə́łilx łáx̣ka ałkłšə́lglágʷačgʷa gʷiłáčg̣mam—
 "gałgyúlxam,
 "'Ašə́mxə̣lglágʷačgʷa!'" 310
 "Iłkíkčm[19] gałkłílut.
"Gałgyúlxam,
 "'Ačimlúda ipłə́x̣:
 "'néšqi amiwə́lq'ma;
 "'amyumġʷída. 315
 "'Dáłáx iłkíkčm.
 "'X̣áw ałə̣mx̣úx̣a imíkʷšxat.
 "'Kínwa ačłə̣mlúda iłčə́qʷa:
 "'níšqi amłuġúmšda.'"
"'ə̂.' 320
 "gačłúlxam."

"Kʷálá aġa gałúyam idłáġiwam,
 "ipłə̣x̣ gałgyúkʷłam.
"Gałgyúlxam,
 "'A·'ġa amyuġúmšda ipłə́x̣!' 325

"Gałgílut;
 "čłgǝlgát iłyáx̣ikčm,
 "wáx̣ gałgilux̣ íyakʷšxat,
 "gašix̣ilálagʷa x̣áwx̣aw níx̣ux̣,
 "gačyúmqʷit ipłǝx̣." 330

"Gałgyúlxam,
 "'Dałáx iłčǝqʷa:
 "'łǝqǝmšt!'
"Gačłúlxam,
 "'K'u·'ya.' 335
"Qáx̣ba níguya ipłǝx̣,
 "sáq'ʷ gačílgalq íyakʷšxat."

"Gałgyúkštam.
"Gačłúlxam,
 "'Amšgǝntgálmama lálayx!'" 340

"Gaqiwgálmam,
 "gaqíwkʷł idíyaqʷłba,
 "gayax̣awigʷǝ́łičk.
"Gačdúlxam,
 "'Qáma k'uya łáxawi iłgʷǝ́łilx, 345
 "'níšqi mšgnúqmit aǧa ánǧa pu inúmaqt.
 "'Idłáǧiwam ipłǝ́x̣ iyámla łgiyawítim idǝ́lxam,
 "'uxʷałálit.'"

"Áx̣ka wápul—
 ""łúxwan qáx̣ba galiwáx̣it idyáǧiwam; 350
 "K'u·'·ya!
 "nǝ́šqi qánčíx̣ gaqíǧǝlkl qáx̣ba.
"K'ʷáλqí nagímx̣:
 "'Qánaǧá łga gałx̣áytam qdudínax̣bamat idǝ́lxam.'
"K'ʷáλqí nagímx̣, 355

"'Qánaġa ičġə́mam gadə́kitẋ itk'ániyukš laẋáykabamat.
"'Dáyax wílẋalx q'áẋš gadə́kitẋ.'"

4A Kʷálá núwiẋ wagábašdənba,
 Gagulxámẋ,
 "Aqəmšúkʷła qáẋba q'ʷábixix a·ġa." 360
 Gagulxámẋ,
 "Néšqi dán amiġəldáqłq:
 "Kánawi dán itmíkdi amdúkʷła;
 "Amíxnim qáẋba amútga:
 "łán ałkšalglágʷačgʷa." 365

 "Əmẋlúẋix qánčíẋ dán aliẋúẋa išgákʷal ašẋúẋa:
 "aġa amšdíya,
 "amšguxʷašámida idəmšáłẋlm:
 "aġa mšxk'ʷáyuniła.
 "K'ʷáλqí amšẋúẋa. 370
 "Qáẋba aqəmšúkʷłama,
 "wílx aqimšlúda;
 "itġʷə́łi aqdəmšlúẋa;
 "dánmaẋ aqimšlúda,"
 gagulxámẋ. 375

 Aġa łúxʷan qánčíẋbt,
 gaqdúkʷłẋ idə́lxam.
 Núwiẋ gagúkʷšdamẋ waġagílak,
 gagulxámẋ,
 "A·'··nga aġa qdugʷít idə́lxam qaẋbámaẋix." 380

 Naxk'ʷáẋ,
 galúyamẋ.
 Wičáq'iwqt a·'·nġa λk'úpλk'up gačyúẋaẋ iłáxnim,
 dánmaẋ k'áwk'aw gakdúẋaẋ,
 Káwux aġa gaqłúkʷłẋ wasdinbútba,[20] 385

áyxt qánaǧa p'álǧiq, *Insert 6*
 tqáwadikš kʷábá gaqdagláydmitẋ.

Wagə́škix nagímẋ, *Insert 7*
 nḗšqi łxlúẋix.
Íxt ikíyutan²¹ gagilgíštẋmitẋ,
 íxt naykłáytẋ.

Núwiẋ Dəmwáda,²² (5)
 núyamẋ,
 gagwiǧʷímamẋ itgášuxʷdikš.

Káwux aǧa gaqdúkʷłẋ idə́lxam,
 áẋkamaẋ gaqúkʷłẋ;
 išgáxyatan díka našǧluqʷłqaẋ. (10)
Gatgíyamẋ qáẋba k'ú qə́duẋt idə́lxam.

I·'·yaλqdix áyma kʷábá gaqútga,
 aǧa kʷalíwi gaqíwkʷłam ičə́k'ak'u,
 wíčłm akʷa ik'áškaš mank.

Kánawi muláliš gaqdúkʷłamẋ. (15)

4B "Gančúwiẋ,
 "gaqənčúkʷłamẋ qáẋba k'ú qə́duẋt idə́lxam.
 "pa·'··λ ikíẋaẋix.
 "Káwux imúsmuski aqyudínaya,
 "iǧušúmaẋ²³ aqiwdínaya: 390
 "aqdawíkʷłama."

 "K'ʷaλqí wít'aẋ wiłšúga,²⁴
 "wiłǧa·'čaw,
 "idə́qat,
 "widsábll; 395
 "Kánawi dán aqinčəlǧʷímama."

"Tqáwadikš itqʼíwqdikš néšqi nuẋʷiłẋálamčk.
"Áyš nuẋínimčk,
 "kawéx aluẋinímaya.
"Kʼʷáλqí nuẋaẋ." 400

"Łíxt aqłgəlgáya qáẋba iłálxam,
 "łáẋka aqłúẋa iłkákʼmana.
"Ałkšawiglágʷačgʷa idłálxam."

"Tqáwadikš néšqí idáłẋlm i*músmuski* íyałġʷl;
 "wáʔaw i*gušu* néšqí gayuẋímuẋ. 405
"Náyaẋ ganúyam ičáłẋlm kánawi dan."

"Ag*ábašdn* dánmaẋ gagəngəngígiqʼnanəmčk:
 "i*gúšu* čáwčaw anyúẋa;
 "sáqʼʷ iłyáġču anłəlgítga.
 "Qáẋba atgiyawiłáda námni, 410
 "yáẋka anyúkʷła.
 "Iλġʷál ganuxʷašámid.
 "Iłš*úga* ganłəlkitk i*lisák*ba.
"Dánmaẋ ganátuẋ."

"I·ʼ·yaλqdix gančẋílayt kʷaba. 415
"Itqʷłímaẋ ids*ílhaus*[25] gaqdənčáluẋ."

"Gaqúgiga qánčíẋbt itkálukš,
 "gaqiwxanimámam wílẋ.
"Yániwa qʼʷábix:
 "ʼkʼúya, 420
 "néšqí tqʼíẋ gatgíyuẋ."

"Yaxát gaqátukʷł,
 "qáẋba aġa dábá alẋiláytix.
"Nugákim,
 "ʼItʼúkdi wílx dáyax: 425
 "ʼitbuġúxmaẋ ttʼúkdi waqʼʷálabamat.ʼ"

"Wít'aẋ gatgúġikl idmúyuqʷit,
 "wípan,
 "it'úba;
"Kánawi dán laẋáykabamat iʎẋə́lm ɫábla." 430

4C "Aġa yáẋka gatgígitga dáyax wílx wilẋigláytix:
 "Wít?ampġʷáyukš,
 "Itčašdíyukš,
 "Idwálamš,
 "Itk'álapuyuwaykš, 435
 "Idyáŋgalayukš.²⁶
"Kánawi díka gaqdúkʷɫamẋ."

"Yániwadix áys-ids*ílhaws* gaqdənšlútimčk.
"Niša náwi iɫmqšmáymaẋmán itġʷə́ɫi gančẋílayt kwábá,
 "pa·'·ʎ idə́lxam núẋaẋ." 440

Tqáwadikš itġʷə́ɫi digənxát wílx gaqyáwit. Insert 8
 iẋinxádaẋ ilibúm27 idíyamqu:
 kwábá nuẋʷílayt.
Tqáwadikš k'úya itġʷə́ɫi,
 áɫqičwa gaqdáwiẋ kdúkʷaycaẋ itqʷɫímaẋ. (5)

Náyaẋ ganúġitkl idə́kaqʷɫ iɫə́mqšmaymaẋmani:
 Ičə́k'ak'u díxt gaqdilútẋ,
 kdúqbayʎ ilibúm idíyamqu iẋinxádaẋ.
Kwábá gaɫẋílayt.

Íxt íkala iyáẋliw Dúšdaq díxt itġʷə́ɫi gaqdilútẋ: (10)
 kdúqbayʎ šbúq ugʷakíẋaẋ;
Ilibúm idíyamqu iẋinxádaẋ.

Iwád ínadix íxt wíkala Ik'alapúyuwa díxt itġʷə́ɫi ɫəmqšmáymaẋmani,
 itġʷə́ɫi kdúqbayʎ.
Kʷábá nuẋʷílayt. (15)

Iwád wít'aẋ íxt wíkala díxt itġʷə́łi gaqdilútẋ,
 kʷáλqí wít'aẋ ilibúm²⁸ idíyamqu iẋinxádaẋ.
Dáyax áġa iẋinxádaẋ,
 aġa iq'íwqdikš ikíẋaẋ ilibúm idíyamqu.

"I·'·yaλqdix kʷalíwi wílx gaqinčítimčk.
"Gaqtλámida tqáwadikš ínadix qáẋba aġa uẋʷiláytix.

"Aġa itqʷłímaẋ gatgə́ttẋ yáxa níša gigádiwa.
"Tqáwadikš itqʷłímaẋ uẋʷinẋát.

"Kʷábá nuẋʷidə́layt. 445
"Yániwadix idə́nčaqʷł yaxíba· šáẋlix qáẋba díxt itġʷə́łi gatgatxʷíla;

"Aġa gaqdúkʷłamẋ idšúlčast,²⁹
 "gatkšinšitglákʷačk."

"Qáẋba ančúya,
 "wíč'axʷi atginšlúda. 450
"Inádmaẋix wíxat uẋʷinẋát,
 "idə́ġʷalala tgugigát.
"Tqáwadikš gatgátp'iłayu,
 "nuxʷádagʷa qáẋba idálxam.
"Dáyčka néšqi gatgígitga wílx." 455

"Dábá díka šdmákʷšt ganišgítga išgə́xan.
"Wíʔaniwa wíłalxt *imúsmuski* gačidúwaq."

"I·'·yaλqdix dábá gančẋaλámit,
 "dáyax wílx gaqínčit,
"Aġa díka dábá ə́nčẋiláytix." 460

5A Agə́škix agúnaẋ áyxt.
 Nagímẋ,
 "Dán ačẋə́lk'amidałẋa."

Aġa alaxəlp'aláwəlalma Kílipašda:[30]
 alax̣k'ayáwəlalma. 465
Alagíma,
 "Qáx̣ba dán galgigə́lkl Wačínu dán gačíwx̣?
"ə̂·,
 "łúxʷan a·ʹ·nġa dán gačíwx̣,"
 alagíma agə́škix. 470

Aġa alagíma áyxt waq'íwqt,
 "Ġánač'a qáx̣ba ačłġəlgláya łabla idłákdimax̣ iłġagílak,
 "aġa łáx̣ka q'áx̣š alix̣ałgúx̣a.
 "Ačłumlálmama,
 "aqłilúda dánmax̣ idłákdimax̣: 475
 "ačdúdima,
 "ačłəmlálma wiłláytix.
 "Nə́šqi yáx̣ka idyákdimax̣;
 "ačλ̓kλ̓xúma idłákdimax̣.
 "Ałíġəldaqłġa." 480
K'ʷáλqi nugʷagímx̣.

Wagə́škix alagíma,
 "K'ʷáλqi náyt'ax̣ ganxəlčmáqʷax̣:
 "Wáʔaw wiłlámbt[31] gatkłə́tqəmšt;
 "yáx̣ka wáʔaw." 485
"ə̂·, k'ʷáλqí áw níx̣ux̣,"
 galugʷagímx̣.

Alax̣k'ayáwəlalma.
Alagíma,
 "Qá wít'ax̣ ənx̣úla? 490
 "Galgíġəlkl k'ʷáλqí níx̣ux̣.
 "Kʷábá łúxʷan qáx̣ba k'ʷálalak ikíx̣ax̣;
 "aġa gatgígitga idmímlušdikš,
 "tə́l·tl gadə́kitx̣
 "q'ʷáp pu nídəmqt. 495

"Gačitxádag^wabt.

"Gačitxádagʷabt.
"Aġa kʼʷáƛqí dáyax qíyuqmit.
"Idyáƛʼuẋyakš.
"Ayútxʷida aławiƛáya idyáqʷit."

Agə́škix alagíma, 500
 "Náyaẋ néšqi inẋə́lutkt dán gačíwẋ qá gačə́tuẋ idə́lxam.
 "Qánaġa kʼʷaƛqí dadáyč-díwi itkálukš:
 "néšqi dán gačíwẋ iyáġayƛ.
 "Kánawi gatẋiġidúwaqłq idyánəmškš;
 "aġa idyágyutgʷaẋ níẋatẋ. 505
 "Łúxʷan łíxt čimákʷšt idyáġixəltgiyukš dáymadikš dánmaẋ
 /gatgə́tuẋ.
 "wígʷa ayúya qáẋba.
 "Qánaġa łúxʷan qá aġa néšqi dawax Wásusgani, néšqi
 /galayġítaqłq."

Nagímẋ Kílipašda,
 "Qánaġa áw aġa kánawi nuxʷáƛayt łúxʷan itgášuxdikš. 510
 "Qánaġači aġa núłayt."
 "ə̂.
K'ʷáƛqí áw gaqáġəlkl."³²

Aġa ašẋkʼayáwəlalma,
 aġa gán ašẋúẋa. 515
Aġa dányámt ališẋəlxíkʼałẋa.

Náyaẋ qáẋba anúya:
 anẋmútẋmama.

Łúxʷan qánčíẋ lawíska alaġlúqłġa,
 alaxkʼʷáya. 520

Kílipašda gaguġumčxukaẋ,
 "Amẋlúẋixči qánčíẋbt idyáẋ*iwdan*yukš kttʼúkdimaẋ?"

"Łúxʷan.
 "Néšqí ganuġʷigə́lẋ."
"Álugʷagíma alúxmat'ayučgʷa; 525
 "yáẋka idyáẋiwdanyukš.
 "néšqi qánčíẋ ganúwiẋ."

Də́nuči p'ála ganẋúẋaẋ.
Ayš uẋʷáẋikʷłila aluẋáẋa,
 anúẋʷačmlidma alugʷagíma: 530
 "Wačínu igíkiłq."
Kʼʷáλqí alugʷagíma.

Nagímẋ Kílipašda,
 "Náyaẋ néšqí ganúġikl qánčíẋbt idyáẋiwadanyukš.
 "Qánaġa aw łúxʷan gadiẋəlmíštẋaẋ." 535

Nugʷagímẋ qáẋba atkadímama idə́lxam,
 idə́kmat'ayučk adigídiyaydama.
Aġa káwux awači qáẋ wígʷa,
 aġa alúxmat'ayučgʷa.
Níša néšqi díka ənčkíẋaẋ, 540
 itbuġúxmaẋba ənčkíẋaẋ.
"Łġá alúxmat'ayučgʷa."
"ə̂·,"
 agə́škix nagímẋ.
 "Kʼʷáλqí áw náyt'aẋ. 545
 "Áyš anuxʷačə́mlidma idə́lxam."

Something would occur to my mother-in-law,
 now she would be a-talking.
Sometimes in the morning she would get up,
 she would make a fire,
 now she would be a-talking. 5

She said that her father was an evil shaman. Insert 1
Wherever he would doctor some person,
 now he would go to some place,
 he would hide there.
I do not know how long after he would return; *(5)*
 he would give things to the people:
 he would make it right.

Now he would live there.
In vain — pow — they would shoot at him;
 he would return in the evening, *(10)*
 he would sing with his whole spirit-power.
He would take hold of her,
 he would lay her on his back.
Soon now he would vomit blood,
 he would barf up the bullet, *(15)*
 he would get well.[33]

Or if they took him away somewhere
 or if they cut him or stabbed him,
 that is again what he would do:
 he would vomit blood. *(20)*

A·'·ll done,
 he would get well.
That is what she said.

1A She would say,
 "Lo·'··ng ago when I was still a maiden,
 "he was bringing women here.
 "I do not know how long a time,
 "now one of them would leave." 10
 "Now another, he would purchase her,
 "his wives were many."

"I was still a maiden,
 "now he purchased me.
"I lived there; 15
 "I did not get big at once.[34]
"He had three wives,
 "I, too, lived there at that place."

"They said that some of them would become jealous;
 "they would fight. 20
"We did not:
 "we did not get jealous.
"If one of them left him,
 "he did not go to get her back."

"Only a Molale and I lived there.[35] 25
"Now she, too, went back home,
 "she left us.
"Now only I lived with him."

2A "Now close by indeed the myth people have been a-coming.
 "The fi·'·rst ones who came were very tall myth people. 30
 "They called them by their name, King George people.
 "They arrived in their wagons,
 "oxen pulling them.
 "They lived there."

"They traded for fish, 35
 "pans,
 "buckets,
 "various dippers they gave me.
"I would give them various smoke-dried things."

"I do not know how long a time after, 40
 "now lots of them were coming."

"Now I do not know where they began to make whiskey,
 "now they gave it to the men.
"Pretty soon now they got drunk."

"All of their valuables: 45
 "flat bags of woven grass,
 "small soft cattail mats,
 "large stiff reed mats, they paid for it with these.
"They purchased their whiskey with them."

"On the other hand they gave me various things. 50
"Whatever they would give me—
 "skirts,
 "waist (jackets)—
 "they would look us over,
 "they would laugh at us." 55

"Quilts, they gave me,
 "that is where I saw them,
 "that is where I learned.
"I saw how they would snip snip their calico,
 "in that same way I would snip snip. 60
"Now I sew the way they made quilts.
"Here today I do it the same way,
 "all day long I will sew."

"Now from that time on the men drank,
 "they got drunk. 65
"In the evening now they would sing,
 "they would help him sing.
"He would sleep,
 "they would cover him up.
"He slept, 70
 "he woke up:
 "now it was over.

"That is the way they did,"
 she would say.

"Nothing did they wear on their feet, 75
 "nothing at all did they put on them,
 "like those of today.
"Only a board they tied on their feet,
 "that is what they walked on."

"Pans: they gave us new ones, 80
 "now these we used for projecting ourselves.
"We would laugh and laugh doing that every which way."

"One old man named Kʼamíšdiqwnq,[36] Insert 2
 "he had one new pan.
"All day long he would look into it,
 "ly···ing down holding his pan,
 "he did not let go of it. (5)
"He would sit holding his pan.
"Wherever he laid it he would cover it
 "so that no one could take it."

"Also, his daughter gave him a squash.
"He hurried off, (10)
 "he grabbed a knife,
 "he wanted to cut it open:
"No.
 "He could not cut it.
"He grabbed it, (15)
 "he threw it away.
"He said,
 "'Anything she wanted from me,
 "'she brings that![37]
 "'I thought it had juice.'"[38]

"This was the first time we saw a yellow thing,
　　"with birds on it.
"Now that is what we called it."　　　　　　　　　　　　85

"It was just this that they put on,
　　"they called it their buttons,
　　　　"on various things such as men's clothes.
"Not before that time had we seen such things."[39]

A skirt, she gave her,　　　　　　　　　　　　　　　*Insert 3*
　　she put it on.
She showed it to them,
　　they watched her,
　　　　they laughed at her.　　　　　　　　　　　*(5)*

They said to her,
　　"Let us see you walk around."
She walked around,
　　they laughed at her skirt.[40]

They also had a name for apron.　　　　　　　　　*(10)*
They said it was made the same way too,
　　just like a skirt.

"We baked potatoes,　　　　　　　　　　　　　　90
　　"now they would go, pop.
"We said,
　　"'Oh dear these potatoes are different.'
"We laughed at them,
　　"that is what they did.　　　　　　　　　　　　95
"Some people did not eat the potatoes,
　　"while some people ate them at once."

"This white bread, we did not know how they made it;
　　"a Boston woman showed me how.

"I showed them the white bread I made 100
 "the ve·´·ry first time I made some.
"We laughed at my white bread."

"All kinds of things there:
 "I learned them from that Boston woman."

"Her name was Barclay, 105
 "a good Boston woman."

"A sample of everything, I took some to her.
"She would eat the smoke-dried things."

"When blackberries ripened,
 "now she would say to me, 110
 "'Pick some for me.'
"Lots of blackberries: we would pick them,
 "I took them to her."

"All kinds of things she would give me.
"That is how I made such things my own food, 115
 "those things that the myth people ate."

2B "I do not know how long after,
 "now one of them got drunk,
 "he got back.⁴¹
"In the evening soon now he started singing, 120
 "they helped him in his singing,
 "right there, he went to sleep."

"The next day, they said to him,
 "'Do not stop your singing again.'
"Now they would tell the people it would be tonight, 125
 "nothing whatsoever did he tell."

"One night later, now they gathered.
"Now he sang,
 "they danced throughout the night."

"The following day, now they said, 130
 "they would tell people from all over.
"One man, they would choose,
 "that one would go,
 "he would inform the people:
 "in the evening they were to come." 135

"Now he would sing,
 "they would give things away.
"Now they would sing,
 "they would dance.
"So many nights." 140

"Now they would stop,
 "they would go back home.
"Five nights, that is the way they did."

"A long time later,
 "now some others would dance." 145
She said,
 "Perhaps were it not for the whiskey,
 "perhaps they would not have been like that.
 "When someone got drunk,
 "now he would sing. 150
 "I do not know how long they were like that."
She would laugh;
 that is the way she would speak.[42]

She said, *Insert 4*
 "Only in winter should one sing.

"They would work on him,
 "to make it stop.
"They said, (5)
 "'Soon it is winter,
 "'now he should dance.'

"That is the way they did;
 "many of them did like that:
 "in the winter someone would sing; (10)
 "when that person got to the end,
 "they rested for many nights,
 "before they started up dancing there again."
That is what she said.

She would say, (15)
 "That is why the people were fearful;
 "they would sing it at once.
 "They would make him sing and dance,
 "now he would stop."[43]
She would say, (20)
 "Someone had passed out,
 "now someone sings.
 "They would get that person,
 "he would stay beside him,
 "he would sing. (25)
 "That person would catch on to it."[44]
That is what she said.[45]

3A Again she would tell me about something that would occur to her:
 "There was a sick person, 155
 "(and) they would say,
 "'Maybe she got the cough,[46]
 "'she is ill.'
 "Or they would say,
 "'She has got the ague, 160
 "'or the measles.'"

She would say that long ago the people did not know this illness;
 soon after the myth people come to this land,
 they brought with them all sorts of diseases such as these.

"At first they announced it: 165
 "they told them a deadly disease was coming.
"A person would cough,
 "straightaway his breath would be short:
 "now he is dead."

"One man was sitting there when they announced this. 170
"He stood up,
 "he said,
 "'No·ˊ·w I am coughing!
 "'Hack hack hack hack,'
 "he went like that." 175
"He said,
 "'No·ˊ·w the cough has got hold of me!'"

"They told him,
 "'Now, don't talk like that!
 "'The illness that is coming is bad.' 180
"'Hmm,'
 "he replied to them."

"I do not know how long after,
 "now they started coughing.
"The very first one was the one who had laughed at it, 185
 "the cough got him:
 "right away he died."

"Children would be running about,
 "they would start to cough.
"They would be running about, 190
 "while they are running about they would drop right there,
 "they would die."

She said,
 "Many of them died;
 "the cough killed them." 195

3B "I do not know how long it was,
 "now again, they would make an announcement:
 "they said,
 "'The ague is on its way here.'
 "'Dear oh dear! 200
 "'Now one more thing!'"
"Soon though I do not know how long,
 "now someone got the ague.
"He lay with his back to the fire,
 "he got co·´·lder. 205
"They threw covers over him,
 "but the ague got worse.
"His who·´·le body shook."

"So long a time, and then it stopped.
"Now he would get feverish, 210
 "he would get thirsty for water.
"They gave him some,
 "he would drink it.
"So many days,
 "now he died." 215

"Now again another person;
 "again, I do no know how many people got the ague.
"Soon now a great many of them,
 "I do not know how many.
"In a very large village of inhabitants, 220
 "all of them got the ague.
"In every house, so many of the people were ill."

"They said that when they had the fever,
 "they would go to the river,

"they would go drink water; 225
"they would go back home,
"while they were going,
"there they would fall,
"they would die."

"Some of them would become feverish, 230
"they would run to the river,
"they would go and swim in it;
"they would go ashore,
"there they would fall,
"they would die." 235

There was one woman, *Insert 5*
she went toward the river to drink water.
She went ashore,
she fell right there,
she died. *(5)*
Her little son was crawling about there.
People going along there saw a person moving about.

They said,
"Looks like a person or something is moving about.
"Let us go see." *(10)*
They went,
close by they saw a child crawling about:
he had crawled over to her,
he was suckling her.

They reached shore, *(15)*
they took hold of the infant,
and they took him along with them.
I do not know where the people who took him were from.

There, he grew big.
When small, I do not know what his name was. *(20)*

When he was an old man, his name was K'amáłamayx,
* a Clackamas.*[47]

He grew big,
Now his older brother-cousin brought him back here to
* Clackamas country.*
* Right here he lived.*[48] (25)

"The people died,[49]
 "I do not know how many:
 "only a few did not die.
"It ended before they even gathered them."

"They buried them: 240
 "a·'·ll of them and it stopped.
"Now they lived there."

3C "I do not know how long afterward,
 "now again they got the measles.
 "Now again they were just like that: 245
 "they died."

"Again that way, they would drink lots of water,
 "quickly they would die.
"For a long time it was like that."

"It would come out on a child, 250
 "he would get cold:
 "it would go in.
"Soon now he would die."

"Some of them went to sweat.
"A·'·ll over them it would appear, 255
 "the measles would come out on their eyes."

"Some of them would come outside,
 "they would pour cold water on themselves.
"Soon they would die."

"Some of them came outside, 260
 "they lay down,
 "they put covers over them.
"They would recover."

"A long time it seemed and no longer did they die from that.
"A lo·'·ng time before the disease went away." 265

3D "I do not know how long afterward,
 "now again a pain got them."

"One shaman got it quickly,
 "it bit him,
 "Ah·' ah·' ah·', it went. 270
"He died."

"They fetched a shaman,
 "he doctored them.
"He said,
 "'I shall take it out; 275
 "'I shall throw the disease to a dog.'"

"He took out the disease,
 "he threw it to a dog.
"Presently then the dogs got the disease,
 "it bit into him: 280
 "*ga·' ga·' ga·' ga·'*, it went.
 "It dropped,
 "right there, it died."

"Soon after, the people got well,
 "not many more died of it; 285
 "only their dogs all died."
That is what she said.

3E "Right here at this place, they again caught the fever.
 "One myth person's shaman lived here.
 "When they got sick,[50] 290
 "they would come to get him,
 "they would take him to the house of diseases."

 "They would bring the sick person,
 "they would shave him.
 "They would give him medicine, 295
 "they would give him water.
 "Soon now he would die."

 "That is the way the myth people's shaman was doing.
 "Many of them died."

3F "Now one of them got sick. 300
 "They went to get him,
 "they took him with them,
 "they took him there.
 "Snip snip: they cut his hair,
 "they shaved it off." 305

"One person—
 "I do not know where he was from,
 "he was the one who took care of sick people—
 "he said to him,
 "'Be on your guard!'" 310
"He gave him a handkerchief.
"He said to him,
 "'He will give you medicine:

"'do not swallow it;
　"'spit it out.　　　　　　　　　　　　　　315
"'Here is a handkerchief.
　"'Wipe your mouth with it.
"'He will try in vain to give you water:
　"'you will not drink it.'"
"'Alright,'　　　　　　　　　　　　　　320
　"he replied to him."

"Soon now the shaman came,
　"he brought him medicine.
"He told him,
　"'No·'w drink the medicine!'　　　　　　325
"He gave it to him;
　"holding his handkerchief,
　　"he poured it into his mouth,
　　　"he hurried and wiped it,
　　　　"he spit out the medicine."　　　330

"He said to him,
　"'Here is water:
　"'drink it!'
"He replied to him,
　"'No·'.'　　　　　　　　　　　　　　335
"Where the medicine ran out,
　"his mouth was all burned."

"They went to see him.
"He said to them,
　"'Come get me quickly!"　　　　　　　340

"They went to get him,
　"they took him to their house,
　　"he told them about it.
"He said to them,

"'If not for that other person, 345
 "'I should now be long since dead.
"'The shaman is giving bad medicine to people,
 "'they are dying.'"

"That very night—
 "I do not know where—the shaman fled; 350
 "No·ʼ·!
 "they never saw him again anywhere.
"This is what she used to say:
 "'He must have come to live here just to kill people.'
"That is what she used to say, 355
 "'The myth people just fixed up the disease for us:
 "'They want this country of ours.'"

4A Shortly afterward she went to her Boston woman.
She told her,
 "They will take you all off somewhere no·w." 360
She told her,
 "Do not leave anything:
 "Take all your things with you;
 "Put your canoe away somewhere:
 "someone will take care of it." 365

 "You know the time when such things as eels come:
 "now you may return,
 "you may come and smoke-dry your foods:
 "now you must go back home.
 "That is the way you will do. 370
 "Wherever they take you,
 "land, they will give to you;
 "a house, they will build for you;
 "various things, they will give you,"
 so she told her. 375

Now I do not know how long after that,
 they took the people away.
She went to see the woman,
 she said to her,
 "A·ʼ·lready now they are taking the people from
 various places." 380

She went back home,
 she got home.
Her old man had a·ʼ·lready busted up their canoe,
 she tied up everything.
The following day then they took them off in a steamboat,[51] 385
 one that was just flat,[52] *Insert 6*
 they put some of them on it.

My mother's mother used to say, *Insert 7*
 they did not understand.
On one horse, she had put packs,
 on one she rode.

She went to Tumwater,[53] (5)
 she got there,
 she came to give her relatives food.

The next day then they took the people away,
 and they took her along too;
 her two horses, she left right there. (10)
They got to the place where they had gathered the people.

For a lo·ʼ·ng time alone there they kept her,
 now before they brought my mother's father,
 and my mother's brother who was yet little more than a baby.
All of the Molales, they brought them there. (15)

4B "We went there,
 "they brought us to the place there where they had
 gathered the people.
 "it was crowded.
 "On the following day they killed cattle,
 "they killed hogs; 390
 "they took them to them."

 "In the same way also sugar,
 "grease,
 "potatoes,
 "wheat flour. 395
 "All sorts of things, they came and gave us."

 "Some of the old people would not eat it.
 "They just cried,
 "the days following they were still crying.
 "That is what they did." 400

 "Someone was taken from the place of his people,
 "he was the one whom they made chief.
 "He was to take care of his people."

 "Some of them would not eat the meat of cattle;
 "even worse the pork, which they would not eat. 405
 "When I got there, I ate everything."

 "The Boston woman had taught me everything:
 "the pork, I would fry it;
 "all done, I would store the grease.
 "Where they had thrown away whole pieces, 410
 "I would take them.
 "I smoke-dried the meat.
 "I put the sugar in a sack.
 "I used everything."

"For a lo·'·ng time we stayed there."[54] 415
"The houses were sail houses they built for us."

"They took a number of men,
 "they went and showed them the land.[55]
"First a place close by:[56]
 "'No,' 420
 "they did not want it."[57]

"They took them farther,
 "to where we are living now.
"They said,
 "'This is good land here: 425
 "'the mountains are fine for hunting.'"

"They also saw camas,
 "wild celery,
 "another type of celery;
"Lots of different things that were our foods." 430

4C "Now they chose this place here where we live:
 the Upper Umpquas,
 the Shastas,
 the Rogue River Indians,[58]
 the Kalapuyas, 435
 the Yonkallas.
"All of them, they brought them (all) here to this place."

"At first they just gave us sail houses.[59]
"Speedily we lived in log houses there:
 "they were full of people." 440

Some houses were already there on the allotted land. *Insert 8*
 standing there, apple trees:
 there some of them lived.

Others had no houses,
 but later on they built small houses for them. *(5)*

I saw their log houses:
 they gave one to my mother's father,
 big apple trees (are) standing there.
There they lived.

They gave one house to a man named Dušdaq: *(10)*
 it was big and gray;
Apple trees (are) standing there.

Across yonder one Kalapuyan man[60] *had one log house,*
 a large house;
There they lived. *(15)*

Over there also they gave one man one house,
 apple trees stand there too.
Here now they stand,
 now the apple trees are getting to be old ones.

"A lo·ʹ·ng time before they gave us land.
"They moved some of them to where they are now living."[61]

"Now they constructed houses for us here on this side.[62]
"Some houses are standing there."[63]

"There at that place they lived. 445
"At first our house was yonder up above where one house stood.

"Now they brought soldiers:
 "they watched over us."

"Wherever we went,
 "they gave us a paper."[64] 450

"They stood on each side of the road,
 "holding their guns.
"Some ran away,
 "they went back there to their village.
"Those people got no land." 455

"Right here I gave birth to my two sons.
"The first and older brother was killed by cattle."

"After quite some time we moved here,
 "this land here, they gave it to us.
"Now right here, we are living." 460

5A My mother's mother had another one.[65]
 She used to say,
 "Something occurs to me."
 Now Kílipašda would be talking it over with her:
 she would laugh and laugh. 465
 She would say,
 "Where did we ever see Wačínu do anything?"[66]
 "Ye·s,
 "possibly he did do something lo·ʼ·ng ago,"
 said my mother's mother. 470

Now the other old woman said,
 "It is only where he sees that a woman has many possessions,
 "now that is just the one he wants.
 "He will be going to purchase her.
 "They will give him all her possessions:[67] 475
 "he will spend them,
 "he will buy a slave.
 "They were not his own possessions;
 "he would use up all her possessions.
 "She would leave him." 480
That is what they used to say.

My mother's mother said,
 "That is what I heard too:
 "worse with the whiskey they drank;
 "and he was the worst. 485
 "Yes, that is the way he really did then,"
 they used to say.

She would laugh and laugh.
She would say,
 "Why should I have to say it again? 490
 "We saw that that's the way he was.
 "There, I don't know where, he was drunk;
 "now dead persons got hold of him,
 "they made him paralyzed,
 "he pretty nearly died. 495
 "Later he recovered.
 "Now this is the way they see him here.
 "He is deaf.
 "When he stood his legs would shake."

My mother's mother would say, 500
 "I do not recall anything whatsoever that he did for
 the people.
 "He was just like these other men here:
 "he never did anything grand.
 "All his wives left him,
 "now he has become poor. 505
 "Possibly one or two of his slaves were the only ones
 who did anything.
 "All day long he would be gone somewhere.
 "So I just wonder now why this Wásusgani, she did not
 leave him."

Kílipašda said,
 "Only because of her own relatives, they were perhaps
 /all dead then. 510

"It is solely for that that she stayed."
"Yes.
"That indeed is the way they saw her."

Now they would laugh,
 now they stopped. 515
Now they would talk about something else.

I myself would go elsewhere:
 I would go play.[68]

Perhaps sometime in the evening she would leave her,
 she would go back home. 520

Kílipašda asked her,
 "Do you know how many good horses he had?"
"Possibly.
 "I never saw them."
"They would say that they had [horse] races; 525
 "he had his own horses [in the race].
 "I never went."

I was always moving about.
It was only from what they would tell,
 I would overhear them say: 530
 "Wačínu won."
That is what they would say.

Kílipašda said,
 "I did not see how many horses he had.
 "Perhaps he just borrowed them anyway."[69] 535

They used to say that when people came from elsewhere,
 they would come for horse races.
Now the next day or some other day,
 now they would have horse races.

We were not here, 540
 we were in the mountains.
"They must be having horse races."
"Yes,"
 said my grandmother.
 "That is indeed the same for me. 545
 "I would only overhear about them from the people."

Inventions and New Customs as
Sources of Amusement

Howard presents here a conversation between her maternal grandmother, Wagayuhlen, and another Clackamas elder, who are making jokes about the new media technology and cultural objects introduced by Euro-Americans, which influence life at Grand Ronde.[1]

Íxt wíkala iyáqʼimaš ayaxalkʷłíčgʷa agəškix,
 ačulxáma,
 "Dángi x̣lúyda-aq.
 "Dángi aġa wítʼax̣.
 "Itpáṣ̌dnukš[2] wiġíwiqi aqyuqbílxma, 5
 "aġa awáwa alakdáya yaxi·ʼ··:
 "qáx̣ba íxt wílx awáwa alakdáyaytam."
Agyulxáma,
 "Ana·ʼ··!
 "Dángi kʼʷaλqi. 10
 "Tkʼaníyukš[3] dángi x̣lúymax̣ tgíwx̣t."
"ə̂…,"
 ačulxáma,
 "kʼʷaλqí atx̣anəlkʷłílal."

Aġagyulxáma, 15
 "ə̂….
 "Qátx̣u.
 "Níšqiči qíwqmit dángi dáyax ikdála:
 "wátuł čúkčan.
 "Kʷála dán wítʼax̣ atgyúx̣a dáwax̣. 20
 "Aqyalgíłx̣a iłčə́qʷaba.
 "Aġalakdáya:
 "wátuł agúkʷła,

"alaɫkdáya iɫčəqʷa."
Alagíma agə́škix, 25
 "Qa·'·tx̣u k'ʷaƛqi aw."
Aǧa dáyax nugʷagímx̣,
 "Kʷálá dán amšgiǧəlgláya.
 "Aǧa k'ʷaƛqí dáyax əlkíx̣ax̣—
 "dánmax̣ tk'ániyukš tkdux̣úla." 30
Aǧa ašx̣k'ayáwəlalma.
Ačulxáma,
 "Ɂə̂··!
 "Qánčix̣ ǧánǧa *iladám*⁴ alxigə́mlayda alx̣ɫx̣ə́lma?"

One Clackamas man used to say to my mother's mother,
 he would tell her,
 "Some things are different now.
 "Some things, now yet again.
 "The Americans will strike an iron, 5
 "now a word will run far, far away:
 "there at some other land the word will arrive."
She would say to him,
 "Dear oh dear!
 "Things are like that. 10
 "The myth people are making things different."
"Yes,"
 he would reply to her.
 "that is what they have been telling me."

Now she would say to him, 15
 "Yes.
 "It is indeed so.
 "Have you not seen this thing here that is running along:
 "the fire wagon.⁵
 "Soon something else, they will be making it here. 20
 "They will burn it on the water.

"It will move along:
 "fire will move it along,
 "it will move along there on the water."
My mother's mother would say, 25
 "Indeed that is how it is now."
Now to this they would say,
 "Soon now you will be seeing something.
 "That is the way we have now become here—
 "all sorts of things, the myth people are making." 30
Now the two of them would laugh.
He would say to her,
 "Yes!
 "When did we ever, long ago, sit around a table and eat?"[6]

Cultural Landscapes

Išknúłmapx (Two Grass Widows)

Two grass widows[1] are carrying on one evening.[2] They wander outside and soon a flock of geese fly over their heads. One of the grass widows wishes that a goose would come to her but then tells her friend it is just talk. Soon a goose falls near the women, followed by a second one. The women laugh even harder and then carry their geese into the house. They announce that they will pick the goose feathers the following day. The two women stay up into the night, carrying on, and the people ask them when they will go to bed. The following day, everyone is out of bed except the two women. The people approach the women slowly and discover that they are dead. When they look for the geese by the door, there are no geese, and the people conclude that the two grass widows had a bad omen.

Išknúłmapx gaqšuq'iƛwałx̣.
Dáwix̣t idə́lxam łúx̌ʷan qánč̓íx̣ iłgábla.
Aġa q'ʷap iġíwitm gašdúpa ƛáx̌nix,
 šx̣k'ayáwəla,
 šdúx̣t. 5
I·ʹ·yaƛqdix aġa gašgilčə́maq ik'lak'lámax̣ idít.

Šdúx̣t šx̣k'ayáwəla.
Kʷálá aġa dába saybá šáx̣lix yúit.
Nákim áyxt,
 "Ádi·ʹ·· anixčwa íxt awači mákʷšt itxʷíyučxitx̣ dábá." 10
Áyxt gagúlxam,
 "Dánba k'ʷáƛqí amx̣úla?"
"Qánaga ənx̣úla."
Gašx̣k'ayáwəlaləmčk.

Kʷálá škíx̣ax̣ də́p· nišgílkʷču. 15
Kʷálá aġa wít'ax̣ igúnax̣,
 mákʷšt gatktxʷíyučxit ik'lák'lamax̣.
Aġa wáʔaw gašx̣k'ayáwəlaləmčk.

Gašdə́kim,
 "Qá atgyux̣a?" 20
Áyxt nákim,
 "Ana·ʼ· ʔ!
 "Atgiyašgúqʷčga áw."

Gašgúgiga,
 íxtmax̣ gašgə́tukʷɫ. 25
Gašdáškupq,
 íxtmax̣ šgigəlgát ikʼlakʼlámax̣,
 gašgux̣áyma.
Šx̣kʼayáwəla.
Gaqšúlxam, 30
 "Dán amtgiuǵánimx̣?"
"Kʼu·ʼya qánaǧa dáyax ikʼlákʼla əntgiuǧʷánimx̣."
Gašdə́kim,
 "Áɫqi káwux kʷalíwi pʼə́kpʼk atgyúx̣a."
Šdáwix̣t. 35

Íyaƛqdix aǧa gaqšúlxam,
 "Qánčíx̣ aǧa amtx̣úkšida?"
Gašdə́kim,
 "Kʷála áɫqi."
Dánmax̣ išx̣əlkʷɫíla: 40
 šx̣kʼayáwəla.
Ɫúxʷan qánčíx̣ wápul kʷalíwi ašx̣úkšitam.

Káwux idə́lxam nux̣ʷaláyučk.
Šx̣i·ʼ···mat.
Nugákim, 45
 "Wápul šdáwix̣t."
 "Əmtx̣ə́lačk!
 "Aǧa pʼə́kpʼk əmtgyúx̣a imdákʼlakʼlamax̣."
Šx̣i·ʼ·mat.

"Əmtkšə́qučq!" 50

Gaqšgə́luya,
 gaqsk'ə́lutk:
 né šqi šgə́łudəlk.
Íwi gaqə́šgəlga:
 cə́s· wíštałq. 55
Gałə́kim,
 "Mánkčxa šdúmqt!"
Gaqšgə́luya,
 gaqšgə́lgílagʷa:
 kánawi wíštałq g̣áyat. 60
Nugákim,
 "A·ˈ·ng̣a išdúmaqt.
 "Qáx̣ba³ našguxatgʷáya itk'lak'lámax̣?"
Łíxt gałə́kim,
 "Kʷábá q'ʷáp išə́qiba nančg̣əlgláya dángi našgix̣imáya." 65

Nugʷak'ínax̣ƛčk,
 "K'u·ˈ·ya."
Nugákim,
 "K'úya dán qáx̣ba úx̣ax̣t ik'lák'lamax̣.
 "Qánag̣a naqšuk'íƛxʷałxa."
"Ə̂·," 70
 nugákim.

Ag̣a łúxʷan qá núx̣ax̣.
Ag̣a yáymayx kʷábt inx̣ə́lutkt.
"Ag̣a q'ʷáp idə́lxambt,"⁴
 nugʷagímx̣. 75

Two grass widows had a bad omen.
I do not know how many people were sitting up.⁵

Now when it was nearly time to sleep, the two of them
 went outside,
 they are laughing,
 they are sitting there. 5
Ju‥st a little while, now they heard geese coming.

They are sitting there laughing.
Presently now, straight up from there, they are going along.[6]
One of them said,
 "Oh dear I wish that one or two would fall down right here." 10
The other one said,
 "Why are you talking like that?"
"Just talking."
They laughed and laughed.[7]

While the two of them were there — plop — it dropped down
 near them. 15
Soon, now again, another one,
 two geese fell down.
Now, all the more, they laughed and laughed.
They said,
 "What shall we do with them?" 20
One of them said,
 "Oh me oh my!
 "Let us take them inside now."

They took them,
 each of them carried one. 25
They went inside,
 each of them holding one of the geese,
 they laid them down.
They laughed.
They said to them, 30
 "What are you laughing about?"[8]

"Oh no, we are merely laughing about these geese."
They two said,
 "It will be tomorrow before we pick their feathers."
They sit up there. 35

After a while now they said to them,
 "When, now, are you going to lie down?"
They said,
 "Pretty soon now."
They are telling each other about all sorts of things: 40
 they laugh.
I do not know how late in the night before they go to bed.

The people arose the following morning.
The two of them were lying there yet.
They said, 45
 "The two of them sat up all night long."
 "Get up!"
 "Now pick the feathers of your geese."
The two of them continued to lie there.
"Wake them up!" 50

They went over to them,
 they looked at them:
 they were not breathing.
They took hold of them:
 their bodies were cold. 55
They said,
 "They seem to be dead!"
They went to them,
 they uncovered them:
 their bodies were completely stiff. 60
They said,
 "They have long been dead.

"Where did they put the geese?"
Someone said,
 "I saw them lay something there close to the door." 65

They looked for them,
 "No."
They said,
 "There are no geese lying there.
 "The two of them merely had a bad omen."[9] 70
"Yes,"
 they said.

Now I do not know what occurred.
Now that is as far as I remember it.
"Now the people are close by here,"[10] 75
 they used to say.

Restrictions on Women

This ethnographical exposé discusses Clackamas taboos regarding female sexuality.[1] Howard explains that proximity to menstruating women, women having had adventurous sexual relations the night before, and widows are experienced as dangerous to medical patients and newborn babies. She describes the restrictions placed on these women to protect the ill. Howard also indicates that certain consumables become poisonous for the ill. In a third part, Howard speaks in the voice of her maternal grandmother, Wagayuhlen Quiaquaty, who affirms that the elders of Grand Ronde have preserved their well-being because they have respected these taboos handed down by their own elders.

A Alugʷagíma itq'íwqdikš,
 "Áng̱a łg̱a ałqłáxida,
 "néšqi ałqłúkšdama gʷiłáčg̱mam."
 Ałgíma,
 "Gʷiłáqłačk ałkłg̱əlgláya gʷiłáčg̱mam, 5
 "wáʔaw iłáčg̱mam ałx̱úx̱a.
 "Áwači dán iłx̱əlm ałgiłlúda,
 "áwači ałkłg̱əlgláya dán aliłx̱əlmúx̱ma,
 "ag̱a wáʔaw iłáčg̱mam ałx̱úx̱a."

 "Kʼʷaƛqí wítáx̱ qáx̱ba łkdála, 10
 "iłə́kala łkłúkʷčan wápul,
 "káwux ałúyama dáx̱kamax̱,
 "ałgíma,
 "'Ag̱ápul.'
 "Néšqi dán ałkix̱əlgláya aliłx̱əlmúx̱ma, 15
 "háʔay ałx̱g̱ʷáda máła ałgyúx̱a wíłałq."

B Kánawi dán kʼʷáƛqíyax̱ gʷiłáqłačk.
 Kʼʷáƛqí wít'ax̱ g̱ʷə́nmix ayučúkdiyayax̱dixa,

aɬx̣ǵʷáda máɬa aɬgyúx̣a wíɬaɬq,
 kʷalíwi aɬkɬúkšdama gʷiɬáčǵmam. 20
Ƙʼʷáλqí wítʼax̣ iɬəpɬqaw néšqi aɬkɬúkʷšda gʷiɬáčǵmam,
 dán aliɬx̣əlmúx̣ma,
 áwači itqádutinkš dán ayux̣imúx̣ma.
Néšqi aɬksukʼítga,
 áwači gʷiɬálkaw, 25
 aɬkdúkša aqɬkgílagʷa.
Ƙánawi dán kʼʷáλqí núx̣ax̣.

Nugʷagímx̣,
 "Ƙánawi dán itkʼíɬawa,
 "dán aliɬkɬáyda aliɬx̣əlmúx̣ma iɬáǵʷamniɬ, 30
 "iɬáčǵmam aɬx̣úx̣a,
 "aɬúλʼlx̣da."
Ƙʼʷáλqí nugʷagímx̣.

C Agə́škix agnulx̣áma,
 "Ka·ʼ·nawi dán áng̣a gaqənčúx̣iwa; 35
 "gančx̣áwix qá aqənčulx̣áma.
 "Ƙʼʷáλqí ančx̣úx̣a;
 "qánag̣ači dáyax mnčúqmit.
 "Ag̣a ančqʼíwqdikš ančgúšgiwa;
 "kánawi dán gančgux̣ágišga." 40
Ƙʼʷáλqí agnulx̣áma.

A The old people would say,
 long ago when they menstruated,
 they would not go to see a sick person.
 They would say,
 "If the menstruating woman were to see the sick person, 5
 "he would become even sicker.
 "Or if she gave him food,
 "or she looked at what he was to eat,
 "now he would become even sicker."

"In that same way when a woman is running around, 10
 "a man takes her at night,
 "the next day she would come back,
 "they would say,
 "'Her night.'
 "Nothing should she see of what he was to eat, 15
 "first she must swim and cleanse her body."

B All sorts of things were that way for women who menstruated.[2]
 In that same way five times it would dawn,
 she would swim and would make her body clean,[3]
 before she would go to see a sick person. 20
 In that same way, a widow would not go to see a sick person,[4]
 what he was to eat,
 or what any children were to eat.
 They would not look at them,
 or at a baby, 25
 when it suckled, she would cover herself.[5]
 All sorts of things that is the way they did.[6]

 They used to say,
 "All sorts of things were poisonous,[7]
 "such things they had eaten would stay in their stomach, 30
 "they would become sick,
 "they would become thin, bony, and debilitated."
 That is what they used to say.

C My mother's mother would tell me,
 "A·'·ll sorts of things, long ago, they warned us about them; 35
 "we minded what they told us.
 "That is what we would do;
 "that is why you see us here.[8]
 "Now we old persons still get around;
 "all those things, we believed them."[9] 40
 That is what she would tell me.[10]

Laughing at Missionaries

The first Catholic priest to arrive in Western Oregon warns the Native peoples that they must pray all the time and believe what he tells them to avoid growing tails like wild forest animals.[1] Howard's mother-in-law, Wásusgani, jokes about the sight of the women playing shinny with tails whipping around at each other.

> Ya·ʹ·niwadix łga iłáx̣igiwuludamit gałúyam dáyaxba wílx,
>> gałgdúlxam,
>>> "Gʷa·ʹ·nisim amšx̣gíwuludamit,
>>>> "šáx̣lix[2] íštamx ačəmšgəlgláya.
>>> "Yáxa néšqi amšgix̣gišgáyda, 5
>>>> "aǧa idəmšáyčx̣ukš amšx̣úx̣a,
>>>>> "X̣ʹá-dánmax̣ iqtx̣awayúg̓ʷax̣ dəmqubámax̣ix itqšx̣iłáwkš."
>> Aǧa nagímx̣ wákšdi,
>>> "A·ʹ·di·ʹ··!
>>> "Łúxʷan dángi kláyx:
>>>> "alx̣admútx̣umniła waƛ̓áqƛ̓aq, 10
>>>>> "idəlx̣áyčx̣ukš adilxičimniła!"

It must have been the very first time he-who-prayed came to this land,[3]
> he told them,[4]
>> "All the time, you should be praying,
>>> "the chief above will see you.
>> "Thus, if you do not believe it, 5
>>> "now you will have tails,[5]
>>> "like the various animals that run about in the forests."

Now my husband's mother would say,
 "Dear oh dear!
 "Wouldn't it be something:
 "when we are out playing shinny together, 10
 "our tails would be a-whipping at each other!"

The Honorable Milt

This very short anecdote presents the manner in which Howard's mother-in-law would joke around about Native women marrying white men.[1] It reflects upon a myth Howard narrated for her recordings with Jacobs titled "She Deceived Herself with Milt," in which a widow wishes that the milt (sperm-carrying fluid of a male fish) in her salmon would transform into a man.[2] The transformation takes place, and another woman steals the milt husband, only to make fun of the former wife. In turn, the first wife transforms the man back into milt using her spirit-power song and regalia. In Howard's anecdote, her mother-in-law sings this same song as she makes fun of the Native women marrying white men.

> Idə́nčaqʷɬ q'ʷáp wíxat:
>> aɬənčx̌ƛáġʷa iɬgʷə́ɬilx,
>>> akɬsk'lútga,
>>>> aġa alax̌k'ayáwəlalma.
>
> Alagíma, 5
>> "Adi·ʼ...!
>> "Iɬátk'abumit!
>> "Łúxʷan išə́qčx̌št!"
>
> Aġa alaglaláma;
>> k'ʷáƛqí alagíma: 10
>>> "Wi·ʼqčx̌šdi·ʼya!
>>> "Galínx̌idlulámidaya!"[3]

> Our house, near the road:
>> when some person would pass by us,
>>> she would look,
>>>> now she would laugh.
>
> She would say, 5
>> "Dear oh dear!

"It is a light one![4]
"Maybe it is Milt!"
Now she would sing;
 this is what she would say: 10
 "The Honorable Milt!
 "I deluded myself with him!"[5]

Išk'áškaš škáwxaw gašdəx̱ux̱
(Two Children, Two Owls, They Became)

A boy and a girl stay up late chattering and quarreling.[1] Despite repeated warnings from adults, their behavior causes them to transform into owls. The two owl-children fly up into the rafters. The adults attempt to keep the disobedient youngsters shut inside the home. At the advice of others, who tell them that there is no use in keeping nonpersons inside the house, the adults set the owl-children free. The two reach the tops of nearby fir trees, where they are heard still chattering. Ultimately, the owls fly away.

A Ux^wiláytix.

A Uxʷiláytix.
 X̱ábixix níx̱ux̱ix;
 dawiláytix išk'áškaš,
 šxmútxəmx.
 Kʷálá aǵa gašx̱ə́dina gašx̱ə́dina. 5

 Aǵa gaqšúlxam,
 "Qánčix̱ aǵa p'ála amtx̱ùx̱a?"
 Wa·'··ʔaw.

 Gaqšúlxam,
 "Wíska əmtkáwxaw amtx̱úx̱a." 10
 K'u·'··ya,
 wa·'··ʔaw šx̱dínx̱.

 Aǵa idə́lxam nugʷaǵíwitx̱it,
 šdáx̱ šdáwix̱t.
 Šx̱dénx̱ k'anadítułmax̱. 15

B Ánix aǵa kláyx gaqšilčúmlitəmčk;
 Qaqə́šúkʷšt:
 aǵa ipǵʷə́lx íxtmax̱ íšq'lpx.

Aǵa nux̣aláyučk,
 gaqšúlxam, 20
 "Áǵa p'ála mdə́x̣ux̣!"

Kʷálá aǵa gašdúka:
 waǵagílak wak'áškaš ínadix iq'ípaqɬq naygə́ɬayt,
 wičámxix ínadix.
Aǵa iškáwxaw gašdə́x̣ux̣. 25

Wak'áškaš nagímx̣,
 "Wa·'mi·'qšt!"
Yáxa wičámxix nigímax̣,
 "Imi·'gə́lutím!"

Gaqúxabu itǵʷə́ɬi; 30
 akálama gaqáyx̣bwix.
Wi·'···kayt aqšəlčúmlitma iškáwxaw.

Aǵa nugákim,
 "Dánba qašx̣bút?
 "Nɛšqi wítax̣ aǵa šgʷə́ɬilx̣." 35
"ʔə̂ⁿⁿⁿⁿ," nugákim.

Aǵa gaqəšx̣ə́laqɬq.
Gašdúka:
 áyxt waqíx̣alq kʷábá nagə́layt;
 yáx̣ áyxt wít'ax gayagə́layt. 40

Aǵa kʷábá gašdə́x̣ux̣.
Wí·'·gʷa gašx̣əlčúmlitəmč.
I·'···yaλqdix kʷalíwi ɬúxʷan qáx̣ba gašə́tuya.

A They are living there.
 Night was coming on;

sitting up there are two children,[2]
 they are playing.
Soon now they quarreled and quarreled. 5

Now they told them,
 "Now when are you going to quit chattering?"
A·ʹ··ll the more.[3]

They told the two,
 "You might become owls." 10
No·ʹ··,
 a·ʹ··ll the more, they quarrel.

Now the people went to bed,
 the two of them are sitting up.
They are quarrelling on opposite sides of the fire. 15

B Oh now they heard the two of them sounding different;
 they look at them:
 now feathers, here and there on them.
Now they got up,[4]
 they told the two, 20
 "Now stop chattering!"

Soon now the two of them flew up:
 the woman female child sat on a crossbeam on one side,
 her younger brother on the opposite side.
Now the two of them had become owls. 25

The girl would say,
 "You have lice on you!"[5]
On the other hand her younger brother would say,
 "You have been giving it to him!"[6]

They shut the house;[7] 30
 they shut the smoke vent.
A·ʹ···ll day long they hear the two owls.

Now they said,
 "Why have they shut them inside?
 "No longer now are they persons." 35
"Yes," they said.

Now they opened it up for them.
The two of them flew up:
 One of them[8] lit upon a fir there;
 he himself lit upon another.[9] 40

Now there the two of them stayed.
A·ʹ·ll day long they were heard.
It was a lo·ʹ···ng time before the two went off I don't know where.

Joshing during a Spirit-Power Dance

Kílipašda makes fun of children without traditionally flattened heads that arrive with their families at Niʔúdiya's spirit-power dance.[1] She tells her Clackamas friends that they look like mauls.[2] James Winslow retorts in Clackamas, telling the jokesters that their (flattened) heads resemble those of cows. Surprised that a man without a flattened head would speak Clackamas, the women laugh. On another evening of spirit-dancing, Wásusgani tells the story of getting lost when leaving the dance. Kílipašda retorts that Wásusgani is making up this story to dissimulate that it was her own wish to be out sleeping with someone. Everyone laughs. In both instances, the jokesters are told to quiet down.

Uwíla Káwał ayágikal.
Tgíyamnił idə́lxam.
Yaxa łáyč łqʼíwqdikš,
 łax̣láytix wátuł,
 łx̣ax̣ikʷłíla dánmax̣, 5
 łx̣kʼayáwəla.

Kʷala qáwayčgi gadašgúpqax̣,
 dawištx̣mítix̣ idáquq.
Íwi gałx̣úx̣a.
Kílipašda íwi nax̣úx̣ax̣; 10
 gagulxámx̣ Niʔúdiya,
 "A···dɛ··y idə́lxam itgadímam gʷidáxmagapx;
 "ławíštx̣mitix iłgá*maul*."

Qúšdyaxa čux̣ačémlit James.
Kʷála aġa gačłuxámx̣, 15
 "ə̂·!
 "Mšx̣kʼayáwəlaləmčk!
 "Háʔay pu mišáyka dmšáqʼakšdáqukš,

"díwi ƛ'á-*imusmusgímẋ*!"³

Gaɫẋk'ayáwəlalmẋ. 20
 "Łángi iɫgalẋčemaq yáẋkamaẋ iɫáq'akšdaq?"
Aġa wáʔaw gaɫẋk'ayáwəlalmẋ.
Kʷála aġa gakɫulxámẋ,
 "Qánčiẋ wíska ġán amšẋúẋa?"

Agúnaẋba wápul aġa Wásusgani naxkʷáẋ. 25
Iɫgák'iwa.
Aġa numádakʷitẋ,
 kínwa naglúmniɫ.
 K'u·'ya, nɛšqi ɫán gaɫgaẋčmáqʷaẋ.

Áyxtba wápul núyamẋ, 30
 aẋawikʷɫíla:
 "Dáyax nanúya,
 "dába gnẋiƛúxʷayt ašayƛq'ʷɛ́p anúya."
 "Qúšdyaxa iwát nanúya.
 "Itq'láẋmaẋ qánčiẋbt nanugáqʷamniɫ. 35
 "Nnẋɫuxʷáyda,
 "'Qáẋba dádax dabt itq'láẋmaẋ?'"

Kʷálá aġa Kílipašta nagímẋ,
 "Łángi yaxa láẋlaẋ mə́ɫuẋt?
 "'Naqɫawiġúyamida'— 40
 "aġa ɫẋáẋluymaẋ ɫkíẋaẋ."
Aġa nuẋak'ayáwəlalmẋ.

Aġa wít'aẋ gakɫumílaẋ,
 aġa gán gaɫẋúẋaẋ.

Káwaɫ's wife is dancing.
People are a-coming.⁴

As for those elders,
 they are sitting there by the fire,
 they are chatting about this and that, 5
 they are a-laughing.

After a while someone or other arrived,
 packing their children.
They turn and look.[5]
Kílipašda turned and looked; 10
 she said to Niʔúdiya,
 "Well oh we··ll, the people coming in are workers;
 "they are packing their mauls."[6]

Indeed, James overheard them.[7]
Soon now he said to them, 15
 "Oh yes!
 "You two go on and laugh!
 "If they looked like your own heads,
 "'just like cattle,' it should be said!"[8]

They laughed. 20
 "Who is that one with that sort of head who overheard us?"[9]
Now they laughed even more.
Soon now someone said to them,
 "I wonder when are you going to shut up?"

On another night now Wásusgani went back home.[10] 25
She had a torch.
Now she got lost,
 she called out to no avail:
 no, no one heard her.[11]

On another night she came,[12] 30
 she was telling about it:
 "I was going along here,

"I thought that at this place I would go straight through."
"However, I went in another direction.[13]
"I was getting to quite a number of fences. 35
"I was thinking,
 "'Where is this place that has so many fences?'"

Soon now Kílipašda retorted,
 "Who are you fooling?
 "'Someone had her sleeping out—;[14] 40
 "now someone is turning things around."
Now they laughed and laughed and laughed.

Now again they got after them,
 now they quit it.[15]

Fun-Dances Performed by Visitors

Villages along the Pacific Coast and along rivers thrived in western Oregon, practicing distinct languages and cultures for centuries before the arrival of Europeans.[1] Customary practices of trade were shared during common-place business trips. This short narrative provides an example of how one village group could impact the imagination of another during such occasions. The Clackamas, who marvel at the Kalapuyan fun-dances, attempt to imitate their singing and dancing during one of their own trading ventures outside of the Grand Ronde community.[2]

A Atgíyama qáx̣ba dán alux̌ʷigínmanmama,
 idk'alapuywáykš alux̣iláyda,
 qáwadix atqgúya.
 Aġa alux̣itwíčgʷa,
 aġa alugʷagíma, 5
 "Káwux aġa nčxk'ʷáwa.
 "Łúx̌ʷan dáyax wápul aqmšglwíyučgʷa."
 Âw," aqdúlxam.

 Aġa qáx̣ba aqyux̣anímayax̣dixa idáġayƛ itġʷə́łi;
 aqyuq'ílayax̣dixa, 10
 idə́mqu aqdugixatġʷáya łábla.
 X̣ábixix aġa alux̌ʷáġʷa.
 Aġa atgúyučġʷa.
 Aqux̣ilúčx̣a.

 Dánmax̣ búškš aqdawíx̣a núƛ'max̣. 15
 P'ála alux̣áx̣a.

 Łúx̌ʷan qánčix̣ wápul—
 łúx̌ʷan qíq'ayaq wápul—
 aġa dáxka nugʷagímx̣:
 "Alx̣awix̣áyamida idk'alapúywaykš." 20

B Łúxʷan qáx̣ba gatgíx̣ dabábamat idə́lxam.
 Aġa nugʷagímx̣,
 "X̣ábixix álma alx̣ugiwíyučġʷa."
 Łíxt gałgímx̣,
 "Łán awałglaláma?" 25
 Íxt wiq'íwqt nigímx̣,
 "Náyka álma anglaláma."
 Nux̣ʷak'ayáwəlaləmx̣.
 "Łán ałanƛágʷačgʷa?"
 Áyxt nagímx̣, 30
 "Nayka ananƛágʷačgʷa."

 Aġa x̣ábixix gałuġiwíyučkʷax̣;
 wiq'íwqt niglalámx̣.

 Aġa gaqulámx̣,
 "Ayáq! 35
 "Yaxa aġa anƛágʷačk-aq."
 Aġa nanƛágʷačkʷax̣.

 Qá gałgugigəlx̣ nux̣ʷáx̣ax̣ idə́lxam.
 Kʼʷaƛqí gałə́x̣ux̣.

 Dángi yaxámax̣ búškš gaqiłə́lux̣. 40
 P'ála gałə́x̣ux̣.
 A·'ġa gałx̣k'ayáwəlaləmčk.

 P'ála gałə́x̣ux̣.
 Kawéx aġa galuxʷakʼʷáyumniłčk.

A When they got to a place there where they would go for
 trading things,
 the Kalapuyas would stay there,
 for some time they would stay on.[3]
 Now they would prepare themselves,

now they would say, 5
 "Tomorrow, now we head back home.
 "Perhaps tonight we shall dance for you."
"All right," they would reply to them.

Now they would point them in the direction of a big house;[4]
 they would clean up all around, 10
 wood, they would prepare lots of it.
In the evening now they would come together.
 Now they would dance.
 They would look on.[5]

Some things for potlatch: they would give them little things.[6] 15
 It came to an end.

I do not know when during the night—
 I do not know if it was in the middle of the night—
 now here is what they said:
 "Let us do as the Kalapuyas did."[7] 20

B I do not know where the people went from here.[8]
 Now they said,
 "Tonight, let us dance for them."[9]
One of them said,
 "Who will sing?" 25
 One old man said,
 "Let me be the one to sing."[10]
They laughed at him.
 "Who will frisk around the fire?
One woman said, 30
 "I shall do the frisking around the fire."

Now in the evening they danced;
 the old man sang.

Now they said to her,
 "Hurry! 35
 "Now it is your turn to frisk around by the fire now."
Now she would frisk by the fire.

Such is what they saw the people doing.
That is what they did.

Different sorts of things were given to them for potlatch. 40
 It came to an end.
No·'w they laughed and laughed at one another.

It came to an end.
The following day now they were heading back home.

NOTES

Introduction

1. In 1887 a U.S. census taker filled in "Indian names" for members of Grand Ronde. During this census, the name Kin-i-shi was listed as Victoria Howard's Indian name. As research into Grand Ronde history advances, there may be reasons to prefer this more ethnic name to Howard's European one. However, I am reluctant as yet to adopt a name for such an important figure that was listed only once by a census taker and never appears in Howard's work with Jacobs or in any other Grand Ronde document. We also know from historical documents and from fieldwork by Henry Zenk (in conversation, September 2009) that Howard was commonly referred to as "Victoire," the French equivalent of "Victoria," by community members, confirming she was locally addressed and referred to by her European name. I have no doubt that within her birth family and intimate circles Howard had been given a Native name or names. However, she never disclosed these names to Jacobs, a close Euro-American associate whom she trusted and respected.

2. See "Sarah Gwayakiti" in Olson 2011, 154–56.

3. See "Wagayuhlen Gwayakiti" in Olson 2011, 157–58. The spelling of the Molalla chief's name, Quiaquaty, appeared in an 1855 treaty and has been retained for reference to his wife and to his daughter, Sarah.

4. Jacobs transcribed the Victoria Howard corpus in his field notebooks 51–70 for a total of nineteen composition notebooks of 140 pages each. These notebooks are archived in the Melville Jacobs Papers in the Special Collections of the University of Washington Libraries in Seattle, Washington, and may be consulted there. They are also available on microfilm.

5. Ik'áni is the Clackamas term for myth. Jacobs implies that the formal recitation of myth allows for more flow and even timing, whereas narratives for which there is greater necessity for innovation and personal creativity cause hesitation or stumbling. This note attests to Howard's mastery of both traditional and innovative verbal art. It is taken from JFN 59, 2.

6. Howard's letter to Jacobs can be found in the Melville Jacobs Papers (see note 4 above).

7. Melville Jacobs's renderings of Victoria Howard's performances in text form, or *entextualizations*, in *Clackamas Chinook Texts* were based on his phonetic transcriptions from her fluent dictation some thirty years earlier. Very little of the material from the Howard-Jacobs sessions, unfortunately, was secured in the form of audio recordings, except for spirit-power songs. Jacobs transcribed

the linguistic matter of Howard's verbal performances into composition note-
books and, following each performance, translated the Clackamas into English
with Howard's assistance. Translations are placed between the lines of the
Clackamas version. Jacobs's notebooks include various remarks concerning
the performance as well as semantic and morphological interpretations of the
Clackamas forms, placed between the lines of the Clackamas version, in the
margins of the page, and on the page facing the original version. Practically all
of these notes are found in the endnotes of *Clackamas Chinook Texts*.

8. Chinookan languages are polysynthetic languages, not comprised of words
that have isolatable meaning with regard to a single grammatical function as
we know them in analytical languages such as English. Verbs are complex,
consisting of a sequence of morphemes (prefixes, roots, and suffixes) whose
meanings are determined by their position in the sequence; such verbs express
fully predicated thoughts as in a complete sentence in English. A verb may be
supplemented by separate noun phrases (NP) that establish the subject, the
object(s), or both (which are designated by pronominal elements in the verb).
Particles may function as adverbs, adjectives, circumstantial complements,
such as temporal and spatial markers, or modal auxiliaries.

9. Another difference between Chinookan grammar and English grammar is
found in the operative role of the actor or "doer" of the verb with respect to
grammatical agency. In Chinookan languages, characterized as "ergative," a
sharp distinction between transitive and intransitive verbs is marked in subject
and object pronouns. In "accusative" languages such as English, on the other
hand, the grammatical form of the subject or nominative case is not affected
by (does not depend on) the transitivity of the verb. In other words, transi-
tivity is not formally reflected in subject and object pronouns. Generally, we
observe that in ergative languages the subject of an intransitive verb operates
in the same way as the object of a transitive verb. It would be more precise to
say that ergative languages configure "agents" as opposed to "subjects," the for-
mer highlighting agency, while the latter focuses attention on (nominative)
subjectivity. The grammatical expression of transitivity in Chinookan makes
agency explicit: does the agent transfer action to a grammatical patient (erga-
tive pronoun + absolutive [direct object] pronoun, hence a transitive verb) or
not (absolutive pronoun, hence an intransitive verb)?

10. See CCT, 4–7. There are exceptions in my use of Jacobs's phonemic system. For
typographical convenience, I have substituted ġ and x̂ for the Americanist use
of dots below these letters (g and x). Also, out of typographical preference, syl-
lable stress is marked just above the vowel of the stressed syllable as opposed
to Jacobs's practice of placing it after the vowel.

11. This line of inquiry into literary competence gained significant methodolog-
ical thrust with advances in the "ethnography of communication" (Gumperz

and Hymes 1972, Hymes 1974, Bauman and Sherzer 1974) and with Hymes's notion of performance competence (Hymes 1981, 79–141).

12. See Hymes 1983 for an excellent analysis of Howard's focus on the feminine. For texts on generation-specific discourse, see "Seal and Her Younger Brother" (in the present work and in Hymes 1981), "Two Maidens: Two Stars Came to Them," and "Restrictions on Women" (also included here).

13. In cases where descriptions or episodes were dictated after a discourse was completed, these inserts are marked in italics in the present volume. The intention is to make a distinction between a flow of spontaneous discourse and units added during the editorial process.

14. Examples of literary features are pointed out in endnotes to the texts reproduced here, although these are kept to a minimum. The analytical models that I have used to work out the formal designs of the current edition will be discussed in forthcoming works of a more academic nature, in hopes of further advancing understanding and appreciation both of Howard's poetic achievement and of Native American Northwest Coast literatures in general. In the present volume, I wish to encourage readers to seek out designs and features in ways that will inspire and stimulate interpretation and lead to appreciation of Victoria Howard's artistry and worldview.

15. In Hymes's usage, the term "verse" refers, not to the metric units and rhyme schemes of phonologically based poetic analysis, but to features such as grammatical or syntactic parallelism, rhetorical devices, or turns of speech. Thus, for example, a line may consist of a verb and its subject or object, a verse (a group of lines) may consist of a sequence of clauses of quoted speech in direct discourse, and a stanza may correspond to an event. The search for verse form in the Hymesian sense is a search for discursive logic that may be dominated by semantics, grammar, narrative form, or a purely stylistic feature used for balance or enhancement of meaning.

The Wagʷə́t

1. This performance is found in JFN 61, 82–84, CCT, 533. The wagʷə́t is a bird whose song could be heard by the Clackamas in the early morning. According to a note inserted in JFN, the singing began around "1 or 2 am," which is just before astronomical twilight in Portland, Oregon. Unable to identify the name of this bird in Latin or English terms, Jacobs and Howard translated it as "the early dawn bird." The title of the notebook entry for this piece is "Power wagʷə́t bird," which becomes "The bird heard at dawn" in CCT. The title in this book is intended to capture the symbolism of the bird's singing as it played out in the daily life of Victoria Howard's maternal grandmother, Wagayuhlen Quiaquaty, and others inspired or empowered by the spirit-power of this early-morning singer.

2. Jacobs pays careful attention to Howard's use of vowel prolongation in her performances, marking them as explained in his introduction: "Raised dots after a phoneme indicate lengthening for rhetorical purposes, as in adi·ˑ···, 'oh dear me!'" A peak tone is also marked in these prolongations with a stress accent. These markings are transposed in English translations.

3. These two elements, *aġa* and *nčuya*, are combined in the CCT edition, possibly indicating a liaison in pronunciation (CCT, 533) rather than a typographical error.

4. This narrative describes a lifestyle of consistency and simplicity, reflected in its form as well as its content. It is also illustrative of certain characteristics of Chinookan syntax, as reflected in the following description by Walter Dyk: "This structure, or verb complex as it has been called, is a tightly knit formal unit in which every element has its definite place and function. The composition of these elements, so often of the merest phonemic content, presents an example of regularity, simplicity, and economy hardly equalled in any other language" (Dyk 1933, 83).

5. Note the neat two-part structure of the narrative voice in the first segment and Howard's maternal grandmother's voice in the second.

6. The adverbial *sámniẋ* marks a condition commonly translated with *if* ("if this, then that"). Jacobs places "we heard" to read "when we heard" to specify the condition upon which the people would rise. In his notebook, he places "we'd hear it" under the transcription of *gʷə́tgʷə́t*, implicit in the onomatopoeic utterance. In the present translation of this text, I have made the condition explicit by using *hearing*, though the verb *hear* is not used in the original Clackamas version. People would rise when they heard the singing of the *gʷə́tgʷə́t*.

I Lived with My Mother's Mother

1. JFN 69, 113–17. CCT, 534–36.

2. Jacobs specifies in an endnote that "Mrs. Howard was born and brought up at the Grand Ronde Reservation." He also writes, "I would have liked an autobiography and I tried to get one. But Mrs. Howard never seemed in a mood to describe her life in detail. Possibly I was too young for her to feel like revealing inward things, or perhaps I failed to handle the relationship in a manner which made clear what I wanted and how she could present the story of her life" (CCT, 656, endnote 506).

3. Victoria Howard's mother married Foster Wacheno.

4. Jacobs provides the following details about Wagayuhlen's medical practice: "She sat beside the patient, then 'warmed' that patient without singing or dancing unless she judged that the person was extremely ill. She doctored men, women, and children" (CCT, 656, endnote 507).

5. We find these formulaic instructions given by a grandmother to her son's daughter in a myth-telling by Howard (CCT, 435).

6. The phrase *kinwa ɬx̣lúwida* translates literally as "in vain strangers," implying that it is in vain to refer to them as strangers or to speak of strangers. I have kept Jacobs's translation, "Even strangers [are] our people," to retain the simplicity of the original as well as the two-part structure, which establishes a stylistic parallel between the two lines (42–43). A colon has been added to mark the parallel between the two nouns (*stranger* and *our people*). "In vain 'strangers': they are our people" and "They are not 'strangers,' but our people" provide translations that are closer in grammatical semantics to the original.

7. This narrative has the flow of nostalgic stream of consciousness while, nonetheless, unfolding in four distinct themes fitting together neatly into a whole: 1) she provides a general overview of childhood, family, and household; 2) she zooms in on the career of her grandmother, the maternal figure who shaped her cultural and moral character; 3) the grandmother relates her work experience; and 4) Howard describes the moral principles that shape the character of her grandmother.

Summer in the Mountains

1. JFN 52, 105–9. CCT, 489–90. Jacobs states in an endnote that this text "is poor for linguistic purposes because it is one of the first texts dictated" (CCT, 647, endnote 421). Though I detect no grammatical or semantic flaws, Jacobs may be referring to the unevenness of the episodes and the lack of narrative development, which is unusual in Howard's recordings.

2. The guiding theme of this text is clearly a description of summer preparations for winter. Despite the seeming lack of a narrative or poetic configuration, the performance is structured. It begins with two lists: family members in stanza 1 (Howard's uncle, most likely Moses Allen; Howard's mother, Sarah Quiaquaty Wacheno; Howard's maternal grandmother, Wagayuhlen Quiaquaty; and Howard's aunt-in-law, perhaps "Lucy" or Mary Ann Jones [see Olson 2011, 69]) followed, in stanza 2, by a list of the steps in preparing the meat and hide of a deer. Stanza 4 presents the activity of preparing berry-cakes, as carried out by Howard's mother, in a more elaborate series of acts. The final stanza provides closure. This formal segment adds a temporal dimension, "a long time," and states the purpose—preparing food for the winter—of such traditional summer gatherings and hunting trips in the mountains.

My Grandmother Never Explained

1. JFN 66, 24. CCT, 493.

2. The particle *lux̌ʷan* is used to express the pondering of an unknown. Its repetition in lines 8 and 9 insists on the young Victoria Howard's lack of knowledge of the birthing process. This repetition is paralleled with the repetition of *nêšqi qánčix̌* in lines 12 and 13, in which the young Howard is "never told"

and "never asks." This ending lends weight to the overall theme of education, or rather non-education. These elements serve to weaken the authority of the adult's explanation, "The child's intestines might wrap around you," revealing an antagonism between the young Howard and her elder.

3. Jacobs specifies with a text insert that the mother-to-be goes into labor (CCT, 493).
4. The binary structure, observed in three parts of this short text, reflects a natural event, its mystification by adults, and a child's curiosity about the reality. The parallel drawn between being placed in the dark under a blanket and being kept in the dark through a lack of information is powerful and provocative.

Weeping about a Dead Child

1. JFN 65, 25–28. CCT, 502.
2. At the time of this incident, many Grand Ronde children were dying of disease. Wagayuhlen's tears are reflective of an influenza epidemic that hit hard among Native Americans. As part of her narrative purpose, Howard shows that, as a young child, she was not entirely conscious of the sorrow and suffering that these deaths had caused. She was nonetheless attentive to her grandmother's practice of tradition, and she would live to pass on her family history.
3. Jacobs specifies in a text insert that this was late afternoon (CCT, 502).

A Molale Hunter

1. JFN 59, 38–40. CCT, 559. The greater part of this narrative is told by Howard in the voice of her maternal uncle, Moses Allen, lending a stronger sense of his presence and rendering the discovery of the beast that frightens him through his eyes. Howard's text focuses our attention as much on her uncle telling the story of this frightful event, and his unlikely experience of fear, as on the event itself.
2. Jacobs uses a mid-line dot to signify the prolonged n- and m-sound. In the present editions, I replace the dot with repeated *m* and *n* as is commonly used with prolongations of these consonants, retaining nevertheless the mid-line dot for vowel prolongations.
3. Jacobs clarifies in text inserts that Moses did not see anything "frightening" or hear anything "scary" during any of his other hunting trips.
4. Jacobs specifies in text inserts that Moses uses "big chunks" of bark "from a dead fir" and places them "against a tree" (CCT, 559).
5. Howard provided information about her uncle, his hunting trips, and his mighty character, edited in this endnote by Jacobs: "Mrs. Howard's Molale uncle would stay out two or three nights, sleeping under chunks of bark from a dead fir; he leaned the bark against a small tree. It was just enough to sleep under. He might spend two or three nights before returning. Among his spirit-powers were eagle and rattlesnake. His eagle spirit-power gave him ability to

hunt with ease and to get anything else he wanted. He used to play with impunity with rattlesnakes" (CCT, 661, endnote 541).

6. Jacobs provides the following narrative details in an endnote: "Mrs. Howard added that it was fortunate for him that this snake, with the head of a deer and forepaws, was turned slightly, so that it did not see him. Otherwise, it might have pursued him. That day he proceeded to another place for his hunting. No one else ever reported seeing this creature. He himself never saw it again although he returned to the place on later hunting trips. He said that this was the only time in his life that he saw or heard anything untoward, or was actually frightened, while on a hunting trip" (CCT, 661).

A Shaman Doctored Me

1. JFN 67, 54–58. CCT, 510–11.
2. Šə́mxn ("Shimkhin" in Olson 2011, 326) was a powerful shaman who transformed his gender identity from male to female following the intervention of a spirit-power. She was known as Qánat'amax̣ (see "A Tualatin Woman Shaman and Transvestite" in this volume), and her American name was Jack Nancy. For a biographical portrait of Shimkhin, see Olson 2011, 326–28.
3. Jacobs states in an endnote: "Among other features of expressive content in this dictation, note especially the last sentence with its clear expression of acceptance of the fact of deadly hostility of an older woman toward her daughter-in-law" (CCT, 650, endnote 456).
4. The onomatopoeic verbalized particle *wãx*, very similar to Howard's duplicated form in Clackamas, *wáx̣wax̣* (pour), is identified by Franz Boas in Lower Chinook. Boas offers the following insight into languages with a significant use of onomatopoeia: "It seems likely that, in a language in which onomatopoetic terms are numerous, the frequent use of the association between sound and concept will, in its turn, increase the readiness with which other similar associations are established, so that, to the mind of the Chinook Indian, words may be sound-pictures which to our unaccustomed ear have no such value. I have found that, as my studies of this language progressed, the feeling for the sound-value of words like *wãx* TO POUR, *k·!ē* NOTHING, *k!ǫ̃mm* SILENCE *Lō*, *pā́ᵋpā́ᵋ* TO DIVIDE, increased steadily. For this reason, I believe that many words of the miscellaneous class conveyed sound-associations to the mind of the Chinook Indian" (Boas 1911, 629).
5. Jacobs provides a text insert specifying that the mother-in-law's indications were to wash her eyes (CCT, 510).
6. Jacobs tells us in a text insert that Howard's father's aunt was "a shaman named Šə́mxn" (CCT, 510). Šə́mxn is the shaman in "A Tualatin Woman Shaman and Transvestite" (see this volume).

7. Šə́mxn suggests here that a spirit disease-power has invested the patient (Jacobs text insert, CCT, 510).

8. The shaman is suggesting that the patient should have fasted (Jacobs text insert, CCT, 510).

9. Jacobs provides the following interpretive comment relating to the doctor's suspicion of Howard's mother-in-law's intentions: "Among other features of expressive content in this dictation, note especially the last sentence with its clear expression of acceptance of the fact of deadly hostility of an older woman toward her daughter-in-law" (CCT, 650). Howard, indeed, leads us to believe that her mother-in-law placed the disease-power in her head.

I Was Ill, Dúšdaq Doctored Me

1. Jacobs transcribed this text in JFN 58, 119–33 (CCT, 523–26). Jacobs informs us, in endnote 482, that Howard "worded the title" (CCT, 654).

2. The honorable shaman Dúšdaq (anglicized by Olson as "Dushdak") was also known as Dr. John Smith by Euro-Americans. See Olson 2011, 429–31. I have kept the Jacobs spelling as an original form of writing personal names, an ethnographical occasion for promoting written Clackamas culture. "Dushdak" is an equally interesting form, and we may hope that the anglicized name for this important figure in Grand Ronde history will be as catchy as "Jack" is, as a version of the French name "Jacques."

3. In addition to the parallel drawn between Dúšdaq's two-line discourse in lines 55–56 and 60–61, we identify a sound pattern between the verb roots -kšd (to look on) and -qšt (biting on it). These parallels compare the dog sensing Dúšdaq's spirit-power to the Umpqua shaman hoping to gain insight into his skills by attending the spirit dance and looking on. Dúšdaq draws a parallel between the dog and the shaman as a way of insulting the shaman.

4. *Búškš* is the Clackamas term for *potlatch*.

5. "Mrs. Howard told this about herself. She was eighteen or nineteen at the time referred to in the text. She had married at fifteen, and at sixteen she had had her first child, a girl. Although this text contains a number of details about shamanism, a fuller discussion should feature an ethnographic sketch of Clackamas" (CCT, 654, endnote 482).

6. A note in Jacobs's notebook informs us that the fire came from a "stove-heater" (JFN 58, 121), and Jacobs specifies in a text insert that Dúšdaq spit the disease-power into the fire (CCT, 523).

7. Though Dúšdaq advised that the patient might not get well if the family did not dance for her, he did not state explicitly that she would get well if the family did dance. This is precisely what Sarah Quiaquaty Wacheno is asking him. These exchanges between the doctor and his patient's family reveal that the doctor, despite his good reputation, does not assume full authority for medical decisions.

8. Jacobs indicates that, at this point, Dúšdaq would grin and laugh, "Háhə́hə́hə́hə." Jacobs does not specify why Dúšdaq laughs when his patient's mother asks for reassurance of the efficacy of the therapy that he is proposing. Perhaps he is laughing at her skepticism; perhaps it is an expression of contentment over her acceptance of the treatment. Jacobs shares the following insight concerning Dúšdaq's distinct laughter: "This Tualatin shaman then grinned and laughed *háhə́hə́hə*. According to Mrs. Howard, who did not speak a Kalapuya dialect but who doubtless understood many Kalapuya words, *hə́* may be a cognate of Tualatin *hếʔ*, 'yes,' rather than a peculiarity of the man's speech" (CCT, 654, endnote 483).

9. The people of Grand Ronde were invited to participate in the power dance as an integral part of Dúšdaq's treatment of his patient. This practice of group singing and dancing during a patient's convalescence is surprising to Westerners, who are instructed to be quiet and get rest when recovering from illness. One may gather from the narrative that whatever infection Howard had suffered had completely passed and that, at this point in her recovery, she would need to build strength and resistance against further disease-power. The goodwill of her friends and neighbors, expressed in this culturally appropriate way, must have served to improve her morale and her focus on getting better.

10. Dúšdaq's presence at the power dance was a paid service. Jacobs specifies in a text insert that the shaman attended the dance "in order to 'look after everything' with his spirit-powers" (CCT, 524). As we see in the text, he also treats his patient during these evenings of singing and dancing.

11. Howard elaborated the following contextual information about Dúšdaq's medical practice and about the practice of spirit dances more generally: "*Dúšdaq* was there each night, but such a shaman doctored only during the first two or three nights. He was the first to come forward, during the evening session, to sing his own spirit-power songs. The first night, only a few persons came and everyone went home early. Attendance increased each night until the house was crowded during the fifth and last session. If a person became ill during the summer, a series of five nights of shamanistic therapy would not be undertaken for him unless he survived until well along in the autumn. Each person came forward and sang his own spirit-power songs exactly as in ordinary winter spirit-power dances" (CCT, 654, endnote 484).

12. Howard added, during the translation of the narrative, that the people would dance another hour or two after Dúšdaq sang his power songs. Jacobs noted this information in the field notebook (58, 123) and included it as a text insert in his edition of the text (CCT, 524).

13. Jacobs provides information about the visitors and about Dúšdaq's powerful influence in this annotation: "*Dúšdaq* scared off the dog. An uninvited shaman, an Umpqua Athabaskan woman named *úbidi*, from a group which at one time

lived a few hundred miles to the south of the Columbia River in southwest-ern Oregon, was one of three Athabaskan women shamans who came inside during the evening. Mrs. Howard's stepfather did not fear them. He welcomed *úbidi*, probably the other two Athabaskan shamans also, because of the secu-rity which he and the family felt in the presence of *dúšdaq*. That gentleman had frightened away the spirit-power of whatever shaman he reported had been sending it inside to see what was happening there" (CCT, 654, endnote 485).

14. Jacobs relates the following in an endnote: "*Dúšdaq* had already seen, in his dreaming, that such a shaman was coming. Sure enough, she entered presently, carrying eagle tail feathers just as he had predicted" (CCT, 654, endnote 486).

15. Dúšdaq's wife's name was Niʔúdiya. Jacobs records this in a text insert (CCT, 525).

16. Note the narration, condensed into three two-line verses (lines 78–83), of the three most important spirit-dance participants as they take turns singing, fol-lowed by an elaborate three-verse description (lines 84–88) of the Umpqua shaman's singing, ending with Dúšdaq's mockery of her. These two stanzas are thus framed, first, with the powerful shaman's singing and, last, with his unfailing show of confidence while observing his opponent's spirit powers.

17. It is specified in a text insert by Jacobs that it is the "uninvited Umpqua" sha-man who now takes a turn at singing (CCT, 525). Jacobs also notes the follow-ing details about the performance of the shaman, in his field notebook, as provided by Howard during the translation session: she was "full of power, loosening her hair, mad with power coming" (JFN 58, 127).

18. The symbolic meaning of this gesture is explained in the following endnote edited by Jacobs: "A person with an eagle spirit-power, like the one which *úbidi* had, would dance with eagle feathers held in the hand, tied on the upper arm, or fastened in the hair" (CCT, 654, endnote 487). Jacobs also inserts in the edited text that Úbidi held the feather like a fan (CCT, 525).

19. Clarification of these narrative events is found in this endnote, edited by Jacobs based on his discussions with Howard: "Mrs. Howard said that he had cleverly placed his spirit-power outside near the entrance. There it sat invisible but standing guard all through the dance. The uninvited Athabaskan women shamans, who came each evening, failed to see his spirit-power outside there, where it protected the people from anything which the women shamans might try to do with their supernaturals" (CCT, 654, endnote 488).

20. Howard's imitation of Dúšdaq's peculiar laughter, "Hə́hə́hə́hə́hə́," is included as an insert in Jacobs's edition of this narrative in CCT. It appears in JFN 58, 131 as a note provided by Howard during the translation: "whatever he said, then he laughed Hə́hə́hə́hə́hə."

21. Dúšdaq is referring to the spirit-powers that the Umpqua women brought with them to Howard's mother's place. It is only through their spirit-powers that

they might have hoped to get a glimpse into the great powers of Dúšdaq: "a spirit-power which they might steal then" (Jacobs text insert, CCT, 525).

22. Foster Wacheno married Sarah Quiaquaty, Howard's mother, after her first husband, Howard's father, died. Howard married Wacheno's brother, Daniel Wacheno, making Foster both her stepfather and her brother-in-law. Howard pays tribute to him in her narrative, relating that he nobly assumed both roles during her severe illness and recovery.

I and My Sister-Cousin

1. JFN 59, 42–50. CCT, 536–38. Jacobs provides the following information about the recording of this text in an endnote: "Since Mrs. Howard was about sixty years of age in 1930, the event which is narrated here could have occurred in the period between 1880 and 1885. Mrs. Howard pressured me to let her tell this little narrative about herself. I did not know what she was planning to dictate. She phrased the title" (CCT, 656, endnote 508). For a study of the contextualization of this performance, see Mason 2017.

2. X̣ax̣šni, also known as Eliza Johnson, was Howard's maternal cousin and around twenty years older than she was. For more biographical information, see Olson 2011.

3. We learn from Jacobs, in an endnote, that the morpheme *-kiwtan* is Chinuk Wawa for *horse*, to which he adds, "Observe that *x* alternates with *k* in Chinook" (CCT, 657, endnote 510). He points to the form *-xyutan*, as found in this line and commonly used in the text (CCT, 657). Note the spatial point of view in these five lines, leading from physical movement of the narrator to her direct view of the dead horse without a verb indicating her act of seeing. This incites visualization of this tragic event in the audience. This narrative strategy draws attention to the death of the horse as triggering the main action, namely the transformation of the cousin. This type of spatial alignment of audience point of view with the narrator's point of view is a common feature of Howard's style.

4. Note the formulaic progression of "went-went back-arrived" that provides a variation of a pattern commonly used to begin new episodes in Clackamas myth-telling, "went-went on-arrived" (see Hymes 1981). Likewise, the primary use of the verbal tense marker *ga-*, expressing the remote past, gives this narration a mythical narrative quality. Added to these features, we count forty-three occurrences of the rhetorical suffix *-x̣* attached to the verb phrases of this ninety-seven-predicate text. The solemn topic of death combined with the manifestation of spirit-power is enhanced by the formal qualities of Howard's style.

5. This verb phrase, *Gagnulx̣ámx̣*, "she told me," is left in suspension. It is followed by a brief description of X̣ax̣šni's small backpack, indicating that she had not given all of her things to her cousin to carry on the surviving horse. The incom-

plete discourse phrase suggests that the backpack came as an afterthought. Howard implants it as an indication that she is not comfortable with her cousin's appearance and of the fear rising in her as a young woman. The phrase is later repeated to introduce the brash commands of her cousin. Dashes have been used to signal the inclusion of the backpack as a parenthetical thought.

6. Note the sound patterns (*ga/ga-nag/nuxk-qaẋ/waẋ*) that draw a stylistic parallel between these last two lines. The alliteration and perfect rhyme serve as an echo of Howard's compliance to her cousin's will and Howard's personal transformation.

7. A note from Jacobs's field notebook tells us that Howard and her cousin went camping to pick blackberries near Mt. Hebo, near Grand Ronde (JFN 59, 42). He also notes that Howard was somewhere between twelve and fifteen years old, which indicates that these events probably took place before her marriage.

8. Jacobs notes in his field notebook, "we left Gr. Ronde at noon on horseback" (JFN 59, 42). Jacobs provides the following information about Howard's cousin in a footnote: "Her cousin *Ẋaẋšni*, who was her comrade on this trip, died long after, during the influenza epidemic of 1919. That woman was part Clackamas and part Chinook. Her husband was a part Klamath who spoke perfect Clackamas. Her daughter *Waġánwəs* was the last wife of Frank Wheeler, a Kalapuya" (CCT, 656–57, endnote 508).

9. Howard tells Jacobs that the other people camping in the area included Louis Kenoyer's mother, Dick Tipton, and Bill Warren (JFN 59, 42). Jacobs includes this information in an endnote to the text, to which he adds, "Louis Kenoyer was my informant in Tualatin Kalapuya research in 1936 and his father had assisted Dr. Albert S. Gatschet in 1877" (CCT, 657, endnote 509).

10. Jacobs informs us in a text insert that Ẋaẋšni imagines that her horse will find water at a nearby spring (CCT, 536).

11. A note in Jacobs's field notebook indicates that the horse "was stiff and swollen-perhaps it swallowed something in the water" (JFN 59, 42).

12. The same spatial strategy of visualization is used here, echoing the first instance of discovery and aligning the cousin's viewpoint with the narrator's, as well as with that of the audience. This common visual plane arouses anticipation of the cousin's reaction and heightens the tension over what is to come.

13. Ẋaẋšni is referring to her daughter, identified by Jacobs in a text insert as Waġánwəš, or Mrs. Frank Wheeler (CCT, 537). See Olson 2011.

14. Jacobs's clarification: "At each step, as the cousin hit the ground with her cane, she blew vigorously, ha. Such puffing, blowing, and steaming along frightened Mrs. Howard. The cousin must have had a grizzly-sprit power! In Mrs. Howard's mind her relative and companion may have been on the verge of metamorphosis into a grizzly" (CCT, 657, endnote 511). Note the elaborate stylization of Jacobs's edited note compared to his field note reproduced here: "everything

time, at each step, as she put down the cane, she let out a forced breath ha ha ha ha. This scared Mrs. H." (JFN 59, 48).

15. It is remarkable that Howard's concern for her cousin's well-being never wavers despite her fears and the abrupt manners of her cousin. In the field notebook, we read: "this last time Mrs. H. confesses she felt pretty uneasy about X̣ax̣cni, the way she was coming along, fearing with her grizzly power that she would really turn into a veritable grizzly" (JFN 59, 50). Note the /c/ in X̣ax̣cni, a phonemic symbol used in Jacobs's field notes, changed to /š/ in CCT.

16. Howard does exactly as her cousin has instructed her. This stanza parallels lines 83–85, tightening the narrative structure and emphasizing the tense complicity between the cousins. What seems to be a mere detail in the development of the conflict serves as the dénouement to the climax. In many ways, this narrative may be read as Howard's means of coming to terms with her cousin's personality and the spiritual forces at work in an experience of death and despair.

17. Jacobs provides the following rhetorical interpretation of Howard's use of style in this narrative: "Note the understatement, or avoidance of explicit statement, in Mrs. Howard's proffered dictation. Obviously, she dictated this in order to point up the fact that her comrade could turn into a grizzly and probably did so during the scary return from the berry patch. But the thought was implicit. Mrs. Howard did not say, in so many words, that her cousin was a real grizzly for an hour or two during the journey downhill. Both the belief and Mrs. Howard's manner of discussion of it are significant" (CCT, 657). Concision or verbal economy is, in fact, characteristic of Chinookan languages, and this text is very much in keeping with a more general style of myth narrative.

A Tualatin Woman Shaman

1. This text was edited by Jacobs from two separate recordings, marked as A and B in the present edition. Jacobs transcribed them in JFN 67, 32–34 and 48–52 respectively and edited them for publication in CCT, 517–19. Other memories of Qánat'amax̣ include a song that she prescribed to the young Victoria, sung to her by her father as a treatment for bad dreams (see JFN 51, 9). Howard also recorded a lullaby that she learned from her "father's aunt," mostly likely Qánat'amax̣ (JFN 51, 42).

2. Jacobs specifies, "A woman shaman doctored irrespective of the sex or age of the patient. The Tualatin woman shaman of this text was the sole shaman Mrs. Howard recalled who employed burning pitch brands in her therapy" (CCT, 652, endnote 472).

3. These are the Tualatin names (anglicized as Kanatamakh and Shimkhin by June Olson [2011, 326–28]) of this well-known Grand Ronde doctor. Howard's attention to the details of Shimkhin's medical practice, as well as her appear-

ance in other sources, indicates that her work was highly respected in the community.

4. This is the end of the first narrative dictated by Howard. Hereafter begins the second narrative. The two are edited together by Jacobs as a whole.

5. Jacobs adds a description of the *išə́qała* (*shadow*) in a text insert: "a 'dark thing' which is of dead persons or of their things" (CCT, 518).

6. The medical shaman in this narrative is Howard's great-aunt on her father's side. Jacobs adds in a text insert that she is "also a transvestite" (CCT, 517). In modern times, a transvestite (the term used by Jacobs) is referred to as a cross-dresser. Though nothing is said of Šə́mxn's fashion habits, Howard refers to her with gender-specific pronouns and a gender-specific family role, indicating that her great-*aunt* has assumed a new gender. Howard's elaboration of her aunt's doctoring technique and her interaction with her patient's family is suggestive of a strong admiration of her relative. Considering this, along with other references in Howard's Clackamas corpus to Qánat'amaẍ's presence in her intimate life, we may easily assume that the older woman played an important role in Howard's life. The peculiarity of her eating habits clearly left an impression on Howard, who uses the detail to evoke the personality of a powerful, insatiable Tualatin shaman. See "Eating Weakens Spirit-Power Strength," CCT, 519–20.

7. We learn that Qánat'amaẍ had more than one spirit-power from Jacobs's text insert (CCT, 517). One of her powers gave her instructions to wear a dress.

8. Jacobs specifies in a text insert that this would be said to the patient's relatives (CCT, 517).

9. "That is, when some emissary of the sick person's relatives or one or two of the latter approached this Tualatin woman shaman in order to obtain her services, they at once gave her, during nineteenth century reservation decades, a horse, cattle, or other things of value. They also indicated what her total remuneration would be in case of successful treatments. Such additional pay was given after the patient's definite recovery" (CCT, 651–52, endnote 469).

10. Jacobs tells us, "She had a prodigious appetite and, unlike any other shaman known to Mrs. Howard, she ate, in fact she always gobbled, immediately before doctoring. Other shamans ate, very likely in the morning, before they left home to go on a doctoring job. But where they doctored all day they would never eat until they were through working. Doctoring took from four to six hours. Mrs. Howard also recalled the name of one of the dogs, a male, which belonged to this woman: *kúli*. Mrs. Howard thought that this could be a Tualatin dog name. It was probably not a dog name which Clackamas used" (CCT, 652, endnote 470).

11. Note the ellipsis of Qánat'amaẍ's doctoring and hence the narrative focus on her appetite. In an endnote, Jacobs informs us that "Excepting only, to Mrs.

Howard's knowledge, the Tualatin woman berdache and shaman, *Šə́mxn*, who ate before she doctored" (CCT, 653, endnote 476).

12. Jacobs includes ethnographic background in the following footnote: "Since they knew that this Tualatin woman might doctor with burning pitch brands, the people of the sick person's family or settlement would then seek pitchwood in an old log. They would split long fine strips, like kindling, as much as three feet long, and they would tie bunches of such strips, perhaps as many as five such bundles for one seance. The woman used a pitch-strips bundle, burning vigorously, as one of her several techniques of treatment, probably as a recourse when other means seemed to her to be unavailing. The burning brand brushed away a poison-power which a dead person, according to native theory, had placed in the patient at night somewhere" (CCT, 652, endnote 471).

13. Jacobs specifies in a text insert that the wood was split "like kindling, into three feet long strips" (CCT, 518).

14. Jacobs explains in a text insert that Qánat'amax̱ would use the burning wood to brush away "a poison-power that had been placed over a patient by dead persons" (CCT, 518). The present edition uses the term "wave," as in "wave away," due to its appropriate use without a grammatical object.

15. This was done "in order to tear off the dead person's shadow from him." Jacobs, text insert (CCT, 518).

16. Jacobs, text insert: Qánat'amax̱ would examine her patient by "feeling around his body, and warming him but without singing" (CCT, 518).

17. A text insert in the Jacobs edition specifies that a "poor cover was used because it might be burned by her lighted brand" (CCT, 518) and in JFN we read, "They'd cover him over with some old cover lest a good cover be burned by the pitch" (JFN).

18. Howard provided details of her great-aunt's medical practice, which Jacobs sums up in this footnote: "This song, recorded on Ediphone cylinder 14546a and dubbed on tape 11, has no words, only so-called nonsense syllables: *aha?a·'hi·' hi·. Hi·hi·hi·* was uttered three to five times. The song belonged to the woman shaman named *Šə́mxn*. She used it when she employed a lighted bundle of strips of pitchwood to brush away a dead person's 'shadow' which had been placed on the patient at night. The dancing and singing shaman rapidly swung the flaming brand back and forth in front of her and over the patient, who lay before her. She sang five times on each occasion that she sang it, if it appeared to be effecting a cure. If the patient perspired she examined him to determine if her therapy was availing. The sweating indicated probable effectiveness. After the second treatment, involving singing and using a burning pitch brand to brush away the dead person's shadow, the patient's failure to perspire might warrant her in not proceeding to a third, fourth, and fifth repetition of the treatment during the night. She would cease for the night. But she would try again on the following night. If the patient became ill during

the daytime, she would do her doctoring in daylight hours. If the patient had become ill in the evening, her doctoring would be undertaken in the evening. However, she and other shamans supposed that night doctoring was more often indicated, because dead people usually came around at night. A frequent cause of illness was, indeed, a dead person's shadow. The woman shaman of this text feared that her patient might die if the pitch brand went out before it had burned completely: 'That was her sign.' But if the brand went out, she took another and fresh one and used it, hope struggling against fate, during another round of singing and dancing" (CCT, 653, endnote 473).

19. Jacobs notes, "she'd jump way off the ground" (JFN 67, 50), reiterated in a text insert (CCT, 518).

20. Covered "by the shadow," Jacobs specifies in a text insert (CCT, 518).

21. The number five (*g̊ʷénmix*) shapes a ritual formula used by Qánat'amaẋ in her healing. Howard provides the following details of her ritualistic procedure, edited as an endnote by Jacobs: "Each time would be punctuated by a stop and the giving of further directions. Then, another song and dance and brushing five times around the patient, another halt, with perhaps additional directions to the people who were present, and so on" (CCT, 653, endnote 474).

22. More ethnographic details are provided in this endnote by Jacobs: "Following the therapeutic seance, Šómxn was given another meal. If her patient died, she returned everything that had been presented to her for her services. However, the people might then give her 'some little something' for her efforts in coming and doctoring. In such an instance, the small gift or token payment might be some beads or a single blanket. If her therapy really cured, she received far more" (CCT, 653, endnote 475).

My Mother's Last Illness

1. JFN 68, 61–69. CCT, 512–14.

2. An elaborate use of discourse and temporal markers serves in the structural design of this narrative build-up. The verb root *-kʷlí* refers to a form of discourse that involves transmitting information, hence the use of "to inform" in line 19, retained from Jacobs's translation, when referring to consulting a doctor for a medical opinion. Sarah uses the transitive discourse marker *-lxám*, "to tell," at the end of this stanza, asking her brother to come back and *tell* her what the doctor *tells* him concerning his availability (lines 27–28). This elaborate discussion between the patient and her brother demonstrates the amount of thought that went into soliciting a doctor at Grand Ronde, and perhaps in traditional Native cultures in Oregon. Within the narrative development, the family dialogue places emphasis on the family's hesitation to call in a doctor, possibly due to financial difficulties. Repetition of the temporal marker *íyaʼlqdix*, using an expressive intonation in the first two stanzas, establishes this hesitation as

a significant component in the narrative meaning. The same adverbial, *íyaⁿ̓q-dix*, is uttered twice by the doctor to inform the family that his intervention has come too late to save his patient, establishing hesitation to call a doctor as not only a running theme in the narrative but also as a partial cause of death.

3. Jacobs's endnote: "This one of Polk Scott's doctoring songs is on Ediphone cylinder 14547e and dubbed on tape 11. I failed to note with accuracy the so-called nonsense syllables which accompanied the melody. They were approximately *u···hámi···há, ha···hámi··*" (CCT, 650, endnote 460).

4. Lines 64 and 65 provide Clackamas and Chinuk Wawa versions of the same event, consecutively. Jacobs tells us, in an endnote, that line 65 reiterates "the exact words which Scott used." From this same endnote, we learn that "Polk Scott did not speak Clackamas. He usually used Chinook jargon, as did everyone who lived at the Grand Ronde Reservation during the middle to late nineteenth century. The jargon words which are italicized are the exact words which Scott used, according to Mrs. Howard" (CCT, 651, endnote 461). Interestingly, by contrast, Wagayuhlen, Polk Scott's sister, did not speak Chinuk Wawa.

5. Jacobs provides information about Howard's great-uncle, her maternal grandmother's brother, in the following endnote: "Polk Scott was partly Yonkalla Kalapuya and partly Molale. He spoke both those languages. Probably all residents of Grand Ronde Reservation during the middle and late nineteenth century would have employed him in doctoring. Mrs. Howard said, in effect, that 'he did not doctor with his hands. During or after his singing, and when he had located the disease-cause, he would seize it and extract it.' She remembered only two of his doctoring songs" (CCT, 650, endnote 459).

6. Half-sun refers to noontime (Jacobs text insert, CCT, 513).

7. Jacobs provides the following details concerning Polk Scott's medical practice, his attempts to cure his patient, and the cause of her death: "Actually the procedure was extraction of the cause of the disease. Perhaps every shaman who functioned in Grand Ronde Reservation society blew on a disease-cause in order to weaken it. Then he bit and bit and bit it, which further weakened it. He 'drowned' it in water in a pan beside him. Finally he 'killed' it in his mouth. Mrs. Howard's dying mother must have suffered from five or six disease-powers. But he caught one or two additional minor offenders during the second day of his doctoring. It was the biggest of the disease-powers which killed the woman" (CCT, 651, endnote 462).

8. Polk Scott uses his "curing spirit-powers at their fullest strength" (Jacobs text insert, CCT, 514).

9. "It was a dark brown fur, of weasel or marten. His strongest doctoring spirit-power was therefore probably weasel or marten" (CCT, 651, endnote 463).

10. Jacobs clarifies the motivations of Howard's uncle in choosing Polk Scott to doctor his sister in this endnote: "He meant, I employed you because you

always talk straight—invariably you are honest and direct. The sick woman died a week or two later. The convinced relatives summoned no other shaman. However, Mrs. Howard also observed that, as a general rule, Clackamas believed that shamans often would not reveal the name of another shaman who had poisoned the patient. The diagnosing shaman might discover who had put the disease-cause into his patient and then he would give no indication that he knew. Mrs. Howard implied that shamans were usually secretive about one another's doings. I got the impression of a more or less specialist group which observed professional etiquette, engaged in log-rolling, and responded to situations anxiously because of fear of reprisal from other shamans. The similarities of shamans' feelings and values to those of physicians of Western civilization are of interest" (cct, 651, endnote 464). Perhaps Scott knew the source of the disease-power and did not divulge the information (see line 63), but there is no evidence of irony in Moses Allen's final pronouncement. It is possible, however, that Howard felt powerless in the face of her uncle and great-uncle and that her mistrust is implied, in the narrative, by the young woman's muteness.

Spearfishing at Grand Ronde

1. JFN 64, 108. CCT, 565. Though the Myth Age had long ended when the Europeans arrived in Western Oregon, its characters and events still had bearing on history, geography, and contemporary social life at Grand Ronde. This short narrative illustrates the importance of myth events as an integral part of post-myth human history in the sacredness of place and the inseparability of nature and culture for Native peoples of Western Oregon.
2. Jacobs notes the dual prefix with the character <s> in both his notebook and his publication. I have changed this to the standard phoneme /š/ in the current edition. We may wonder if Howard pronounced this pronoun with the phoneme /s/ (as sounded in English and used in IPA). However, the IPA phoneme was transcribed by Jacobs with the Americanist phoneme /c/. It is difficult to conceive of his use here of <s> as other than an oversight, despite its occurrence in both sources.
3. Jacobs notes in a text insert that Wagayuhlen would be telling a story "about the Grizzly Women and the fish reservoirs" (CCT, 565).
4. Jacobs indicates that Howard is referring to Wagayuhlen's "Molale husband," Quiaquaty (CCT, 565).
5. Jacobs states in text inserts that Wagayuhlen is referring to "all the water beings" and a "water hole in the hills of Grand Ronde" (CCT, 565).
6. Jacobs specifies in a text insert that "our son" refers to "Mrs. Howard's mother's brother," Moses Allen (CCT, 565).
7. Note the conciseness of this narrative, dominated by a metanarrative. Especially remarkable is the smooth passage linking the grandmother's act of

myth-telling to a geographical description of the narrator's time, followed by a reference to cultural and family life. All of these phenomena are connected by the very important role of fish and of catching fish in the life of the Chinook.

Slaughtering of Chinook Women

1. JFN 53, 35–47. CCT, 566–69. The date of this entry is marked by Jacobs in his notebook as July 17 (1929) (JFN 53, 35). Jacobs provides the following historical and geographical information related to the events of this dramatic narrative: "Mrs. Howard said that in the early nineteenth century the Chinook women were killed by Snake Indians every year, toward dawn during the camas season, at that same camas patch which was, perhaps, somewhere near Hood River about seventy miles east of Clackamas villages" (CCT, 663, endnote 557). Jacobs also provides an interpretive summary in an endnote: "Mrs. Howard's mother's mother, a Clackamas, told this historical narrative of a nineteenth century Snake Indian raid on a group of Chinooks. The Snakes murdered all the women except two who were up in a fir nearby. Chinooks supposed that Snakes killed in order to obtain valuables, but the explanation would seem to be a projection of Chinook motivations in comparable situations" (CCT, 663, endnote 557).

2. Jacobs notes, "she did not feel right, uneasy (got scared, sort of)" (JFN 53, 37).

3. Jacobs inserts an endnote to indicate, with respect to the nominal *agɔ́qal*, as transcribed in his notebook and used in his edition of the text, that "probably agɔqu [my mother] is correct" (CCT, 663, endnote 558). Whether this was a slip of the tongue on Howard's part or a transcriptional error on Jacobs's part, the high probability that *agɔ́qal* is accurate leads me to use it in the current edition of this text.

4. I have kept Jacobs's translation of the archetypal Chinook "maiden." The more modern translation, "adolescent girl," might be meaningful to today's readers.

5. Jacobs describes the movement of the ravens in a text insert: "as if to swoop upon prey" (CCT, 567). He also provides the following supplementary narrative detail concerning these imprecise movements: "Hostile Snake Indians were scouting near a camas patch where a group of either incautious or unsuspecting Upper Chinook women were digging roots. One man, whom the Snakes had stolen when he was a child attempted to warn the Chinook women. He threw moccasins into the air and they fell like ravens darting upon prey. He also dashed about like a coyote. But only one Chinook girl became uneasy when she observed these attempts at warning" (CCT, 662, endnote 557).

6. Jacobs specifies that the daughter speaks "in vain" to her mother in a text insert (CCT, 567). This type of unheeded warning of a younger person to an older one corresponds to the "younger-smarter" motif in Northwest Coast oral literature. See, in this volume, Howard's "Seal and Her Younger Brother Lived There" for a classic example.

184 *Notes to Pages 64–68*

7. Jacobs elaborates on the mother's reason for not taking her daughter's warning seriously in a text insert: "because you are merely sitting and looking and refusing to dig camas." (CCT, 567).

8. Jacobs specifies in a text insert that it was "the three girls who were uneasy" who went to fetch the water (CCT, 567).

9. Jacobs clarifies in a text insert that this line refers to "the Snake Indians" who were "lurking in the darkness nearby" (CCT, 567). It is quite remarkable that Howard provides this information as part of the narrator's point of view and not as being discovered by a character, as she so often does to add suspense when recounting dangerous events or tragic discoveries.

10. Jacobs specifies in a text insert that "one of the Chinook women (. . .) saw a reflection of Snake Indians" in the water (CCT, 567).

11. Jacobs adds in a text insert that they went off to bed "without lookouts" (CCT, 567).

12. Jacobs specifies in a text insert that the two girls were "cautious but frightened" (CCT, 568).

13. Jacobs clarifies in a text insert that the Snake Indians killed the Chinook women who had stayed at the camp and that the two girls "up in the fir" could hear them scream as they were dying (CCT, 568). We find here another example of the narrator providing the tragic information before presenting the character's discovery of it.

14. Jacobs clarifies that "villagers on the opposite side" of the river went to get the two girls (CCT, 568).

15. The metanarrative strategy of a character recounting the events of a story that has just been told by a narrator and was experienced by that character is common in Howard's myth recordings. We also find this in "Seal and her Younger Brother," an excerpt from a myth used to interpret contemporary Clackamas history. In "Seal and her Younger Brother," Seal's daughter retells the story as a way of saying "I told you so!" to her mother. The present narrative carries a similar "I told them so!" connotation, echoing the "younger-smarter" motif in Northwest Coast literatures.

16. Note the more commonplace narrative technique used by the surviving maiden who describes the act of listening as preceding the screams that came as evidence of the expected tragedy. This narrated order of events brings to light the importance of having been attentive as a survival strategy.

17. Howard's metanarrative comprises nearly a third of the full narrative. Interestingly, part D is made up of three subparts, which proportionally reflect the number of lines in the first three parts of the performance: part A (33: 14), part B (18: 8), and part C (18: 8).

Captives Escape Snake Indians

1. JFN 53, 15–29. CCT, 569–71. The date of the notebook entry is marked by Jacobs as July 15 (1929). The linguist tells us in an endnote that "both text 147 ("A Snake

Indian Massacre of Chinook Women") and this text were faultily recorded because they were written in the first weeks of the research and were not rechecked later" (CCT, 663, endnote 559). These two texts should make for an interesting study of Jacobs's standardization of Clackamas orthography. Interestingly, Jacobs publishes the two texts about Snake Indians killing Chinook women in reverse order from their notebook recordings.

2. Jacobs inserts the following endnote: "Mrs. Howard said that in the early nineteenth century the Chinook women were killed by Snake Indians every year, toward dawn during the camas season, at the same camas patch which was, perhaps, somewhere near Hood River about seventy miles east of Clackamas villages" (CCT, 663, endnote 559).

3. Note the extensive use of the particle *aǵa* in both of Howard's narratives of raids against Chinook women. In the present verse edits, each of the two narratives is comprised of exactly 104 lines and 54 uses of *aǵa*. Among the narratives edited in this collection, approximately 20 percent of the lines contain an occurrence of *aǵa* while, in the Snake raid narratives, slightly more than 50 percent of the lines contain this Clackamas particle. The particle *aǵa* serves as a rhetorical device, generally used to mark a new discourse segment. Like "now," it also marks intervals in a sequence of events. In the Snake raid narratives, the frequent use of *aǵa* maintains a tension in the flow of the narrative, lending a sense of urgency to the highly action-filled scenes. *Aǵa* is translated throughout the current edition as *now*, though it can signify other words, in some instances, including *then*, *so*, *thus*, and *and*.

4. The particle *íwa* is missing from the Clackamas edition in CCT, though an English translation ("immediately") is provided. The interlinear translation in the notebook is "just then, just as soon as they hid there" (JFN 53, 25). In another instance of this particle found in Jacobs's editions, the translation provided is "already" (CCT, 40). All other instances refer to a spatial direction to be taken from a given point of departure. This suggests that the temporal sense of *íwa* refers to a sequence of events, such as in the interlinear translation "as soon as." I have thus replaced *immediately* with *straightaway*.

5. Jacobs transcribes the war cry as ʔɛ ʔɛ ʔɛ ʔɛ ʔɛ·w in the notebook and includes it as a text insert. It may be found in a side note in the notebook along with the following information: "wí·nx̣yámxwl, Indian hollering, calling, war cry, war whoop-possibly to scare others" (JNB 53, 24). Jacobs adds in an endnote, "This is a Clackamas war whoop. Mrs. Howard implied that the Snake Indian war whoop was the same" (CCT, 570, endnote 562).

6. Note the abrupt appearance of the aggressors in the narrative. It is understood that "They" refers to Snake Indians who killed the Chinook women on a camas-digging camping trip. In his field notebook, Jacobs summarizes a sort of prologue to this narrative that Howard told, apparently in English: "Neither the Clackamas nor Molale killed squirrels to eat, but at least she hears that at Odell

(near Hood R.) squirrels were killed by the men off in the side hills when the women went camas digging; while the men were off the Snakes would come and steal or kill people—women and children; others say the Snakes came towards dawn. Mrs. H. tells about it in Clackamas" (JFN 53, 15). It may be presumed from line 10 that the women were raped before the massacre.

7. Jacobs elaborates with a text insert that the woman was shot trying to flee (CCT, 569).

8. Jacobs adds a text insert to clarify that the woman is advised to stop fighting (CCT, 569).

9. Jacobs specifies in a text insert that the gunshot wound was in the woman's leg (CCT, 569).

10. Howard tells Jacobs about the practice of sucking for healing injuries: "If one is hurt, cut etc., and it hurts there, you suck blood from the place, or get somebody to do it, who has power to do it or understands how, because not everybody can do that." According to Jacobs's notes, women who specialize in this technique are known as "itcágiłuqʷˈłuqˈʷ" (*ičágiłuqʷˈłuqˈʷ*), and their male counterparts are "iyágiłuqʷˈłuqˈʷ." We also read in Jacobs's field notes that "mosquito is a power that enables one to do it; there is also some water animal or fish (called amə́lqʷłan,_____(?)) that Mrs. H. has not seen or does not know the English of, that sticks on the foot when wading and sucks blood, and this may be the power of such an operator. These people are kind of doctors: med. doctors as such often cannot do this, have not the power to do it. Some practitioners suck it at a distance (!) from the wound, 2–3 inches off, others put their lips right on" (JFN 53, 30). These notes are not included in CCT.

11. Howard provides the following narrative details, placed in an endnote in CCT: "At night his arms were tied folded in front of him, his feet were tied, and he had to lie on his back or slide on the ground at some distance from her in the long row of sleeping Snakes. As she lay on the ground in the row of sleepers, her arms were fastened behind her and her feet were tied, too" (CCT, 663, endnote 560). This is similar to the following note in JFN: "he was tied hands and feet (in front); she was tied hands in back and feet too. He was put way off from her and so they lay, in a long row, they among them" (JFN 53, 19). This note is illustrated with a simple drawing of a person with arms folded in front.

12. Jacobs specifies in a text insert that the group departs the following morning (CCT, 570).

13. Jacobs's text insert states that the child was separated from his mother (CCT, 570).

14. Jacobs added "and silently," to read "slowly and silently," in the CCT edition. This is the only instance I have observed in which Jacobs embellishes the narrative.

15. Jacobs added "anyway" at the end of this one-line speech, though there is no Clackamas linguistic element referring to this term. I am at a loss as to

its meaning or purpose in the English translation. It does not seem to be an embellishment.

16. Jacobs tells us in an endnote, "The third captive did not escape this band of Snakes. Chinooks never heard about her again" (CCT, 570, endnote 561).

17. Jacobs specifies in a text insert that it was a large cedar (CCT, 570).

18. Jacobs adds in a text insert that the two were lying "beneath the trunk at the water's edge" (CCT, 570).

19. Jacobs specifies in a text insert that they arrive at the river "opposite their home settlement" (CCT, 571).

20. Jacobs inserts syntactic elements to say that the mother and son also tell the villagers that the captors took the two girls (CCT, 571).

21. Jacobs clarifies this line with text inserts: The "Snake Indians" were attacking "Chinook women who were at a distance from home" (CCT, 571).

Seal and Her Younger Brother

1. JFN 68, 89–95. CCT, 340–42. Jacobs provides the following background to Howard's version of this short excerpt from a longer myth: "Mrs Howard said that she had heard this fragment—perhaps more—of a myth told by her mother-in-law. That woman was a member of a lineage that lived in Columbia River settlements east of Willamette River Clackamas. Hence the telling of a story about Seal Woman is worthy of note" (CCT, 631, endnote 290). Jacobs labels this narrative as an "ik'ani (myth) fragment." Extensive analysis of its meaning and cultural references by Dell Hymes have shown that Howard reconfigures this episode from the original myth to interpret an aspect of contemporary history: the potential threats of foreign cohabitants and the risks of misinterpreting signs of danger as signs of tradition. Howard's version is thus of a fictional historical genre featuring humans, as opposed to supernatural forces and considerations as related in myth (Hymes 1981, 274–308, 2003, 408–10). Hymes's edit of this narrative also appears in Arkin and Shollar 1989. For other interpretations of the poetic artistry of this piece by Howard, see Ramsey 1983, 76–95, and Kermode 1978, 144–55. The present edition of "Seal and Her Younger Brother Lived There" very much reflects the verse edition provided by Hymes, but not entirely. See footnote 2 below.

2. As with Jacobs's translations and formatting, I have not retained the exact verse format of Hymes's text representation of "Seal and her Younger Brother." This segment (stanza 1) marks the first point of departure that I have taken from Hymes's verse analysis: the members of the household are listed in separate lines in order to punctuate each one with a pause, as would seem natural in an oral naming of individuals. Though we have no way of verifying this pause in Clackamas speech patterns, it would seem difficult to speak the names of people, running them together without a pause. (The pause is consid-

ered a basic segment marker by many ethnopoeticians). As with my deviations from Jacobs's editions of Howard's texts, I will not point to each modification that I have made from Hymes's analysis. Moreover, I leave it to future interpreters of Howard's recordings to provide their own versions, deviating from mine, as new understanding of Howard's work and of Chinookan literatures unfolds.

3. "Go out" is a euphemism for urinating. Jacobs specifies in a text insert the girl implies that there is something dangerous about the new wife (CCT, 340).

4. Hymes provides a valuable analysis of the moral underpinnings of this narrative. He identifies an "opposition between maintenance of formal expectations, general social roles, proprieties, on the one hand, and the heeding of or appropriate response to information about a particular empirical situation, on the other." In a study of social norms and empirical situations as they unfold in the text, Hymes points to the key narrative tension as lying between the mother wishing to uphold social norms, while responding inadequately to a pending danger, and the daughter deviating from social norms, while seeking to respond adequately to a pending danger (Hymes 1981, 288).

5. "The two are going" is a Clackamas euphemism for having sex.

6. Hymes deviated from his original verse analysis of this narrative, published in *In Vain I Tried to Tell You* (Hymes 1981, 309–41). In his initial publication of this narrative, his three-scene analysis unfolds into 3–5–3 stanzas, respectively. In his final analysis, he includes the first two stanzas of Scene 2 (Segment B) in Scene 3 (Segment C), here unfolding into three scenes of 3–3–5 stanzas, respectively (Hymes 2003, 408–10).

7. Seal is referring here to the decorated posts that are part of the facade of their house and that represent the wealth of the family. The loss of her brother represents a loss of economic status (See Jacobs 1960, 239).

Two Maidens, Two Stars

1. JFN 60, 39–41. CCT, 468. Concerning the genre of this short narrative, Jacobs writes in an endnote: "Mrs. Howard was uncertain whether this story of the star husbands was placed toward the end of the Myth Age or in the epoch following. I think that it can safely be categorized with stories of Transitional Times, because she used the identifying expression 'the people are close by now.' She reported hearing the story, which is recorded in field notebook 9, told by her mother-in law. Because of my failure to ask for a title in Clackamas words, I have applied the conventional motif title given by folklorists" (CCT, 644, endnote 401). In other versions of this narrative, the maidens leave their land, whereas in Howard's version, the star husbands come to the maidens. This inversion suggests that Howard borrows the events from the traditional myth to discuss a more contemporary matter, namely the arrival of white husbands in Native lands and culture.

2. The following note is found in Jacobs's field notebook: "The people used to say the little stars are old men, the bright stars younger men. When one star seemed to move to go to another place (probably a meteor) they would say it was a young man going to go to sleep with his girl, his neighbor: *łíx ixúxamt* he's going to sleep with her." Some discrepancy may be noted in the published version of these specifications: "As he lay beside her he was obviously an aged man. That was why he was a dim star. Clackamas used to say that smaller stars were old men; brighter stars were younger men. A shooting star was said to be a young man who was on his way to sleep with a damsel who lived near by: *łíx ixúxamt*, 'he is on his way to sleep with her'" (CCT, 645, endnote 402). One may wonder as to the modification of "his girl" to "a damsel"; the first indicates an à priori relationship between the young woman and the star, while the second gives her a more generic role with regard to her community.

Wásusgani and Wačínu

1. This historical narrative is transcribed in JFN 69, 49–111 and edited by Jacobs in CCT, 538–55. Howard informs Jacobs that her "mother-in-law had at least two Indian names, *wásusgani* and *waš?áwt*" (CCT, 657, endnote 513). Concerning Wásusgani's husband, the Clackamas chief before and during Removal, Jacobs edits the following annotation: "Old Watcheeno had three or four wives before the time when Caucasian farmers colonized the Willamette valley of western Oregon. His manner of functioning as a Clackamas village headman is difficult to describe or assess because of the paucity of information about him" (CCT, 657, endnote 516). The spelling of Watcheeno has been modified to Wacheno by Olson (2011, 462). The Americanist phonetic transcription Wačínu has been used in the present translation. The Americanist form has also been used in notes in this work to specify the character portrayed by Howard in her narrative, as distinct from the historical figure, while "Wačínu/Wacheno" has been used to specify that the narrated character has bearing on both the narrative roles of a narrated setting and the historical figure. This choice is also an attempt to edge closer to the context of nineteenth-century Grand Ronde, configured by Howard's performance. The same principle is followed in the use of Howard's maternal grandmother's name, Wagáyułn, as found in CCT, 268 (endnote 2; Waǵáyułən in JFN 52, 42). Olson's spelling, Wagayuhlen (2011, 157), has been used in my references to Howard's maternal grandmother. Note that Jacobs's English spelling, Watcheeno, is retained in citations of his CCT endnotes.
2. Jacobs endnote: "Mrs. Howard's grandmother said *kaywáx*" (CCT, 657, endnote 514).
3. This and other anecdotal narratives placed in italics were dictated by Howard during the translation sessions of her recordings and not in the flow of the larger narrative, "Wásusgani and Wačínu." Jacobs edited this particular narra-

tive, relating events in Wásusgani's life and relationship to her father, as part of a chronological presentation of the life of a traditional Clackamas woman. It is transcribed in JFN 69, 50.

4. *ʔgúp* is an example of the common use of onomatopoeia in Chinookan languages.

5. Jacobs's endnote: "*Kʰʷák'ʷá ačúxa,* 'he vomited,' is a form that the informant's grandmother used. The mother-in-law said *ačumǧúǧma.*" (CCT, 657, endnote 515). *Kʰʷák'wá* is, in fact, an onomatopoeic form followed by a verbal phrase employing the verb root -*x̣* (often translated as "to do" or "to make," but may be translated as "to go," as in "to go bang" or "pop goes the weasel," with sounds). The form "onomatopoeia +-*x̣*" thus signifies that the subject performs or some-how executes the act which the sound represents. In the present occurrence, the partially onomatopoeic English verb *barf* has been chosen to express both the sound value and the act found in the Clackamas formulation.

6. This Chinuk Wawa combination is composed of the Chinookan masculine pre-fix *i-* and a Native pronunciation of King George. I have used italics for Chinuk Wawa terms where Jacobs has underlined them, using typographic standards of his time. Jacobs's footnote: "This text contains a number of words from Chi-nook jargon. Each is indicated by its underlined phonemes. Of course, each jargon word functioned, in its borrowed form, as a morpheme to which Clack-amas affixes were attached" (CCT, 657, endnote 517).

7. *C'ikcik* is Chinuk Wawa for *wagon* (Jacobs text insert, CCT, 539). The suffix -*max̣* expresses a collective plural form or mass.

8. *Musmus* is Chinuk Wawa for *cattle* (Jacobs text insert, CCT, 539).

9. -*Lám* is Chinuk Wawa for *whiskey* (Jacobs text insert, CCT, 539).

10. Chinuk Wawa for *quilt* prefixed with the Chinookan *i-* (Jacobs text insert, CCT, 539).

11. Chinuk Wawa for *wheat bread,* deduced from the Howard/Jacobs translation (CCT, 541).

12. Chinuk Wawa for *Boston,* referring to Americans. Note the Chinookan femi-nine prefix *wa,* a more formal, at times honorary, prefixation than the ordinary -*a,* which is later dropped in the narrative (see Hymes 1981, 65–76).

13. Jacobs suggests that the English name of this American woman is Barclay (CCT, 658, endnote 520); this name is retained in the present edition.

14. This act transitions to an end with highly formulaic indicators using traditional Clackamas condensed forms in these three lines (141–43): *ǧʷɛnmix* (the num-ber five), *p'ala aluxáxa* (they would stop), marking a formal ending, and *kʰʷáɬqí aluxáx̣* (that is the way they did), marking anaphoric reference. The temporal marker *ǧwɛnmix wápul* (five nights) indicates the ritual number of dances to be held for the traditional spirit-power dance, serving as an ellipsis that meta-phorically brings us back to the formal ending: *p'ala aluxáxa.* The tightness and subtlety of this formal ending give way to the metanarrative that follows as an explanation of the unusual circumstance of these events.

15. Following the entextualization of this episode, Jacobs inserts a narrative from the Late Myth Age that is not included in the present edition, respecting the wishes of Western Oregonians to determine the fate of their sacred literature.

16. Note the long series of events marked by the indentations in these two stanzas. This narrative technique of sequencing events without a pause heightens the dramatic action of these tragic events. Both of these stanzas end with *kʷábá aɫx̣ímaxida* (they would fall) followed by *aɫúmqda* (they would die), creating an echo that could only serve as an ellipsis of the many thousands of individuals who died during these epidemics.

17. These short narratives illustrate the human and cultural experience of massive death due to disease in indigenous Oregon. As with all passages in italics in the present version, they were dictated by Howard during the translation sessions and recorded in JFN 69 (current passage transcribed on pages 72–74).

18. Note the change of rhythm in Howard's narration of a second wave of epidemics. Despite this change, the pace does not let up. Howard must have been quite focused and intent on her narrative construction as she covers a great deal of detail with steady flow and expression. The dramatic effect is enhanced by the verbal economy characteristic of Chinookan languages.

19. Chinuk Wawa for *handkerchief*, borrowed from English (Jacobs text insert, CCT, 549, endnote 530).

20. Chinuk Wawa for *barge* (Jacobs text insert, CCT, 550).

21. Chinuk Wawa for *horse* (Jacobs text insert, CCT, 550).

22. Chinuk Wawa for *Tumwater* (Jacobs text insert, CCT, 550).

23. Chinuk Wawa for *hogs* (or *pork*) with the plural suffix -*max̣* (Jacobs text insert, CCT, 551)

24. Chinuk Wawa for *sugar*, borrowed from English (Jacobs text insert, CCT, 552).

25. Chinuk Wawa for *sail house*, referring to a tent (Jacobs text insert, CCT, 552).

26. Here we have a Native naming of Native Oregon village groups that were gathered by the United States government for the founding of Grand Ronde.

27. The Chinuk Wawa morpheme -*búm* is derived from the French word *pomme*, meaning apple, possibly a diminutive of *pommier*, meaning apple tree (CCT, 553).

28. Chinuk Wawa for *apple tree*, borrowed from French: *la pomme*.

29. Chinuk Wawa for *soldiers*.

30. "A Clackamas woman who married a Molale" (Jacobs text insert CCT, 554).

31. Chinuk Wawa for *whiskey*.

32. Note the long, elaborate lines that characterize Wagayuhlen and Kílipašda's discourse. The content of the elders' dialogue reflects a certain number of details relative to the larger narrative, especially the title characters: Wásusgani and Wačínu, thus establishing a metanarrative structure that echoes the main narrative. A significant number of modals (*inx̣álutkt* and three occurrences of *ɫúxʷan*), and modifiers (*qá, idyágyutgʷax̣, qánaǧa, líxt čimákʷšt*), along

with four occurrences of the negating modal, *néšqi*, establish a density of complex assertions that is not proportionate to or characteristic of the wider narrative, marking a clear shift in discourse patterns. This shift may illustrate a new form of discourse that was developing in post-removal Clackamas history.

33. Jacobs provides the following ethnographical description of Wásusgani's father's shamanism in a footnote: "He had some sort of spirit-power that was 'in the water,' they said. It was reputed to be his strongest spirit-power. It was thought of as having a baby on its back. Therefore he did so, too, and when he sang its song 'full power' he would vomit blood" (CCT, 657, endnote 515).

34. "Getting big" is an expression for getting pregnant (Jacobs text insert, CCT, 539).

35. Wacheno's Molalla wife, mentioned here, was Quiaquaty's sister Sophie (Jacobs text insert, CCT, 539).

36. This humorous narrative illustrating the discovery of Euro-American items by K'amíšdiqʷnq was inserted from a narration transcribed in JFN 69, 56.

37. Several modifications were made in the editing of this passage from the notebook transcriptions to *Clackamas Chinook Texts*. In the notebook, Jacobs jotted down, "She's stingy and brings me something that is no good" (JFN 69, 56), which he modifies in the publication to read, "She is stingy and gives something that is worthless" (CCT, 540–41). The notebook translation of what appears here as line 19 is "and she gives me *that!*" which becomes "she gives it!" in the publication. The choice of the verb *bring* in the present translation is based on corpus study, while use of the demonstrative *that* is largely based on the rhetorical effect of Jacobs's initial interpretation in collaboration with Howard, an effect that is lost in "she gives it." *Something* in line 18 has also been changed to *Anything* in an attempt to make the irony of the father's observation about his daughter's behavior more explicit. Another translation, perhaps less awkward and more expressive in English, would read, "And that is what she brings!" This version captures the irony of the daughter's stinginess in light of her desires (demands) expressed in the elliptical "Anything she wanted from me" (to say that she got anything she asked for and has brought him little or nothing). This translation, however, is not in keeping with the translator's efforts at bending English syntax, when possible, to reflect Chinookan structures and the qualities of its conciseness.

38. In his field notebook, Jacobs writes, "He thought it, squash, was a watermelon" (JFN 69, 56) and inserts "like a watermelon" in the publication (CCT, 541).

39. Jacobs provides the following details about these Euro-American trade items in an endnote: "During the earliest years of Caucasian entry and envelopment, a handful of brass buttons were highly priced and much treasured by Clackamas. Brass thimbles, called *iɬsk'alyuks*, were similarly valued. The people made holes in thimbles to string them. Brass finger rings, named *iɬqiƛáyudax*, were also regarded as valuables" (CCT, 657–58, endnote 518).

40. More on Euro-American items at Grand Ronde from a Jacobs endnote: "In those days a hoop or wide skirt was gathered at the waist with a string" (CCT, 658, endnote 519). Judging from many such instances in Howard's corpus, the Clackamas and Molalla peoples loved to poke fun at each other, all in jest. In this case, Grand Ronde residents are making fun of the Euro-American fashions that were, for them, clownish.

41. Concerning the consumption of alcohol by Native Oregonians, from their first contact with Europeans to the founding of Grand Ronde, Howard informs Jacobs that her "mother-in-law said that the Indian women who lived through the earliest years of Caucasian contact were non-drinkers. She intimated that only the Indian men of the period drank, and drank to excess. Old Watcheeno, her husband of polygynous memory, imbibed heavily, but she asserted that she never touched a drop" (CCT, 658, endnote 521).

42. The following endnote from Jacobs's edition of this text provides some insight into the complexity of excessive alcohol consumption by western Oregon Natives, combined with religious oppression of indigenous beliefs and practices by Euro-Americans, ultimately contributing to the disruption of spiritual life at Grand Ronde. We also discover concerted community efforts at assisting individuals in getting back onto the spiritual path of their traditional heritage: "The Indian theory about this period was that there were many persons who really had spirit-powers but who had long kept such ownership and relationship secret. Now that Caucasians had come, such formerly secretive gentry seemed to be singing their old spirit-power songs in the presence of others, more because they were released to do so, under the influence of Caucasians' whiskey, than because of any pressure from their supernatural kin. That is why Mrs. Watcheeno is described as having laughed at this point. Whatever the stimulus which indicated a new supernatural, other Indians would at once arrange, according to Clackamas custom, a five day session of spirit-power dancing for the new singer and his previously unnoted spirit-power. In short, the first years of Caucasians and whisky resulted in an increase in the number of winter spirit-power dances, the Indians asserted" (CCT, 658, endnote 522).

43. Howard provides the following details concerning the organization of spirit-power dances: "The person with the new spirit-power, for whom a singing and dancing session of five nights was given, would be the first singer each night. After his song or songs, the remainder of the evening and much of the night, perhaps, was devoted to the singing and concomitant dancing of the spirit-powers of some of the other persons who were present and who had already assisted in the novice's singing and dancing" (CCT, 659, endnote 527).

44. Howard provides insights into the procedures of spirit-power singing in this annotation, edited by Jacobs: "The new possessor of a spirit-power might or might not drop, faint, and 'die.' If he did, then when he revived, if it had been

necessary to revive him with the help of shamans, he would try to sing his new spirit-power song for the first time. By general agreement, a person who was supposed to be most likely to have a similar or identical kind of spirit-power sat by the unconscious or reviving novice and listened and watched closely when the latter commenced singing. The informally assigned song-observer, who was called *gʷiláx̱awalčgix*, 'the one who catches on to the song,' attempted to identify and repeat the melody of the novice's new song. The assembled people appear to have caught on, in their turn, to the song-observer's relatively forthright rendition of the new song. They did so before anyone was able to make much of the feeble initial venture, in singing, of the emotionally and often physically shattered novice" (cct, 659, endnote 528).

45. Jacobs inserts a narrative from the Late Myth Age into his cct entextualization of "Wásusgani and Wačínu"; it is not included in the present edition (see cct, 543–44).

46. Jacobs notes in a text insert that this illness was tuberculosis (cct, 545).

47. Jacobs provides biographical information in a text insert: "He was also known as Old Wood. His wife was a part Molale named *w·'·tutamx*. They lived on the Clackamas River or at Oregon City" (cct, 547, endnote 529).

48. Given the number of anecdotal narratives and the elaborate details in this part of Howard's historical account, there can be no doubt that the events of this dramatic period of Native Oregon history were soundly embedded in the oral tradition of early Grand Ronde. The loss of native languages, and even of Chinuk Wawa as a primary language, has also resulted in the loss of collective memory and of historical narratives such as those found here. The U.S. government's termination of the Confederated Tribes of the Grand Ronde community occurred in 1954, after which Grand Ronde residents dispersed along the Northwest Coast, striving as best they could, individually and through family, to adapt to the demands of American education, lifestyles, and professions. (For more information on the termination of Grand Ronde, see Lewis 2009.)

49. Jacobs includes a text insert here to specify that this passage concerns the Clackamas (cct, 547).

50. Howard is referring here to Native patients who were taken to an American hospital. Jacobs specifies in a text insert that "they" refers to "the Indians at Oregon City," placing this part of the text in pre-Grand Ronde history (Jacobs text insert, cct, 548).

51. Jacobs specifies in a text insert that the people headed "south on the Willamette River" (cct, 550).

52. Jacobs states in text inserts that transportation was by barge and that the people were taken "as far as Dayton, on the Yamhill River" (cct, 550).

53. Jacobs inserts "to Oregon City" to specify the location of Tumwater (cct, 550).

54. Jacobs indicates in a text insert that the first camp was in Dayton, Oregon (cct, 553).

55. The American soldiers led the Native Americans in search of a new home.

56. Jacobs writes in a text insert that the first proposal for the settlement of the northwestern Oregon Indians was "at Ballston, about five miles southeast of Sheridan" (CCT, 552).

57. Jacobs reflects upon the refusal by the Native communities of the first proposed site for settlement: "This open site would have been a valuable property from the point of view of the descendants of these Indians after about 1880. But in the 1850s the suddenly uprooted older people, who had been reared under food-gathering conditions, believed that they ought to select a stream, lake, and mountain district where deer, fish, camas, and other familiar foods could be gotten" (CCT, 660, endnote 531).

58. "Mrs. Howard, and presumably others who were resident at Grand Ronde after the 1850s, named the Indians of southwestern Oregon and south of the Coos-speaking villages, notably the Indians of groups along the lower Rogue River and especially the upper-class persons whose faces were tattooed, the *gʷidaʔə́pmax̣* 'black marked faces.' South of Coos districts, the coastal or lower Rogue River Indians—all of Athabaskan dialects—who lacked facial tattoos were called slaves by Grand Ronde Indians" (CCT, 660, endnote 532).

59. Jacobs inserts *tent* to clarify what is meant by *sail houses* (CCT, 552) and writes about the reaction of the immigrants to their living conditions: "The older people disliked the 'sail houses' or tents which they had to camp in along Caspar Creek. Such Indians did nothing but cry for days on end" (CCT, 660, endnote 533).

60. A Jacobs text insert identifies this Kalapuyan man as Victoria Howard's second husband's grandfather, Joe Hudson (CCT, 553).

61. Jacobs specifies in a text insert that "the Shastas, Rogue River Indians and Upper Upmquas" were moved "to new Grand Ronde" (CCT, 553).

62. Jacobs specifies in a text insert: "the Molales, Chinooks, Kalapuyas, and Klamaths" were housed at "at Old Grand Ronde" (CCT, 553).

63. Jacobs inserts "already" in this line to specify that it concerns houses that were built before the arrival of the peoples of the confederated tribes (CCT, 553).

64. This paper was "a two-week leave permit" (CCT, 553, text insert) that Grand Ronde residents were issued, allowing them to leave Grand Ronde temporarily. People would leave for various reasons, including seasonal work, such as fishing and berry-picking, trade excursions, and family visits.

65. Jacobs states in a text insert that Howard's maternal grandmother would perform "another narrative about olden days" (CCT, 553).

66. Jacobs clarifies in several text inserts that Wásusgani and Kílipašda, using cynicism and mockery, are pointing to Watcheeno's failure to behave as a proper chief before his people (CCT, 553–56, text insert).

67. Jacobs notes that it was Watcheeno's "new bride's relatives" that provided for their material needs, further degrading Watcheeno's standing as a husband (CCT, 554, text insert).

68. Jacobs states in a text insert that the young Howard leaves so as to "overhear no more of their gossiping" (CCT, 555). Apparently, Howard confided in Jacobs that she was not comfortable with their degrading way of speaking about Wacheno/ Wačínu.

69. In "I Lived with My Mother's Mother" (see this volume), Howard asserts that her maternal grandmother did not speak ill of others. Soon after her recording of that autobiographical narrative, she recorded "Wásusgani and Wačínu," in which her grandmother is heard denigrating a Clackamas chief and resident of Grand Ronde with whom she is closely related by marriage, as well as by linguistic and cultural affinity. It is interesting to note Howard's seeming contradiction in these portrayals of her grandmother, with regard to Wačínu, and to point to the final lines of this narrative, where Wagayuhlen specifies that this is hearsay. It should also be noted that the steadfast anthropological and epistemic consistency of Howard's narrative art, and of her corpus as a whole, eliminates the possibility of her unwittingly misrepresenting either her grandmother's principles and behavior or her conversations (see note 67). This seeming contradiction of a prestigious tribal elder's moral standards is resolved when we understand that Wačínu is being depicted less as an individual member of a community than as a symbol of the historical disruption of Clackamas tradition, viewed from within the confederated tribal life of Grand Ronde.

Inventions and New Customs

1. JFN 60, 38–42. CCT, 562–63.
2. The element "*pášǎ*" refers to Boston, combined with the element *nukš* (people) to refer to Americans; borrowed from Chinook jargon.
3. The term *Tk'aníyukš* normally refers here to the "myth people" of the "Myth Age" as told in the *ik'ani* (myth). Jacobs reveals the connotation of this reference in these endnotes to "Gitskux and his older brother": "At this point Mrs. Howard commented, 'How strange those Myth Age people were!'" (CCT, 629, endnote 263), and "Mrs. Howard commented, as she did many times, that those Myth Age people were very foolish" (CCT, 630, endnote 277).
4. "The Chinook jargon word for *table* is *ladám*, originally, of course, from French: *la table*" (CCT, 662, endnote 548).
5. The Clackamas man is referring to the telegraph and Wagayuhlen, to steamboats.
6. Jacobs provides further details and keen insight into Grand Ronde humor in the following endnote: "This text, from notebook 9, suggests that Grand Ronde Reservation Indians reacted overtly to many of the changes in their way of life with amusement rather than gratitude, grief, or even some bitterness. For example, they laughed hilariously when they commented upon their new habit of sitting on chairs around a table for meals. Mrs. Howard went on to describe

how, during the 1850s and later, perhaps each Saturday the federal employees at the Reservation gave Indians sugar, shoes, dresses, and the like. Recipients would go outside, try on the new shoes, stumble and fall down, while other Indians roared with amusement. Some managed to walk in the new footwear, but they waddled like ducks, said some of the native observers. Others at once put on the new white garments that the government issued to them. Older Indians stood by and laughed and laughed at the absurd new things. The question arises as to how much hostility and ambivalence was present in such laughter. Doubtless much of the discomfiture and humiliation felt by the Indians was covered up by means of slapstick, clowning, and joking" (CCT, 662, endnote 549).

Two Grass Widows

1. A grass widow is one of the first flowers to bloom in spring in Chinookan lands and beyond. They grow in wet ground surrounded by leaves that are as tall as their stems and have reddish-purple petals. As a story character, grass widows are found in Chinookan myths and folktales. They are differentiated from widows in general, but are associated with them in Howard's performance of *Coyote Went around the Land* (CCT, 80–105).
2. JFN 68, 139. JFN 69, 3. CCT, 471–72. "Mrs. Howard devised this title for my purposes, and on the spur of the moment. She did not recall the exact words which her people used when they referred to the story. It is certainly no story of the Myth Age. It is 'just about people,' that is, in Transitional Times or the epoch directly following the Myth Age. Mrs. Howard supposed that her grandmother, who told her the tale, heard it from Molale rather than Clackamas people, according to her recollection of what her grandmother used to remark when recounting it" (CCT, 645, endnote 403).
3. Jacobs's published version proposes a single assertion in which *qáx̣ba* operates as a conjunction: "They are long since dead there where they laid down the geese" (CCT, 472). This interpretation does not coincide with the search for the geese that ensues. Moreover, a clearly marked period in the notebook transcription indicates a new thought after *išdúmaqt* (they-two have been dead), justifying the translation proposed here: "Where did they put the geese?"
4. *Aǵa q'wáp idə́lxambt* is one variation of the formulaic closing to a transitional tale, announcing the arrival of the people. It refers to the humans who arrive to inhabit the land once the myth people have put things in order for their use and appreciation. "As in other Indian mythologies, it is believed that there was a time when animals walked about as men, though they had approximately the same mental and physical characteristics as now. At that time, when there were no Indians in the country, but only anthropomorphic animals, many things were not as they should be, and in order to make the country fit for habitation

by the Indians destined to hold it, it was necessary for a culture-hero or trans-former to rectify the weak points in creation" (Sapir 1909, 542).

5. Jacobs specifies in a text insert that the people in the story are sitting up during the night (CCT, 471). This story takes places in a traditional Mollala home.
6. Jacobs specifies in a text insert that this refers to the geese flying by (CCT, 471).
7. Note the blend of imagery and sound in this stanza, which begins with the laughter of the two widows followed by the image of the geese flying directly overhead and the expression of a careless wish, followed by more laughter.
8. Jacobs specifies in a text insert that "the other people in the house" speak here (CCT, 471).
9. Note that this narrative is framed by the assertion of the two (grass widows) having a bad omen (the fallen geese). The first is presented in the narrative voice, with the remote past suffix *ga-*, while the second and final assertion is spoken by the people in the house, using the near past *na-...-a*.
10. Jacobs inserts here, "The Indians who will enter this land" for clarification (CCT, 472).

Restrictions on Women

1. JFN 67, 126–30. CCT, 496–97.
2. Jacobs inserts "rules and proscriptions" to qualify "things/dán" (CCT, 497).
3. Jacobs inserts for clarification that "a menstruating woman remained in the menstrual hut" and that she would swim and make her body clean "each of the five days."
4. Jacobs specifies with an inserted note "during five or six months of mourning" (CCT, 497). Jacobs added in his notebook, "long ago for six months, 5 months/ nowadays 4, 5 days or a week" (JFN 67, 128).
5. With Jacobs's parenthetical insertions, this passage reads: "They would not look at them (or even their food), or at a baby (from birth to about three months of age). When it (an infant) suckled she (its nursing mother) would cover herself (her breast lest it be seen by a menstruating woman, a widow in mourning, or a woman who had just had sexual intercourse)" (CCT, 497).
6. Jacobs clarifies the meaning with an inserted note: "observed various cautions" (CCT, 497).
7. With Jacobs's parenthetical notes this passage reads, "They used to say, various things were poisonous (that is, tabooed), such things they had eaten would stay (stick) in their stomach (if they failed to observe the rules indicated above), they would become ill, (and later) they would become thin bony and debilitated" (CCT, 497).
8. Jacobs inserts here, "even today in spite of our age" (CCT, 497).
9. In his publication, Jacobs adds a parenthetical note to this clause: "We believed all those things (and that is why we have lived so long)" (CCT, 497).

10. Elaboration of subject matter and direct speech are used to structure this discourse to highlight ancestral authority. Howard exposes her topic in a three-part progression: 1) the general taboo against female sexuality; 2) details of its application through restrictions and guidelines for cleansing and reestablishing order and balance; and 3) the oral transmission and genuine conviction of the effectiveness of traditional practices. Note also the progression of Howard's use of direct speech: an idiomatic expression pointing to female sexuality is uttered by distant, ancient voices (part A) as a way of documenting Clackamas beliefs; part B elaborates on the dangers of not respecting the taboos in narrative voice, allowing for a more personal take on the matter; and part C provides a profession of the importance of respecting them in the voice of the performer's grandmother, an intimate and well-referenced authority.

Laughing at Missionaries

1. JFN 62, 102. CCT, 563. Jacobs comments in an endnote to his edition of this text: "This sally would be followed by explosions of laughter. Mrs. Howard commented on how the oldtime Indians roared with amusement at the things they heard priests say" (CCT, 662, endnote 550). Dell Hymes's verse edits of this text, along with "The Honorable Milt" and "Seal and Her Younger Brother Lived There," are published in *Longman Anthology of World Literature by Women 1875–1975* (Arkin and Sholler 1989) as well as in D. Hymes 1987.

2. This term, *šáx̣lix*, means "above," often used to refer to the sky, and *íštamx* is translated by Howard and Jacobs as "chief." These terms were possibly borrowed by the Catholic priest as a translation for "notre père qui est aux cieux" ("our father who art in heaven"). There is no indigenous word for "god" in Chinook.

3. In his notebook, Jacobs inserts this interlinear explanation: "when the first Catholic priest came here" (JFN 62, 102). He also adds "[Oregon City]" to his interlinear translation, "to this place here" (JFN 62, 102).

4. In text inserts Jacobs specifies that Howard is referring to the Catholic priest who first arrived in Oregon City to preach to the Native peoples, probably Father François Norbert Blanchet, a French Canadian priest who announces his arrival at Fort Vancouver in a letter to the Archbishop of Quebec on March 17, 1839 (Catholic Church 1878).

5. That is to say, "you will remain just like the animals you are" according to Jacobs's text insert (CCT, 563).

The Honorable Milt

1. [Note on title] Jacobs titles this text "Humor of Mrs. Watcinu" in the top margin of a notebook page (JFN 62, 46). This anecdote is also found in CCT, 560. The title of the present edition of this text has been retained from Dell Hymes's

translation of line 11 (see D. Hymes 1987, 327; Hymes's edit of this narrative also appears in Arkin and Shollar 1989). The title given by Jacobs is "The whites and Milt." Jacobs tells us that this narrative "exemplifies one kind of humor which Clackamas resorted to in order to ventilate their anger toward Caucasians" (CCT, 661, endnote 542).

2. JFN 67, 41–50. CCT, 348–50.

3. These last two lines are an adaptation of a lyric from a song from "She Deceived Herself with Milt" (CCT, 348–50). Jacobs informs us that the song "was recorded on Ediphone cylinder 14544b and dubbed on tape 11. It appears in text 39, the myth titled 'She Deceived Herself with Milt.'" (CCT, 396, endnote 542).

4. In Howard's myth recital, the widow discovers her new husband and responds, "Goodness. A fine-looking man, he is light of skin." Other intertextual elements provide insight into Howard's myth-telling as an interpretation of contemporary social life in the same way as "Seal and Her Younger Brother" and "Two Maidens: Two Stars Came to Them." (See this volume.)

5. Hymes points to the causative suffix *-amid* in this verb phrase, which Jacobs erases in his CCT translation: "She changed him into a man" (D. Hymes 1987, 324). Hymes's translation, "I supposed him for myself," however, fails to express the reflective act of "deceiving oneself" expressed in *-ẋ-d-√lul*, which is more appropriately translated in a romantic context with "delude oneself." We note that this verb form is closer to Jacobs's translation of the myth title, "She Deceived Herself with Milt," and focuses attention on the wife's self-created illusion as the problem at hand.

Two Children, Two Owls

1. JFN 61, 76–80. CCT, 478. Jacobs provides the following details concerning the genre and the social function of this narrative: "Like text 65, this tale from field notebook 10, is only probably placed in the epoch following Transitional Times. People told the story to quarreling children and it served as a means of quieting them. I failed to inquire about my informant's source for the tale, or maybe she could not recall who had told it to her years before" (CCT, 645, endnote 406).

2. Jacobs specifies "one boy and one girl" were sitting up "in bed" in parenthetical inserts in his edited version (CCT, 478).

3. Jacobs inserts the parenthetical note "the children quarreled" to indicate that they quarreled even more (CCT, 478).

4. Jacobs clarifies that it is "the adults" who get up (CCT, 478).

5. Jacobs states that this insult is "said in a high pitch" in a parenthetical insert (CCT, 479).

6. Jacobs lends some insight into the possible connotations of this insult: "This is swearing which Mrs. Howard asserted she could not render in even a crude approximation in English. My venture at a translation, 'You give!' makes a lit-

tle sense, on the good assumption that *-lut-* is the morpheme for give and the word may therefore be 'give it to her,' with an added connotation of aggressive sexuality. If it did possess such a connotation, I am surprised that my informant did not translate it in that way, because she seemed to lack inhibitions about such matters" (CCT, 645, endnote 407).

7. Jacobs inserts notes to specify that the adults shut the "door of the house (. . .) to prevent the owl-children from flying out" (CCT, 479).

8. In a parenthetical note, Jacobs specifies that it is "the girl" that lands first (CCT, 479).

9. The passionate relationship of the inseparable brother and sister raises the issue of incest. The tale was very likely directed at parents as well as children to reinforce the incest taboo.

Joshing during a Dance

1. JFN 59, 54–58. CCT, 561. Jacobs speaks of the interview context of this narrative in an endnote: "This short text was dictated in order to illustrate some Clackamas attitudes and components of humor during the nineteenth century" (CCT, 661, endnote 544). Dell Hymes's intricate verse analysis of "Joshing During a Spirit-Power Dance" demonstrates Howard's use of irony by figuring the content of the narrative into the structural organization of the turns of talk between the characters. He also shows that the (propositional) content and the presentational form of each character's speech establishes an echo with which a speaker one-ups the preceding speaker. Hymes identifies a similar "Chinookan pattern of verbal exchange" (title of his article) as a source of narrative humor in "Habitual Whistling," "Laughing at Missionaries," "Maybe it's Milt," (see this volume for the latter two), and in a myth-telling by Howard, "Bluejay and his Elder Sister," along with a myth-telling in Kathlamet Chinook by Charles Cultee, "Salmon's Myth" (D. Hymes 1987). Also known as Mary Smith, "Ni-udiya" is the anglicized spelling in Olson's Grand Ronde name index (Olson 2011, 432). As noted in the marginal heading of Jacobs's notebook entry of this narrative, Ni?údiya is Dúšdaq's wife (JFN anglicized 59, 54).

2. "Maul" is a borrowing from English in Chinuk Wawa. We read in Jacobs's notebook: "An oak block a foot long, was used for a maul, after the whites came; round-headed (unflattened) people were called in derision 'mauls.'" This insight into Clackamas views of white settlers is edited as an endnote in the publication of CCT: "When Caucasians first entered the lower Columbia River valley, foot-long blocks of oak were used as mauls. Clackamas oldsters derisively characterized as mauls those persons whose heads had not been flattened" (CCT, 661, endnote 544).

3. Jacobs includes the following endnote: "The Chinook jargon word for 'cattle' is *músmus*. Winslow told the oldsters that their heads were flattened like the heads of cattle. Winslow's sally apparently amused and did not discomfit these oldsters" (CCT, 661, endnote 545).

4. Jacobs specifies in text inserts that Káwał's wife was "giving a spirit-power dance" and that the people were arriving "before darkness in order to attend the dance during the evening" (CCT, 561). According to Olson, Káwał is Stephen Cowell, whose wife's name was Dwayaya (Olson 2011, 115).

5. That is, "the older people already sitting and gossiping" are checking out the newcomers (Jacobs text insert, CCT, 561). In an interlinear notebook entry, Jacobs writes below the *íwi gałxúxa* entry, "the observant elders would rubber-neck to see who was entering at the door" (JFN 59, 54).

6. She is making fun of "their babies whose heads have not been flattened" (Jacobs text insert, CCT, 561).

7. Jacobs uses James Winslow's full name in his English translation (CCT, 561) and includes in a parenthetical note that this jokester is "a half-breed who spoke Clackamas" (see D. Hymes 1987, 327).

8. Winslow's utterance is difficult to translate, probably because of several unusual forms in his Clackamas speech, as Hymes explains. Winslow tells the Clackamas jokesters that it would be said of them, with their flat heads, that they resemble cows. Note that the reference to a cow echoes the elders' reference to the maul in a sort of turning of the tables, demonstrating a mastery of the rhetorical pattern demonstrated by Hymes. Hymes translates these two lines as "If they were *your* heads/Like just cattle, would have to say!" and explains the unusual wording of the second line as follows: "The ordinary form *ƛ'á . . . díwi* enclosing a nominal stem expresses a resemblance as with the English suffix *-like* in *cow-like.*" Hymes suggests that Winslow lacks mastery of Clackamas grammar in his use of the form *díwi ƛ'á* + stem. Also, Winslow's utterance of *-gímẋ* "is intelligible only as a unique truncated form (root and customary affix only, no pronominal prefix)," hence a sort of "broken" Clackamas (D. Hymes 1987, 306). While Hymes seeks to capture Winslow's grammatical awkwardness, the present translation is an attempt to expose his meaning more clearly.

9. That is, the old people laughed "at Winslow's retort" in Clackamas. They are surprised he speaks Clackamas since his head is unflattened (Jacobs text insert, CCT, 561).

10. Jacobs notes that this occurs the very next night and that Wásusgani's departure is at the end of the dance (CCT, 561).

11. We learn from an endnote in Jacobs's edition that Wásusgani "spent the night out in a field. The occupants of a nearby house had not heard her calls, and in the darkness she had not perceived the house" (CCT, 662, endnote 547).

12. Jacobs specifies in a text insert that this evening is still part of the "same series of evening dances" (CCT, 561).

13. In text inserts Jacobs clarifies that Wásusgani had wanted to take a shortcut but went in the wrong direction (CCT, 561).

14. In line 38, Kílipašda mocks Wásusgani, who claims that she was forced by circumstances to sleep outside of her home. From Jacobs's notebook, we read, "some man kept screwing you off in the brush somewhere" and "[how could you have kept lost when you have a light?]" (JFN 59, 58). Jacobs's translation, including the parenthetical insert, reads, "Someone was copulating (and was not at all lost in the fields)" (CCT, 562). Hymes integrates the causative suffix *-mid* in his translation, "Someone was made to camp over," further noting that the verb stem *-ǧú-* "is commonly used in the sense 'to camp overnight'" (D. Hymes 1987, 306). Jacobs and Howard also translate this stem as "staying out overnight" (CCT, 179) and "staying away" (CCT, 32). The mention of camping has thus not been retained in the present version as it does not seem to fit the context or qualify as an expressive euphemism.

15. Jacobs inserts for clarification that the "others called out to the chatterboxes to keep quiet" and they "went back to the evening's business of spirit-power dancing" (CCT, 562).

Dances Performed by Visitors

1. JFN 51, 39–41. CCT, 526. Jacobs provides the following information in an endnote about the collection: "The song, which was recorded on Ediphone cylinder 14542c and later dubbed on tape 10, was supplemented by this text written in my field notebook for music items. I lack a notation in that book to indicate when I recorded it during the four months which I spent visiting Mrs. Howard. The song is the visitors' fun-dance song which was used by K'amishdaqʷnq" (CCT, 654). We understand, then, that the narrative was configured and performed by Howard to illustrate the context of fun-dances at which such songs were performed. Jacobs also provides the following interpretation of K'amishdaqʷnq's performance, provided by Howard in an endnote: "Mrs. Howard thought that it might be an imitation, both bad and comical, of Kalapuya visitors' fun-dance song" (CCT, 654, endnote 489).

2. "Grand Ronde Reservation Indians never performed fun-dances when they visited elsewhere. Siletz Reservation Indians, who included various Athabaskan groups of southwestern Oregon, Coos, Takelma, Siuslau and others, did perform fun-dances each Saturday evening when they visited outside the Siletz area. They wore feather headdresses and red and other face paints. Johnny Williams danced with his arrow quiver. Two girls danced in opposite directions: each held a feather, holding one arm up going one way, the other arm up when dancing in the opposite direction. Or holding both arms up and crossed, when going one way, arms straight up when dancing in the opposite direction. Fun-dances occurred at any time of the year, when strangers visited Grand Ronde people. But Mrs. Howard was definite that she never saw Clackamas dance this type of dance. She saw only the Siletz Reservation Indians perform

it when they were at Siletz or elsewhere, or the Athabaskans and possibly the Coos who lived at Grand Ronde. I deduce that Oregon Coast Salish, Molales, and Sahaptins, in addition to Chinooks, lacked possession of the dance" (CCT, 655, endnote 489).

3. Jacobs writes in a text insert that these events would last as long as two or three days (CCT, 526).

4. Jacobs indicates in a text insert that this would be the house "of some well-to-do Clackamas" (CCT, 527).

5. Jacobs specifies in a text insert that the "Clackamas hosts" would look on, suggesting that the Clackamas of all the Grand Ronders took particular interest in these dances.

6. Jacobs adds in a text insert that the Grand Ronders would potlatch small items "such as dried fish, salmon eggs, dried camas, hazel nuts, dried eels, and other things" (CCT, 527).

7. Another Jacobs text insert specifies that it was the "Clackamas who had enjoyed the fun-dances performed earlier by their Kalapuya guests" and that they would later imitate them during their visits to other places (CCT, 527). The fun-loving nature of the Clackamas is depicted in several other anecdotal narratives told by Howard included in this volume.

8. Jacobs specifies in a text insert that the term *idə́lxam* (the people), used in this line, refers specifically to the Clackamas (CCT, 527); Clackamas people would go off to visit other Native homes, perhaps other reservations, for trading.

9. During later travels undertaken by the Clackamas for trading, they wished to dance for their hosts as the Kalapuya had done during their visit to Grand Ronde.

10. Howard provides interpretive insight into K'amishdaqwnq's performance, edited by Jacobs in an endnote: "Mrs. Howard thought that it might be an imitation, both bad and comical, of a Kalapuya visitors' fun-dance song. The words are *łiqamušduwíla*, 'Crawfish is dancing.' A second visitors' fun-dance song, of the same type and used by the same Clackamas man, possibly a song also of Kalapuya origin, is recorded on Ediphone cylinder 145412d and dubbed on tape 10. The words are *dənuči mnáyułmax̣ k'umaǧa amnux̣úlalma*, 'you are not my spirit-power but you are using me.' A third song of the same type, sung by the same man, and having the same possible source among Kalapuyas, is recorded on Ediphone cylinder 14542e and dubbed on tape 10. The words are as follows, in a Kalapuya dialect, perhaps Santiam: *či? či? či? čumyáŋkalat*, 'I I I I am a Yonkalla Kalapuya.' Doubtless this song was funny, because it was as if an Englishman were visiting in America and entertaining his hosts by singing 'Yo ho ho I'm a Russian.' Still another fun song, probably of Shasta origin, is on Ediphone cylinder 14543b and dubbed on tape 10" (CCT, 654, endnote 489).

REFERENCES

Arkin, Marian, and Barbara Shollar. 1989. "Victoria Howard." In *Longman Anthology of World Literature by Women, 1875–1975*, edited by Marian Arkin and Barbara Shollar, 106–9. Translations by Dell Hymes. London: Longman.

Bauman, Richard, and Charles L. Briggs. 1990. "Poetics and Performance as Critical Perspectives on Language and Social Life." *Annual Review of Anthropology* 19: 59–88.

Bauman, Richard, and Joël Sherzer. 1974. *Explorations in the Ethnography of Speaking*. Cambridge: Cambridge University Press.

Beckham, Stephen Dow. 1977. *Indians of Western Oregon: This Land Was Theirs*. Coos Bay OR: Arago.

Blommaert, Jan. 2006. "Applied Ethnopoetics." *Narrative Inquiry* 6 (1): 181–90.

Boas, Franz. 1894. *Chinook Texts*. Bureau of American Ethnology Bulletin 20. Washington DC: Government Printing Office.

——— . 1901. *Kathlamet Texts*. Bureau of American Ethnology Bulletin 26. Washington DC: Government Printing Office.

——— . 1911. "Chinook." In *Handbook of American Indian Languages*. Vol. 1, part 1, edited by Franz Boas, 558–677. Washington DC: Government Printing Office.

Boyd, Robert T. 2004. *People of the Dalles: The Indians of Wascopam Mission*. Lincoln: University of Nebraska Press.

Calame-Griaule, Geneviève. 1894. *Ethnologie et langage, La parole chez les Dogon*. Paris: Éditions Gallimard.

Cassirer, Ernst. 1996. *The Metaphysics of Symbolic Forms*. New Haven: Yale University Press.

Chinuk Wawa Dictionary Project. 2012. *Chinuk Wawa kakwa nsayka ulman-tilixam łaska munk-kəmtəks nsayka/As Our Elders Teach Us to Speak It*. Grand Ronde OR: Confederated Tribes of the Grand Ronde Community of Oregon.

DeMallie, Raymond J. 1984. *The Sixth Grandfather: Black Elk's Teachings Given to John G. Neihardt*. Lincoln: University of Nebraska Press.

Dyk, Walter. 1933. "A Grammar of Wishram." PhD. diss., Yale University.

Foley, John Miles. 1988. *The Theory of Oral Composition: History and Methodology*. Bloomington: Indiana University Press.

——— . 1991. *Immanent Art: From Structure to Meaning in Traditional Oral Epic*. Bloomington: Indiana University Press.

——— . 1995. *The Singer of Tales in Performance*. Bloomington: Indiana University Press.

——— . 2002. *How to Read an Oral Poem*. Urbana: University of Illinois Press.

French, David. 1958. "Cultural Matrices of Chinookan Non-Casual Language." *International Journal of American Linguistics* 24 (4): 258–63.

French, David H., and Kathrine S. French. 1998. "Wasco, Wishram, Cascades." In *Handbook of North American Indians: Plateau*, edited by Deward E. Walker, 360–77. Washington DC: Smithsonian Institution.

Genette, Gérard. 1972. *Figures III*. Paris: Editions du Seuil.

Gumperz, John J., and Dell Hymes. 1972. *Directions in Sociolinguistics*. New York: Basil Blackwell.

Hajda, Yvonne P. 1984. "Regional Social Organization in the Greater Lower Columbia 1792–1830." PhD. diss., University of Washington.

Hymes, Dell. 1955. "The Language of the Kathlamet Chinook." PhD. diss., Indiana University.

——. 1958. "Linguistic Features Peculiar to Chinookan Myths." *International Journal of American Linguistics* 24 (4): 253–57.

——. 1964. "Directions in (Ethno-)Linguistic Theory." *American Anthropologist* 66 (6): part 2, 6–56.

——. 1965. "The Methods and Tasks of Anthropological Philology (illustrated with Clackamas Chinook)." *Romance Philology* 19: 325–40.

——. 1974. *Foundations in Sociolinguistics, An Ethnographic Approach*. Philadelphia: University of Pennsylvania Press.

——. 1981. *In Vain I Tried to Tell You: Essays in Native American Ethnopoetics*. Philadelphia: University of Pennsylvania Press.

——. 1983. "Victoria Howard's 'Gitskux and His Older Brother': A Clackamas Chinook Myth." In *Smoothing the Ground: Essays on Native American Oral Literature*, edited by Brian Swann, 129–70. Berkeley: University of California Press.

——. 1984. "The Earliest Clackamas Text." *International Journal of American Linguistics* 50 (4): 358–83.

——. 1985. "A Theory of Irony and a Chinookan Pattern of Verbal Exchange." In *The Pragmatic Perspective: Selected Papers from the 1985 International Pragmatics Conference*, edited by Jef Veschueren and Marcella Bertucelli-Papi, 293–337. Amsterdam: John Benjamins.

——. 2003. *Now I Know Only So Far: Essays in Ethnopoetics*. Lincoln: University of Nebraska Press.

Hymes, Virginia. 1987. "Warm Springs Sahaptin Narrative Analysis." In *Native American Discourse, Poetics, and Rhetoric*, edited by Joel Sherzer and Anthony C. Woodbury, 62–102. Cambridge: Cambridge University Press.

——. 2004. "Celilo." In *Voices from Four Directions: Contemporary Translations of the Native Literatures of North America*, edited by Brian Swann, 195–208. Lincoln: University of Nebraska Press.

Jacobs, Melville. 1952. "Psychological Inferences from a Chinook Myth." *Journal of American Folklore* 65: 121–37.

———. 1958. "Clackamas Chinook Texts: Part 1." *International Journal of American Linguistics* 24 (2), Part 2, *Indiana University Research Center in Anthropology, Folklore, and Linguistics Publication 8.* Bloomington: Indiana University Research Center in Anthropology, Folklore, and Linguistics.

———. 1959a. "Clackamas Chinook Texts: Part 2." *International Journal of American Linguistics* 25 (2), Part 2, *Indiana University Research Center in Anthropology, Folklore, and Linguistics Publication 11.* Bloomington: Indiana University Research Center in Anthropology, Folklore, and Linguistics.

———. 1959b. *The Content and Style of an Oral Literature: Clackamas Chinook Myths and Tales.* Chicago: University of Chicago Press.

———. 1960. *The People are Coming Soon: Analyses of Clackamas Chinook Myths and Tales.* Seattle: University of Washington Press.

———. 1972. "Areal Spread of Indian Oral Genre Features in the Northwest States." *Journal of the Folklore Institute* 9 (1): 10–27.

Kappler, Charles J., comp. and ed. 1904. "Treaty with the Kalapuya, etc., 1855." *Indian Affairs: Laws and Treaties: Vol. II, Treaties,* 665–69. Washington DC: Government Printing Office.

Kermode, Frank. 1978. "Sensing Endings." *Nineteenth-Century Fiction* 33 (1): 144–58.

Kroskrity, Paul V. 1985. "Growing with Stories: Line, Verse, and Genre in an Arizona Tewa Text." *Journal of Anthropological Studies* 41 (2): 183–99.

———. 1993. *Language, History, and Identity: Ethnolinguistic Studies of the Arizona Tewa.* Tucson: University of Arizona Press.

Lecercle, Jean-Jacques. 1999. *Interpretation as Pragmatics.* London: Palgrave MacMillan.

Lévi-Strauss, Claude. 1971. *L'homme nu.* Paris: Plon.

Lewis, David Gene. 2009. "Termination of the Confederated Tribes of the Grand Ronde Community of Oregon: Politics, Community, Identity." PhD. diss., University of Oregon.

Mason, Catharine. 1999. "Méthodologies de l'ethnopoétique appliquée à l'art verbal de Victoria Howard." PhD. diss., Université de Michel de Montaigne—Bordeaux 3.

———. 2004. "L'ethnopoétique et l'anthropologie structurale à partir d'un récit de Victoria Howard, Clackamas Chinook." *Journal de la Société des Américanistes* 90 (1): 25–55.

———. 2008. "Ethnographie de la Poétique de la Performance." In *Techniques d'enquête en littérature orale,* edited by Brunhilde Biebuyck, Sandra Bornand, and Cécile Leguy. *Cahiers de la littérature orale* 63–64: 262–94.

———. 2010. "Digital Documentation of Oral Discourse Genres." *Literary and Linguistic Computing* 25 (3): 321–36.

———. 2017. "Poetic Inspiration and the Contextualization of Misunderstanding." In *Le poète et l'inspiration,* edited by Dominique Casajus and Amalia Dragani. *Cahiers de littératures orales* 8.

Moore, Robert. 1982. "An Optional Form and Its Patterning in Kiksht Narratives: Semantics, Metapragmatics, Poetics." *Working Papers for the Seventeenth International Conference on Salish and Neighbouring Languages*, August 9–11, 1982, Portland State University.

——— . 1988. "Lexicalization versus Lexical Loss in Wasco-Wishram Language Obsolescence." *International Journal of American Linguistics* 54 (4): 453–68.

——— . 1993. "Performance Form and the Voices of Characters in Five Versions of the Wasco Coyote Cycle." In *Reflexive Language: Reported Speech and Metapragmatics*, edited by John A. Lucy, 213–40. Cambridge: Cambridge University Press.

——— . 2009. "From Performance to Print, and Back: Ethnopoetics as Social Practice in Alice Florendo's Corrigenda to 'Raccoon and his Grandmother.'" *Text and Talk* 29 (3): 295–324.

——— . 2013. "Reinventing Ethnopoetics." *Journal of Folklore Research* 50 (1): 13–39.

Neihardt, John G. 2008. *Black Elk Speaks*. Annotated by Raymond DeMallie. Albany: State University of New York Press, Excelsior Editions. Originally published in 1923.

Olson, June. 2011. *Living in the Great Circle: The Grand Ronde Indian Reservation 1855–1905*. Oregon City: A. Menard.

Pettigrew, Richard M. 1990. "Prehistory of the Lower Columbia and Willamette Valley." In *The Handbook of North American Indians: Northwest Coast*, edited by Wayne Shuttles, 518–29. Washington DC: Smithsonian Institution.

Ray, Verne. 1938. *Lower Chinook Ethnographic Notes*. Seattle: University of Washington.

Ramsey, Jarold. 1983. *Reading the Fire: Essays in the Traditional Indian Literatures of the Far West*. Lincoln: University of Nebraska Press.

——— . 1995. "Generic and Racial Appropriation in Victoria Howard's 'The Honorable Milt.'" *Oral Tradition* 10 (2): 263–81.

Revel, Nicole. 1992. *Fleurs de Paroles: Histoire Naturelle Palawan: Chants d'amours, Chants d'oiseaux*. Paris: Peeters.

Ricoeur, Paul. 1983. *Temps et Récit*. Paris: Editions du Seuil.

Sapir, Edward. 1907. "Preliminary Report on the Language and Mythology of the Upper Chinook." *American Anthropologist* 9 (3): 533–44.

——— . 1909. *Wishram Texts*. Washington DC: American Ethnological Society.

Seaburg, William R., and Pamela T. Amoss, eds. 2000. *Badger and Coyote Were Neighbors, Melville Jacobs on Northwest Indian Myths and Tales*. Corvallis OR: Oregon State University Press.

Sherzer, Joel. 2001. *Kuna Ways of Speaking*. Austin: University of Texas Press.

Silverstein, Michael. 1977. "Person, Number, Gender in Chinook: Syntactic Rule and Morphological Analogy." *Annual Meeting of the Berkeley Linguistics Society* 3: 143–56.

———. 1978. "Deixis and Deducibility in a Wasco-Wishram Passive of Evidence." *Annual Meeting of the Berkeley Linguistics Society* 4: 238–53.

———. 1984. "Wasco-Wishram Derivational Processes vs. Word-Internal Syntax." *Papers from the Parasession on Lexical Semantics*, edited by David Testen, Veena Mishra, and Joseph Drogo, 453–68. Chicago: Chicago Linguistic Society.

———. 1990. "Chinookans of the Lower Columbia." In *The Handbook of North American Indians: Northwest Coast*, edited by Wayne Shuttles, 533–46. Washington DC: Smithsonian Institution.

———. 1995. "Kiksht 'Impersonals' as Anaphors and the Predictiveness of Grammatical Categorical Universals." *Annual Meeting of the Berkeley Linguistics Society* 21: 262–86. Berkeley: Berkeley Linguistics Society.

———. 1996. "The Secret Life of Tears." In *Natural Histories of Discourse*, edited by Michael Silverstein and Greg Urban, 81–105. Chicago: The University of Chicago Press.

Thompson, Laurence C. 1978. "Melville Jacobs, 1902–1971." *American Anthropologist*, n.s., 80 (3): 640–49.

Thompson, Laurence C., and M. Dale Kinkade. 1990. "Languages." In *Handbook of North American Indians: Northwest Coast*, edited by Wayne Shuttles, 30–51. Washington DC: Smithsonian Institution.

Uzendoski, Michael A., and Edith Felicia Calapucha-Tapuy. 2012. *The Ecology of the Spoken Word, Amazonian Storytelling and Shamanism among the Napo Runa*. Urbana: University of Illionois Press.

Zenk, Henry. 1984. "Chinook Jargon and Native Cultural Persistence in the Grand Ronde Indian Community, 1856–1907." PhD. diss., University of Oregon.

In the Studies in the Anthropology of North American Indians Series

The Heiltsuks: Dialogues of Culture and History on the Northwest Coast
By Michael E. Harkin

Prophecy and Power among the Dogrib Indians
By June Helm

A Totem Pole History: The Work of Lummi Carver Joe Hillaire
By Pauline Hillaire
Edited by Gregory P. Fields

Corbett Mack: The Life of a Northern Paiute
As told by Michael Hittman

The Spirit and the Sky: Lakota Visions of the Cosmos
By Mark Hollabaugh

The Canadian Sioux
By James H. Howard

The Canadian Sioux, Second Edition
By James H. Howard, with a new foreword by Raymond J. DeMallie and Douglas R. Parks

Clackamas Chinook Performance Art: Verse Form Interpretations
By Victoria Howard
Transcription by Melville Jacobs
Edited by Catharine Mason

Yuchi Ceremonial Life: Performance, Meaning, and Tradition in a Contemporary American Indian Community
By Jason Baird Jackson

Comanche Ethnography: Field Notes of E. Adamson Hoebel, Waldo R. Wedel, Gustav G. Carlson, and Robert H. Lowie
Compiled and edited by Thomas W. Kavanagh

The Comanches: A History, 1706–1875
By Thomas W. Kavanagh

Koasati Dictionary
By Geoffrey D. Kimball with the assistance of Bel Abbey, Martha John, and Ruth Poncho

Koasati Grammar
By Geoffrey D. Kimball with the assistance of Bel Abbey, Nora Abbey, Martha John, Ed John, and Ruth Poncho

Koasati Traditional Narratives
By Geoffrey D. Kimball

Kiowa Belief and Ritual
By Benjamin Kracht

The Salish Language Family: Reconstructing Syntax
By Paul D. Kroeber

Tales from Maliseet Country: The Maliseet Texts of Karl V. Teeter
Translated and edited by Philip S. LeSourd

The Medicine Men: Oglala Sioux Ceremony and Healing
By Thomas H. Lewis

A Grammar of Creek (Muskogee)
By Jack B. Martin

A Dictionary of Creek / Muskogee
By Jack B. Martin and
Margaret McKane Mauldin

The Red Road and Other
Narratives of the Dakota Sioux
By Samuel Minyo and
Robert Goodvoice
Edited by Daniel M. Beveridge

Wolverine Myths and Visions: Dene
Traditions from Northern Alberta
Edited by Patrick Moore and
Angela Wheelock

Ceremonies of the Pawnee
By James R. Murie
Edited by Douglas R. Parks

Households and Families of
the Longhouse Iroquois at
Six Nations Reserve
By Merlin G. Myers
Foreword by Fred Eggan
Afterword by M. Sam Cronk

Archaeology and Ethnohistory of the
Omaha Indians: The Big Village Site
By John M. O'Shea and
John Ludwickson

Traditional Narratives of the
Arikara Indians (4 vols.)
By Douglas R. Parks

A Dictionary of Skiri Pawnee
By Douglas R. Parks and
Lula Nora Pratt

Lakota Texts: Narratives of Lakota Life
and Culture in the Twentieth Century
Translated and analyzed by
Regina Pustet

Osage Grammar
By Carolyn Quintero

A Fur Trader on the Upper Missouri:
The Journal and Description of
Jean-Baptiste Truteau, 1794–1796
By Jean-Baptiste Truteau
Edited by Raymond J. DeMallie,
Douglas R. Parks, and Robert Vézina
Translated by Mildred Mott Wedel,
Raymond J. DeMallie, and
Robert Vézina

They Treated Us Just Like Indians: The
Worlds of Bennett County, South Dakota
By Paula L. Wagoner

A Grammar of Kiowa
By Laurel J. Watkins with the
assistance of Parker McKenzie

To order or obtain more information on these or other
University of Nebraska Press titles, visit nebraskapress.unl.edu.